America
on my mind

Introduction by
Jimmy Carter

Library of Congress Number: 90-85970
ISBN 0-7627-2360-2

Manufactured in Korea
First Edition / Fourth printing

acknowledgments

The publisher gratefully acknowledges the following sources:

Pages 11 and 56 from *Journey into Summer* by Edwin Way Teale. Copyright 1990; St. Martin's Press, Inc., New York.

Pages 16 and 114 from *America and Americans* by John Steinbeck. Copyright 1968; Bantam Books, Inc., New York.

Page 20 from *The Geographical History of America* by Gertrude Stein. Copyright 1964; Random House, Inc., New York.

Page 31 from *The Necessity of Empty Places* by Paul Gruchow. Copyright 1988; St. Martin's Press, Inc., New York.

Page 36 from *The Mind of the South* by W.J. Cash. Copyright 1941; Alfred A. Knopf, Inc., New York.

Page 40 from *The Sound of Mountain Water* by Wallace Stegner. Copyright 1969; Doubleday & Co., Inc., New York.

Page 44 from *The Edge of the Sea* by Rachel Carson. Copyright 1955; E.M. Hale & Co., Eau Claire, Wisconsin, by arrangement with Houghton Mifflin Co., Boston.

Page 50 from *Collier's* magazine, July 8, 1955.

Page 54 from *Pilgrim at Tinker Creek* by Annie Dillard. Copyright 1988; Harper & Row Publishers, Inc., New York.

Page 64 from *O Pioneers!* by Willa Cather. Copyright 1933; Houghton Mifflin Co., Boston.

Page 71 from *Wandering through Winter* by Edwin Way Teale. Copyright 1990; St. Martin's Press, Inc., New York.

Pages 80 and 150 from *Inside U.S.A.* by John Gunther. Copyright 1951; Harper & Row Publishers, Inc., New York.

Pages 85 and 120 from *A Sand County Almanac* by Aldo Leopold. Copyright 1949; Oxford University Press, Inc., New York.

Page 90 from *The Land of Little Rain* by Mary Austin. Copyright 1988; Penguin Books, Inc., New York.

Page 94 from *Buckaroo* by Kurt Markus. Copyright 1987; Little, Brown & Co., Boston.

Page 98 from *Mark Twain's Letters from Hawaii*, edited by A. Grove Day. Copyright 1975; University Press of Hawaii, Honolulu.

Page 105 from *You Learn by Living* by Eleanor Roosevelt. Copyright 1983; Westminster Press, Louisville, Kentucky.

Page 106 from *Two Cheers for Democracy* by E.M. Forster. Copyright 1972; Edward Arnold, United Kingdom.

Page 110 from *Jet* magazine; Johnson Publishing Co., Inc., Chicago.

Page 112 from *Frontier* by Louis L'Amour. Copyright 1984; Bantam Books, Inc., New York.

Page 122 from *The All American War Game* by James Lawton. Copyright 1984; Blackwell.

Page 123 from *God's Country and Mine* by Jacques Barzun. Copyright 1973; Greenwood Press, Inc., Westport, Connecticut.

Page 131 from *My Antonia* by Willa Cather. Copyright 1977; Houghton Mifflin Co., Boston.

Page 142 from *The Complete Poems of Carl Sandburg*. Copyright 1970; Harcourt Brace Jovanovich, San Diego.

Page 144 from *High, Wide and Lonesome* by Hal Borland. Copyright 1990; University of Arizona Press, Tucson.

Page 146 from *The Points of My Compass* by E.B. White. Copyright 1962; Harper & Row, Publishers, New York.

Page 148 from *The Mysterious Lands* by Ann Zwinger. Copyright 1990; Plume Books, New York.

Page 156 from *An Outdoor Journal* by Jimmy Carter. Copyright 1988; Bantam Books, Inc., New York.

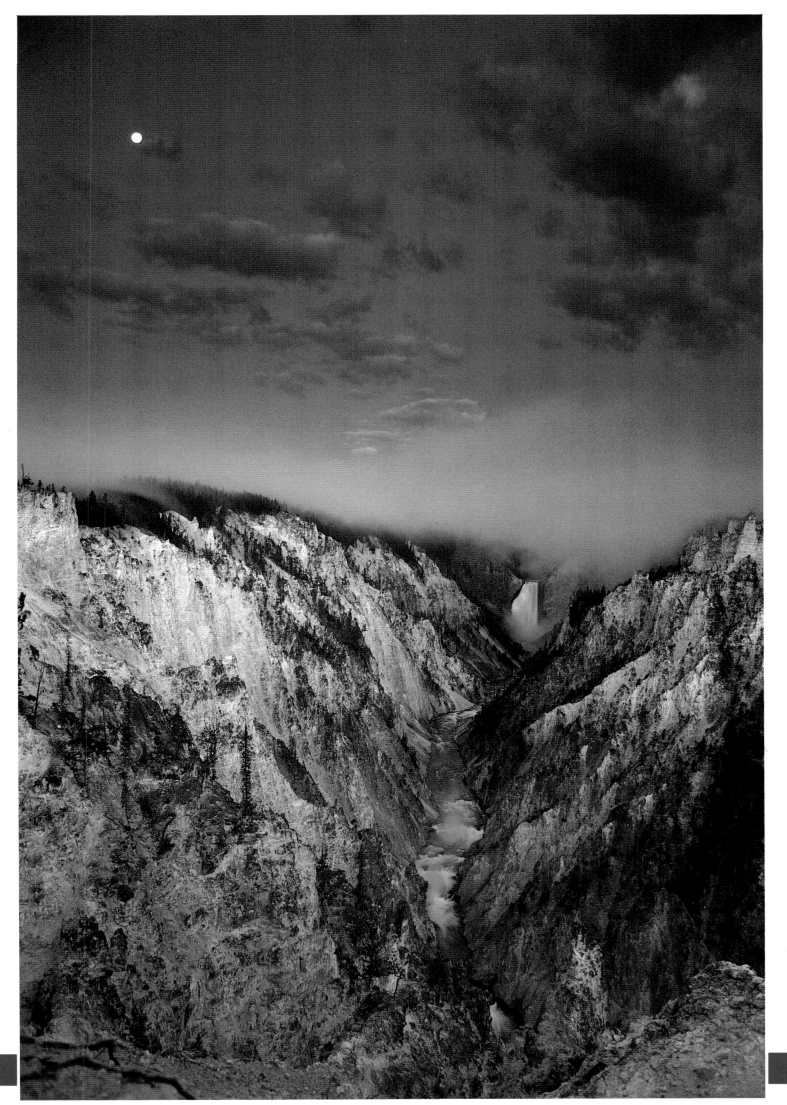

Moonrise over the Lower Falls of the Yellowstone River, Yellowstone National Park, Wyoming GREG L. RYAN / SALLY A. BEYER

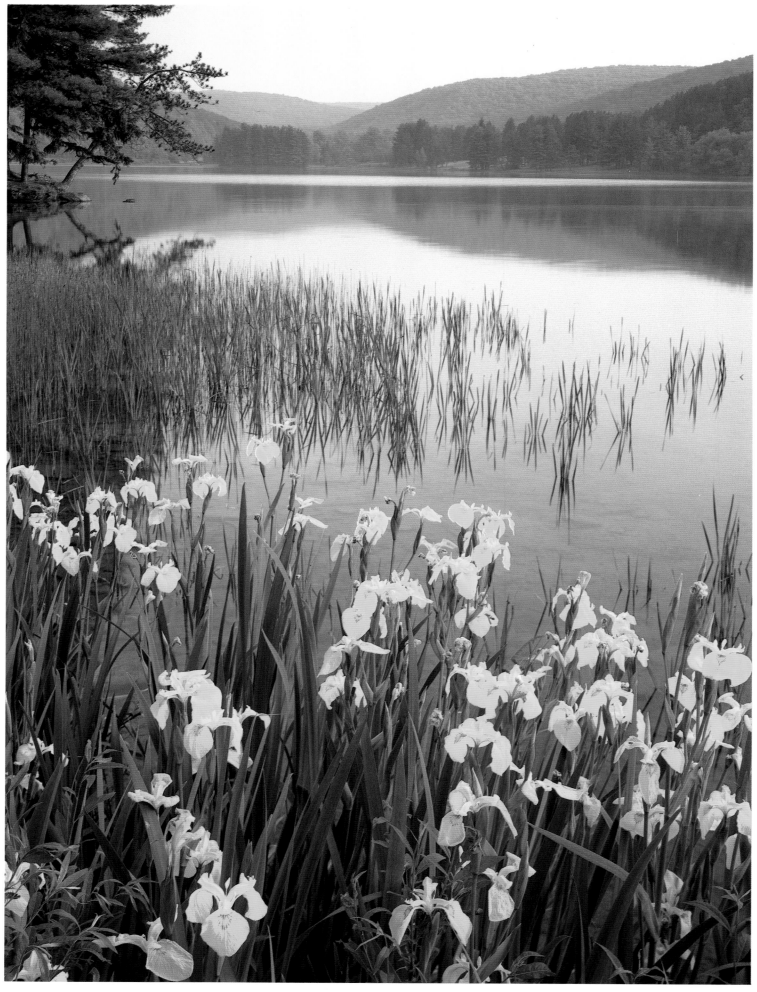

Yellow irises adding color to Red House Lake, Allegheny State Park, New York CARR CLIFTON

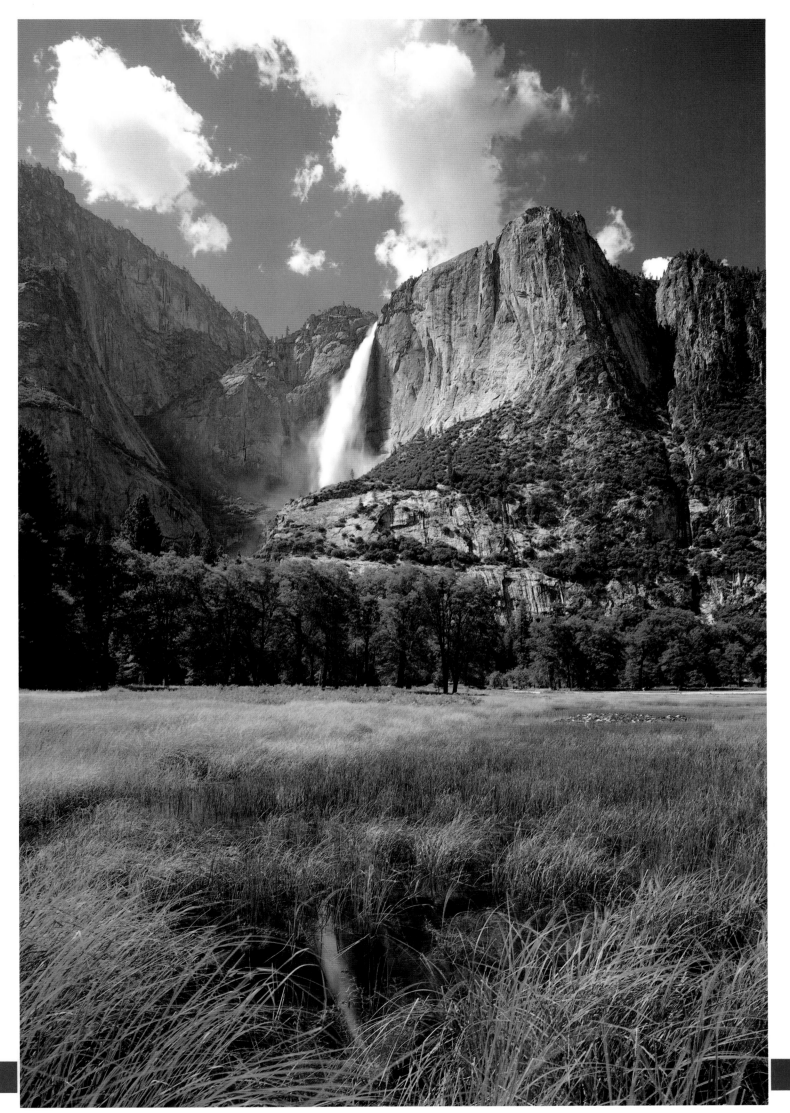

Upper Yosemite Falls plunging 1,430 feet into Yosemite Valley, Yosemite National Park, California DAVID MUENCH

the beauty and promise of America

I grew up as a farm boy three miles west of Plains, Georgia, where one of the 650 residents was my future wife, Rosalynn. During those depression years, our house did not have electricity or running water, and our Southern society was plagued by almost total racial segregation. One exception was that black and white farm families labored long and hard in the fields, side by side. The financial rewards were minimal, but even then—from our patriotic church sermons, history lessons, and school debates on issues of national interest—we knew the beauty and promise of America.

After decades of soil erosion caused by repetitive cotton crops, my father was building terraces, protecting wildlife habitat, planting trees, and practicing contour farming. We worked hard, but we also learned to enjoy and respect the great gifts of the land. After the crops were "laid by," or after a rain when it was too wet to plow, we children spent our free time in the woods and swamps—exploring, hunting, and fishing. We learned where the seasonal fruits, nuts, and berries grew, the need to control soil erosion and to protect wildlife habitat. The squirrels, rabbits, opossums, raccoons, catfish, and eels we caught were a proud contribution to our families' tables.

Education was a top priority in my family. There was a remarkable teacher in our small school who enticed me to read endless lists of literary classics. He made all of us white kids memorize the names of famous artists and their works and listen repeatedly to scratchy recordings of some of the world's greatest music. I am reluctant to admit that in those early days I gave little thought to how my black playmates were being educated in their segregated school. "Separate but equal" was a totally inaccurate but soporific phrase.

As an adult, I can understand at least partially how our resilient and self-correcting society could have allowed one of us to occupy the nation's highest political office and all of us to remove the millstone of racism from our necks. I know that as a Georgian I could not have been considered seriously as a presidential candidate if the South still had been suffering from this tragic heritage. The pioneer American spirit still blesses us with the ability to respond to personal opportunities and to correct our nation's faults.

No one could visit all fifty states, as I have, without being inspired by the beauty and grandeur of our land and seas, our prairies and mountains, our forests and deserts. Some of the vistas seem commonplace; others are truly breathtaking. There are stark differences among the Okefenokee Swamp, the cityscape of San Francisco, the red fields of Georgia, and the Brooks Range of Alaska. Most extraordinary of all are the people. No other nation has such a diverse population. Many families still have ties to relatives in foreign countries and venerate their Old-World language, history, religion, music, and culture. At the same time, we are drawn together by one common force: a commitment to freedom.

Our country has its share of problems, including poverty, illiteracy, and

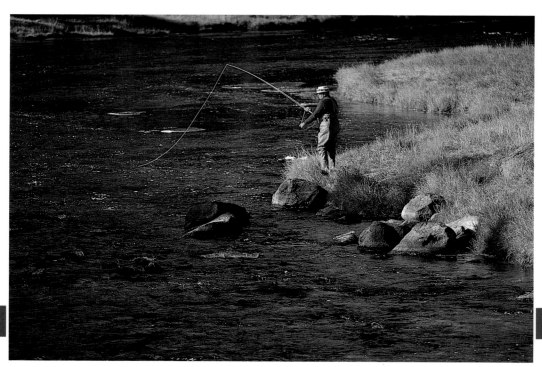

Fly fishing for trout on the Madison River, Yellowstone National Park, Montana / Wyoming / Idaho MICHAEL S. SAMPLE

homelessness. Some of our natural treasures are being despoiled by greed and the misplaced priorities of economic "progress." But we are able to face these challenges with the same drive of the pioneer days, a drive based on determination, courage, hard work, and new ideas.

We are, indeed, still a pioneer nation. Cherishing our precious natural sites exemplifies this heritage. We like to explore, to face the unexpected, and to see the world as God made it. I know how deeply and beneficially my own life is affected by experiences in wild areas. My family still enjoys adventures all the way from Georgia's Okefenokee Swamp to the mountain peaks and glaciers of the Northwest. We fish the warm waters of Georgia and Florida, but we also relish our annual excursions to the trout streams of Pennsylvania, Colorado, Montana, Washington, Oregon, and Alaska. It is to our nation's credit that we protect these outdoor treasures. But tragically, not all Americans share these values. The environmental struggle goes on. Recently, in the Alaska Wildlife Refuge, we were able to access this confrontation.

From a high plateau in the Brooks Range, we observed a flock of three dozen mountain sheep moving delicately above us, feeding on the sparse lichens. Later, we stood quietly as a sea of caribou split and streamed by us on both sides. Just a few yards from the Beaufort Sea, we watched a family of vigilant musk oxen graze, while guarding their frolicking

calves. There are few places on earth that are so unspoiled, so beautiful, so filled with wildlife, so fragile. All this is endangered by shortsighted leaders who would permanently despoil this vast area with drilling rigs and pumping stations, attempting to assuage our extravagant thirst for oil for just a few additional months.

A continuing embarrassment, even after the civil rights victories, is the disinclination or inability of our rich country to alleviate the suffering of our fellow citizens. Homelessness is pervasive. Fifty thousand of our neighbors in New York City will have no shelter tonight, and several million other Americans across our country share this tragedy. Although serious, this is not an insoluble problem.

Rosalynn and I have lived in a governor's mansion and in the White House and have visited with kings and presidents in their palaces. But the most wonderful dwellings we know are the modest homes being built with eager hands by volunteers and some of America's poorest families—working side by side as equals. "The only two good things in our old house was me and my husband," said one proud woman in Philadelphia. Other new homeowners, who have never had a high school diploma to frame for the wall, almost immediately begin to pick out colleges for their children. This spirit of caring and sharing has been one of the great strengths of our country—people with confidence in the future, working together for a better life.

Illiteracy is also a serious infliction. The value of reading and writing is made clear by the poems and essays in this book by the Young Writer's Contest winners, supported by Ronald McDonald Children's Charities. But almost one-third of our adult citizens are unable to read them. I have helped to educate parents who could not

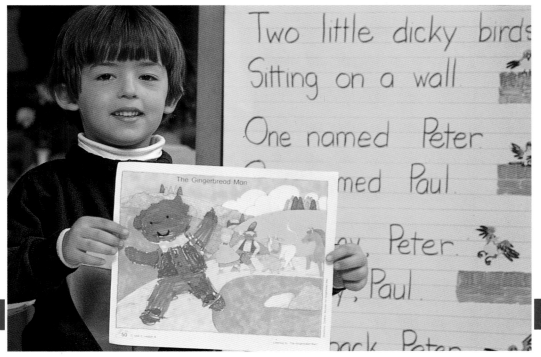

Proud artist in kindergarten, Cambridge, Massachusetts FRANK SITEMAN / NE STOCK PHOTO

fill out a job application, tell what street they were on, or know what items were on a menu. Their plight is almost incomprehensible to those of us who are literate. With modern electronic teaching aids and with a national commitment to literacy, this failure can be corrected. Other countries, not so strong and innovative as ours, have done so.

Strength and real patriotism require a frank assessment of both our achievements and our disappointments. A society can be judged by its ability to set high standards of truth, justice, beauty, and peace and by its willingness to alleviate human suffering, acknowledge its faults, and face challenges successfully. America is truly blessed and beautiful—both with its natural resources and with its people—but we cannot afford to be satisfied or complacent. Meeting the obligation to preserve our treasures and to build even better lives is the measure of our nation's greatness.

Jimmy Carter

Jimmy Carter

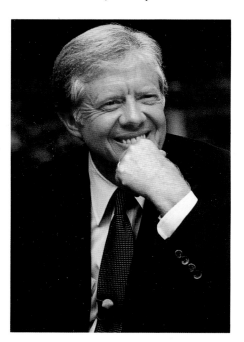

Jimmy Carter

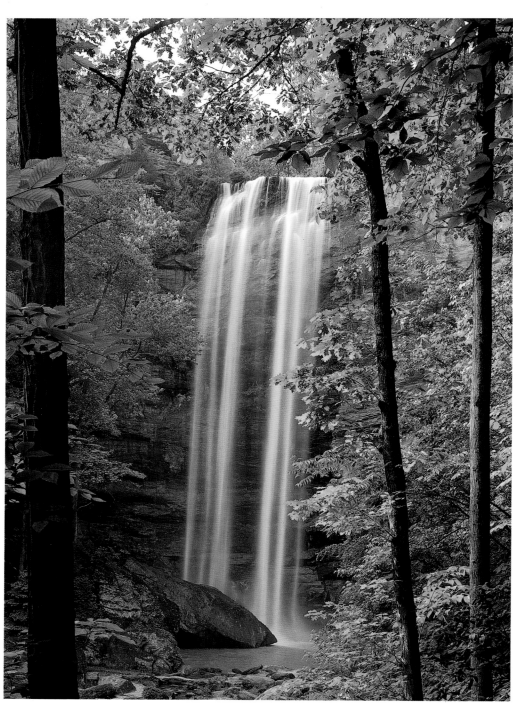

Toccoa Falls, scenic attraction on the campus of Toccoa Falls College in northeast Georgia ED COOPER

*Young Writer's Contest Grand Prize
Winner for* America on My Mind

Patriotism

Patriotism—love for our country and an unending
 devotion to it—is the good and right
 thing that binds America together.
Images of patriotism flash before our eyes like
 lightning daily.

The sun gleaming through majestic American flags
 as they gallantly snap and sway over
 green grass and gray tombstones in a
 national cemetery on Veteran's Day.
People hanging over highway overpasses yelling
 and whooping words of encouragement
 to young soldiers on their way to a
 world a million miles away.
American Olympic gold medal winners' voices
 breaking and eyes glistening as they hail
 their flag and sing their national anthem
 in front of the world.
The soldiers at Iwo Jima, though exhausted,
 raising their flag as artillery rings in their
 ears, smoke stings their nostrils, and
 blasts of fire fill the air.
Veterans, some upright, some handicapped, some
 slumped in wheelchairs, saluting the
 strains of "The Star Spangled Banner" as
 they float through the still air.
Baseball players, dressed in their unsoiled whites,
 their cleats resting on the vivid green
 grass, removing their caps and placing
 them over their hearts as the singer and
 the organist key up to salute their
 country.
The stark blackness of the Vietnam Veterans
 Memorial matching the mournful
 countenance of the respectful people
 who file past the infinite sandblasted
 names.
Flags plastered on rustic country mailboxes and
 red, white, and blue streamers fluttering
 like doves on car radio antennas in
 honor of the U.S. servicemen in the
 Middle East.

P
 a
 t
 r
 i
 o
 t
 i
 s
 m

is America at its best.
May it always remain that way.

Jeffrey Fallis, Grade 8
Teacher: Margaret Wingate
Pine Mountain Middle School
Kennesaw, Georgia

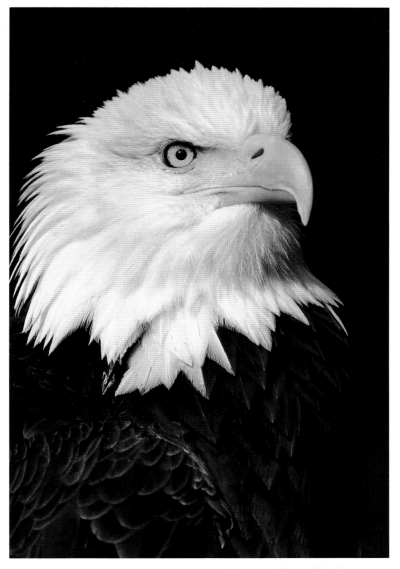

Portrait of an adult bald eagle on the Nisqually River, Washington
TOM & PAT LEESON

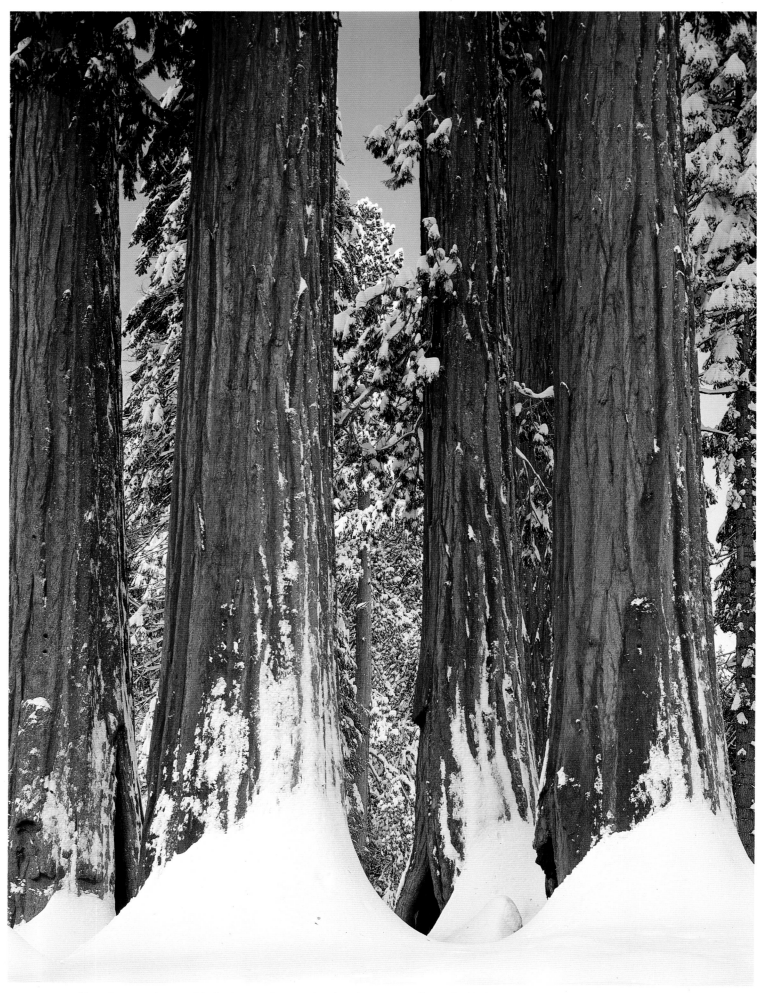

Two-thousand-year-old giant sequoias resplendent in snow at Sequoia National Park, California DAVID MUENCH

"PATRIOTISM—LOVE FOR OUR COUNTRY AND AN UNENDING DEVOTION TO IT—IS THE GOOD AND RIGHT THING THAT BINDS AMERICA TOGETHER. IMAGES OF PATRIOTISM FLASH BEFORE OUR EYES LIKE LIGHTNING DAILY."

Jeffrey Fallis, Grade 8
Pine Mountain Middle School
Kennesaw, Georgia

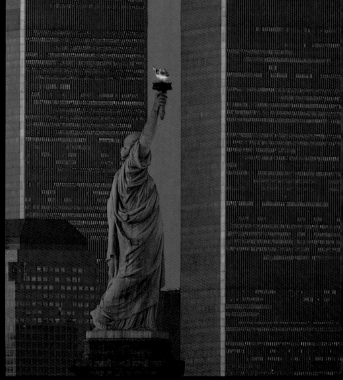

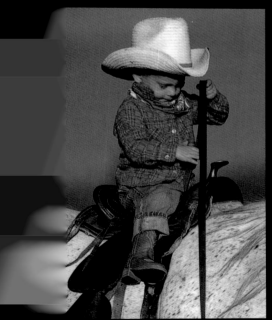

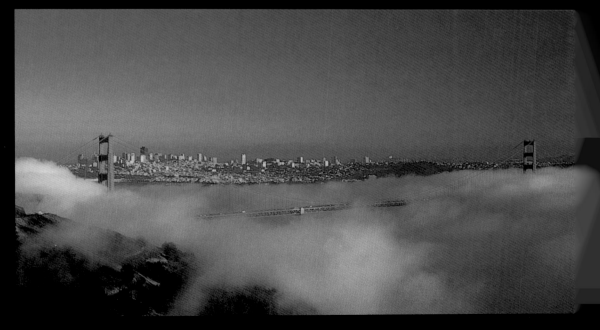

America on My Mind celebrates the magnificent beauty, spirit, and heritage of America—its land, wildlife, cities, towns, and people—with outstanding color photos from the nation's best photographers and memorable quotations from America's finest writers.

The Globe Pequot Press

Guilford, CT 06437
www.globepequot.com

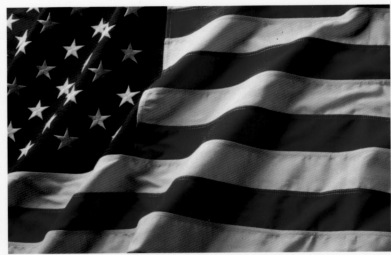

*A*merica on My Mind books by The Globe Pequot Press celebrate the beauty and spirit of America. With brilliant color photos from the nation's best photographers and selected quotations from our country's finest writers, these high-quality books provide the perfect way to keep your favorite place on your mind and in your heart.

FRONT COVER PHOTO:

Lincoln Memorial, Washington, D.C.
STEPHEN TRIMBLE / DRK PHOTO

BACK COVER PHOTOS:

Statue of Liberty and the Manhattan skyline, New York
PETE SALOUTOS / PHOTOGRAPHIC RESOURCES

Wheat harvest in eastern Washington SCOTT SPIKER

Golden Gate Bridge, San Francisco, California GALEN ROWELL

Young cowboy, Idaho DAVID STOECKLEIN

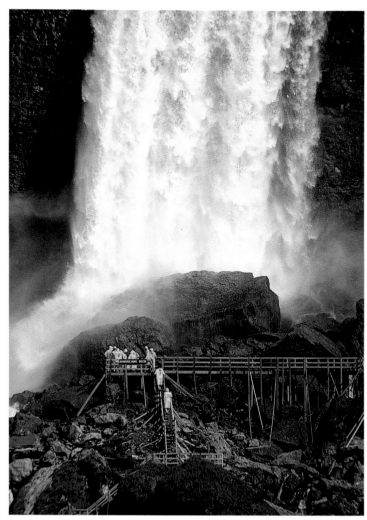

Approaching the American Falls portion of Niagara Falls, New York
SAM ABELL

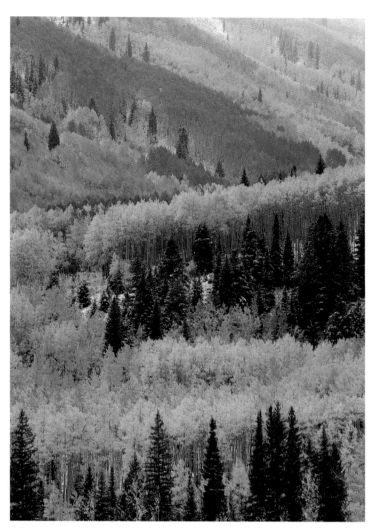

Autumn in White River National Forest, Colorado
JEFF GNASS

" *Other nations have glorious mountains, breath-taking views. But none can approach the incomparable variety of wild beauty that is the heritage of this land—with its Yosemite, its Niagara, its Grand Canyon, its Old Faithful, its Carlsbad Caverns, its timberline gardens and deserts bursting into bloom, its Olympic forests and its ancient sequoias, its snow-clad peaks and all the teeming bird life of its coastal swamps. This gift of natural beauty is a rare and precious possession. The opportunity for citizens to enjoy it freely, now and in the future, is one of the inalienable rights of Americans.* **"**

Edwin Way Teale,
Journey into Summer

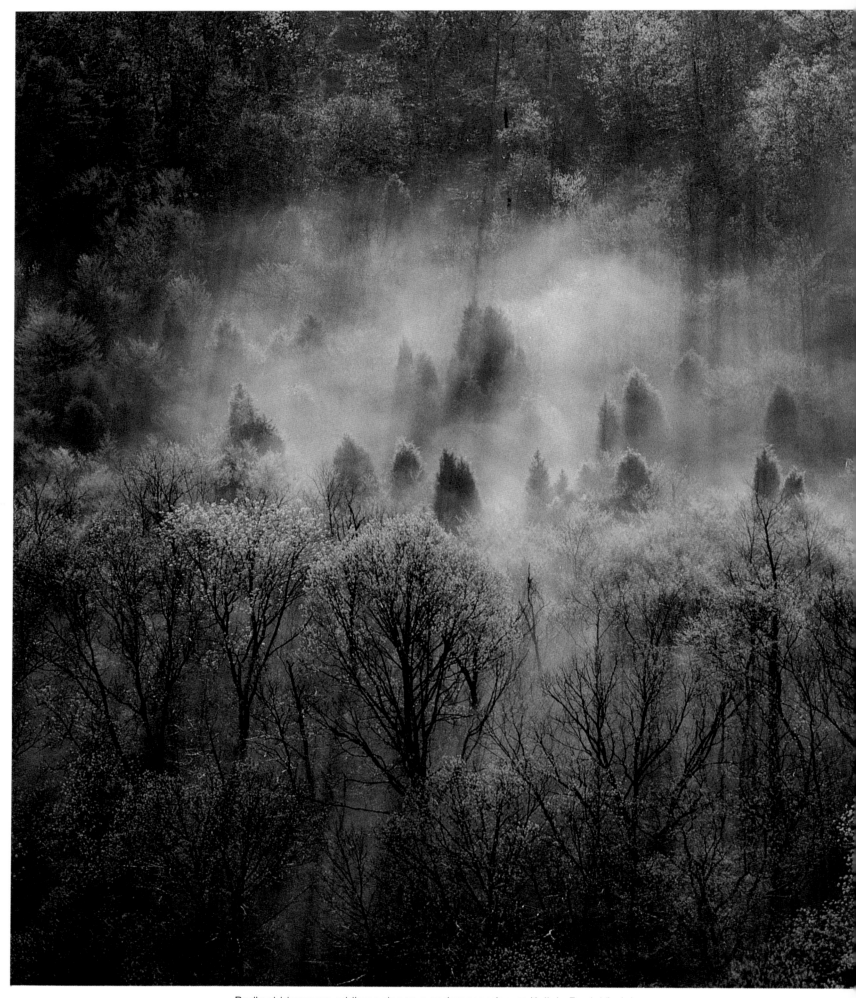

Redbud blossoms adding color to a spring morning at Kelly's Ford, Virginia SAM ABELL

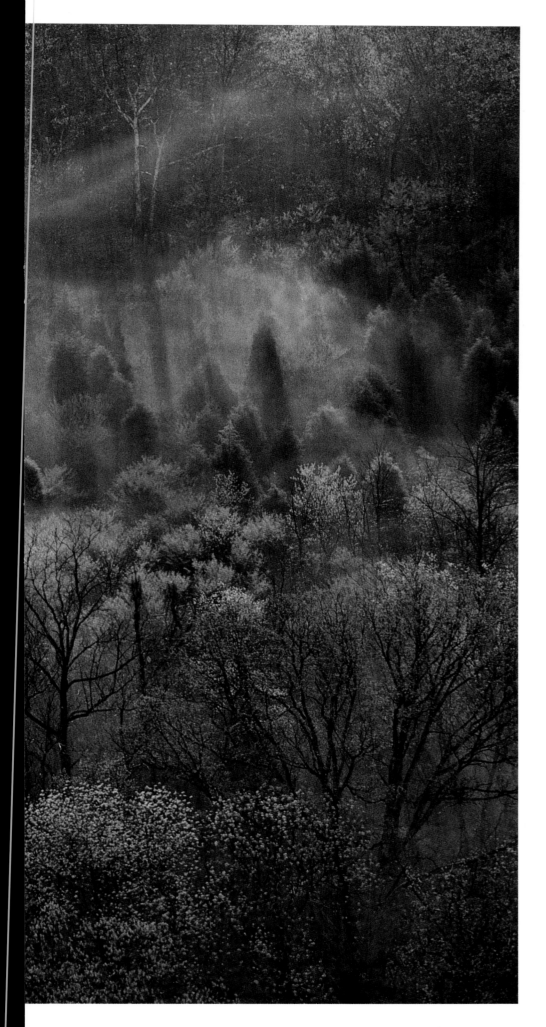

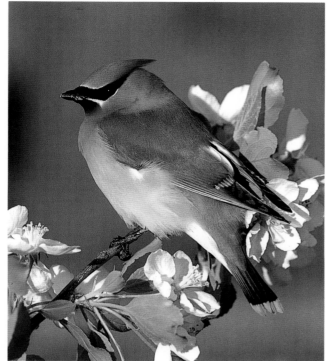

Cedar waxwing with apple blossoms near
Madison, Wisconsin WAYNE LANKINEN / DRK PHOTO

America my country,
A nation proud and free,
From the mountains to the
 valleys,
How beautiful to me.

Matthew Gorski, Grade 5,
Hampstead, New Hampshire.
From "America My Country"
in the Young Writer's Contest.

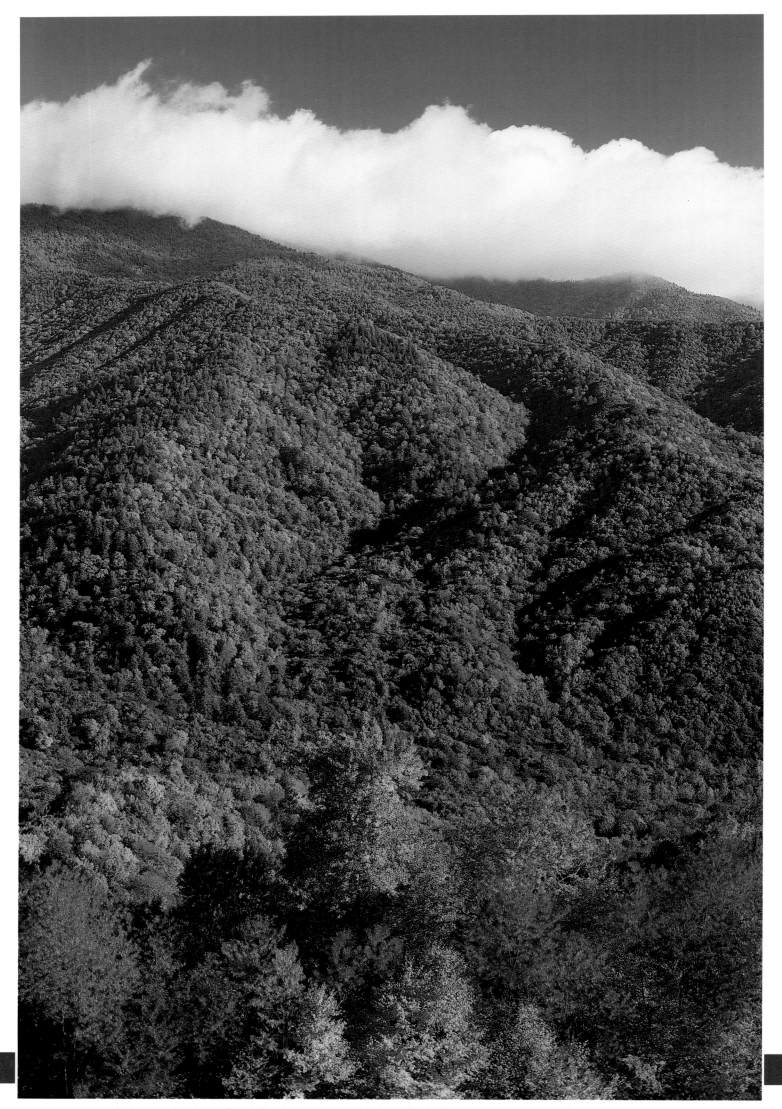

Autumn splendor in Great Smoky Mountains National Park, Tennessee / North Carolina LARRY ULRICH

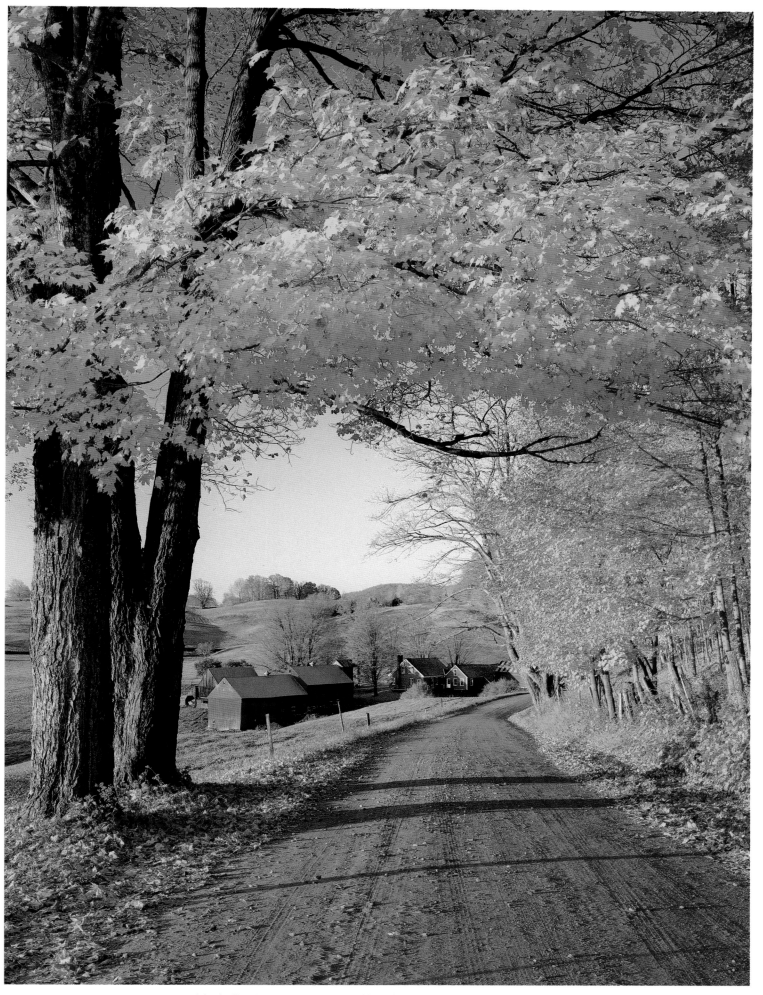

Maple-lined country road near Woodstock, Vermont STEVE TERRILL

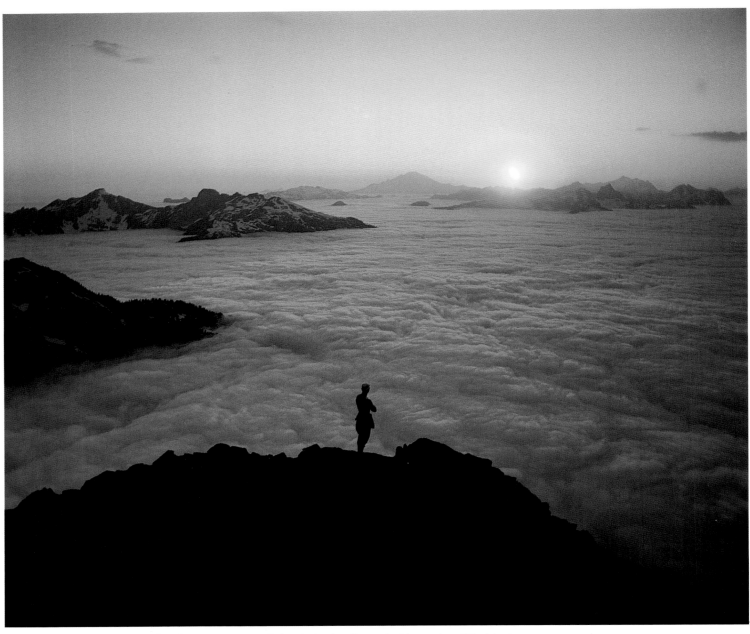

Sunrise over a sea of clouds in the Cascade Mountains, Washington CLIFF LEIGHT

 Something happened in America to create the Americans. Perhaps it was the grandeur of the land—the lordly mountains, the mystery of deserts, the ache of storms, cyclones—the enormous sweetness and violence of the country which, acting on restless, driven people from the outside world, made them taller than their ancestors, stronger than their fathers—and made them all Americans.

John Steinbeck,
America and Americans

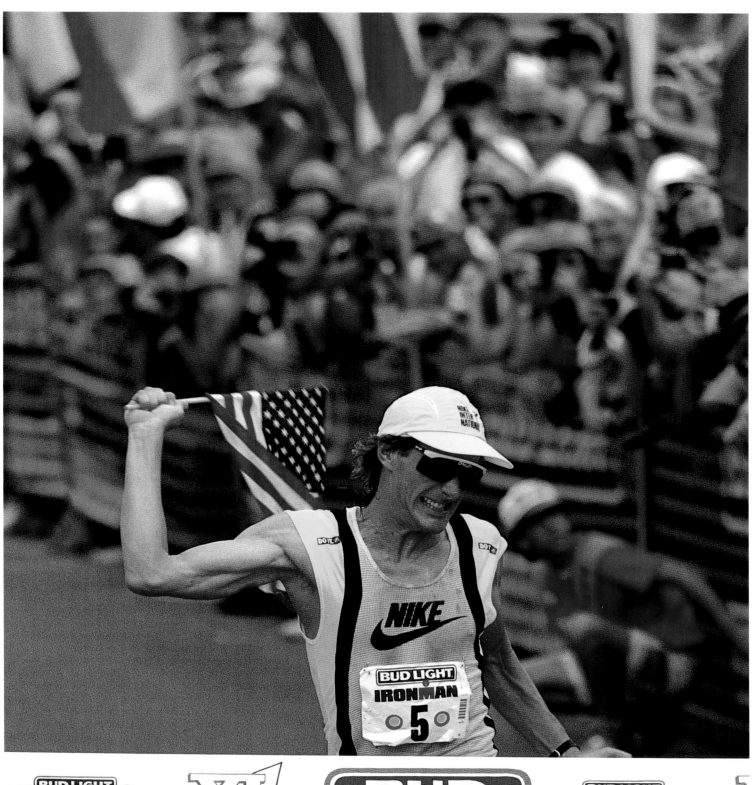

Mark Allen of Cardiff, California, winning the 1989 Ironman Triathlon in record time (8:09:15), Kona, Hawaii GREG VAUGHN

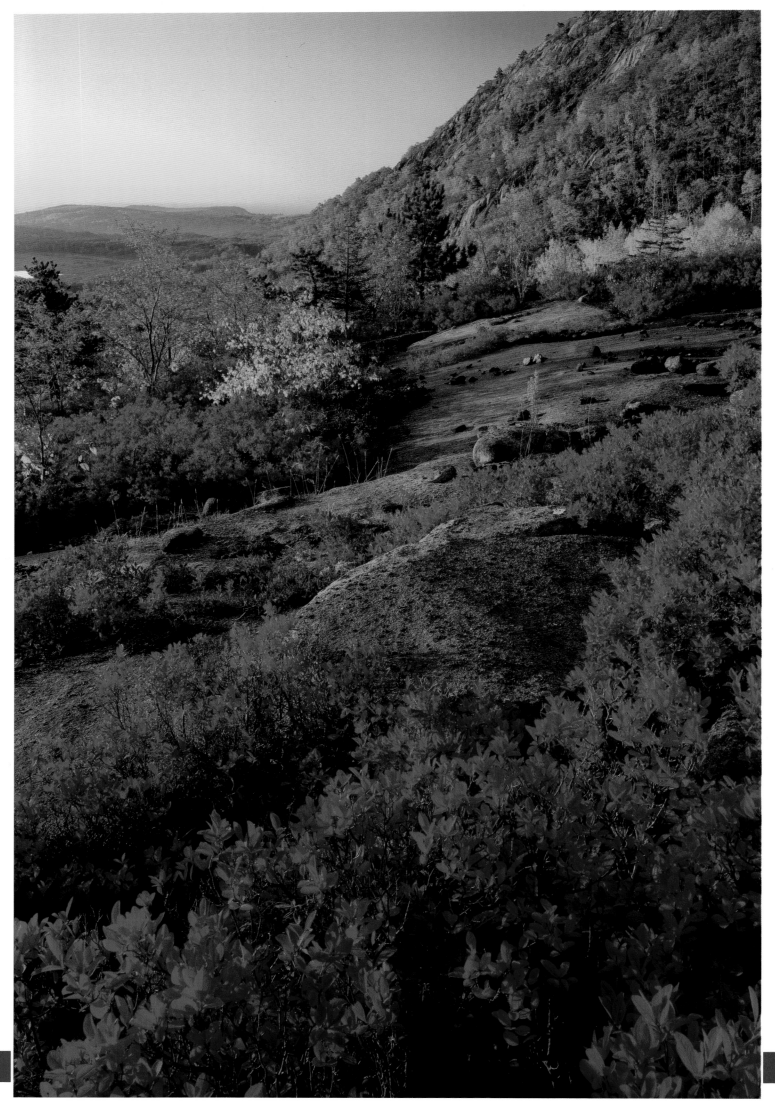

Blueberry leaves celebrating autumn on Mount Desert Island, Acadia National Park, Maine LARRY ULRICH

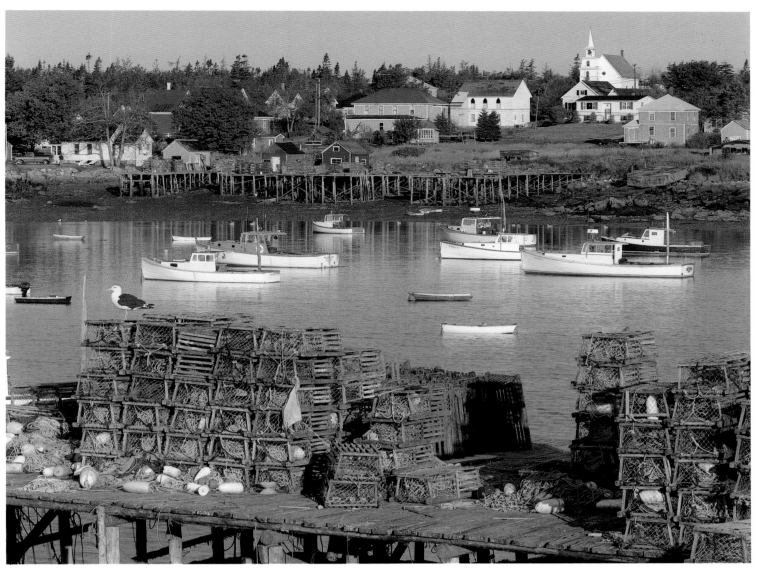

Quiet morning amid the boats and lobster pots of Corea, Maine WILLARD CLAY

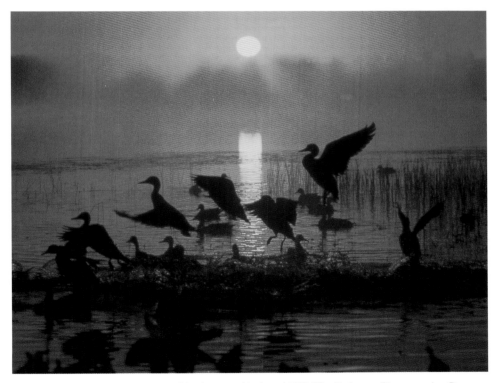

Black ducks in a red dawn, Blackwater National Wildlife Refuge, Chesapeake Bay, Maryland SCOTT NIELSEN

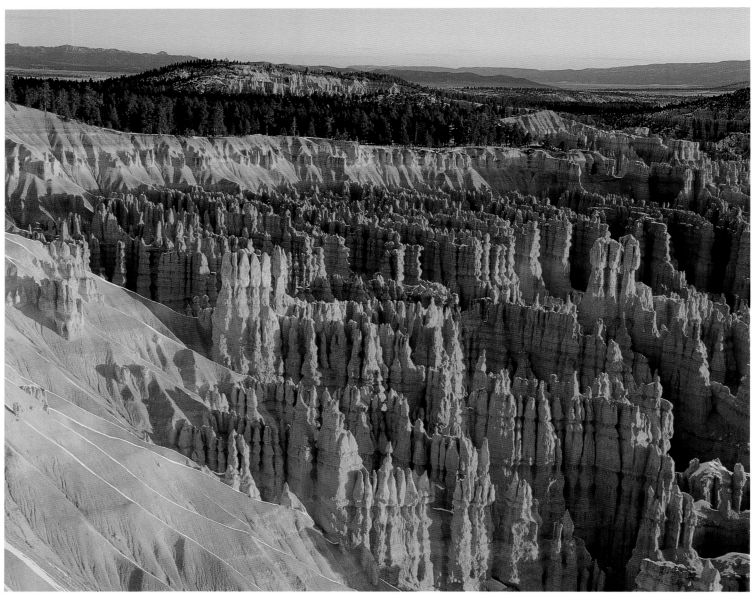

Hoodoos—fluted columns of limestone and sandstone—in Bryce Canyon National Park, Utah FRED HIRSCHMANN

" In the United States there is more space where nobody is than where everybody is. That is what makes America what it is. "

Gertrude Stein,
The Geographical History of America

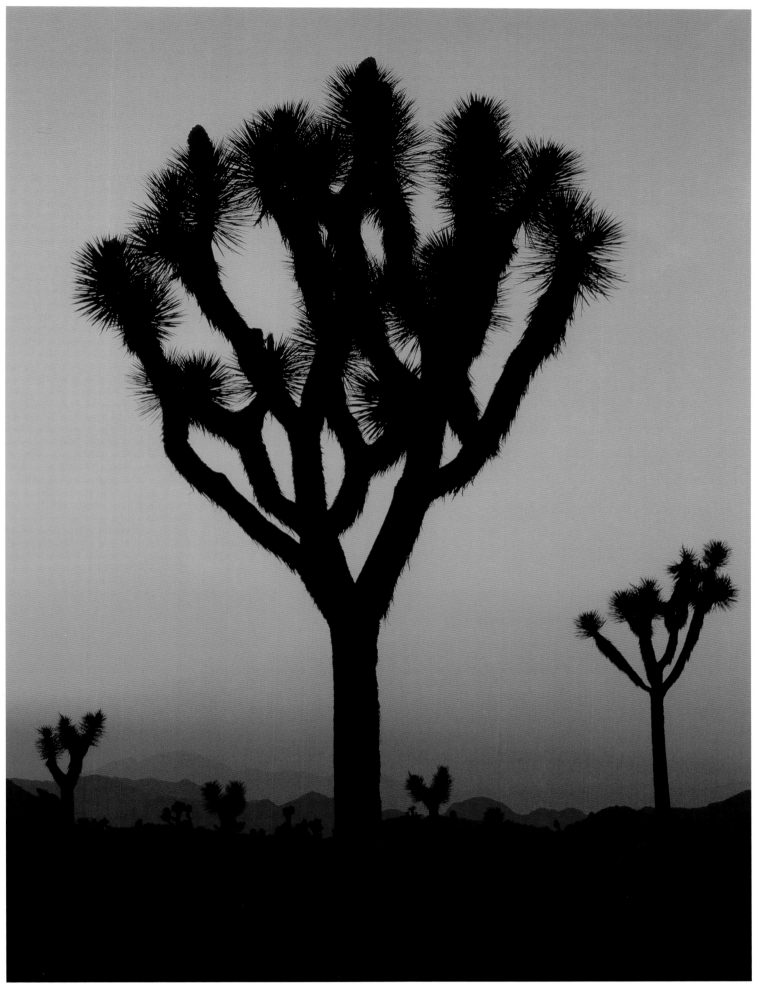

Forty-foot-tall Joshua trees silhouetted by sunset at Joshua Tree National Monument, California WILLARD CLAY

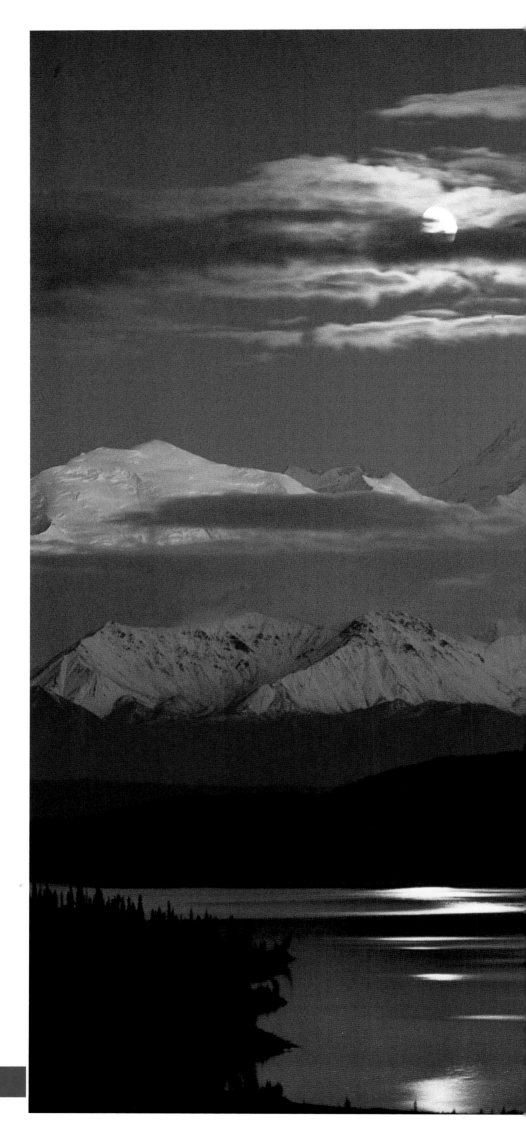

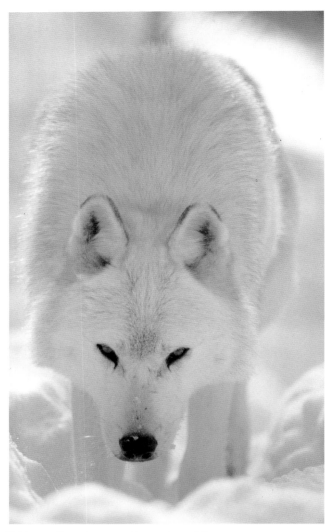

White wolf on the prowl in northern Minnesota DANIEL J. COX

*"Silently as a feather falls to the
earth,
It runs through the woods
With the speed of the wind
And the beauty of the dawn....
It is a living legend,
The wolf."*

Julia Price, Grade 6,
Rexburg, Idaho.
From "The Wolf" in the
Young Writer's Contest.

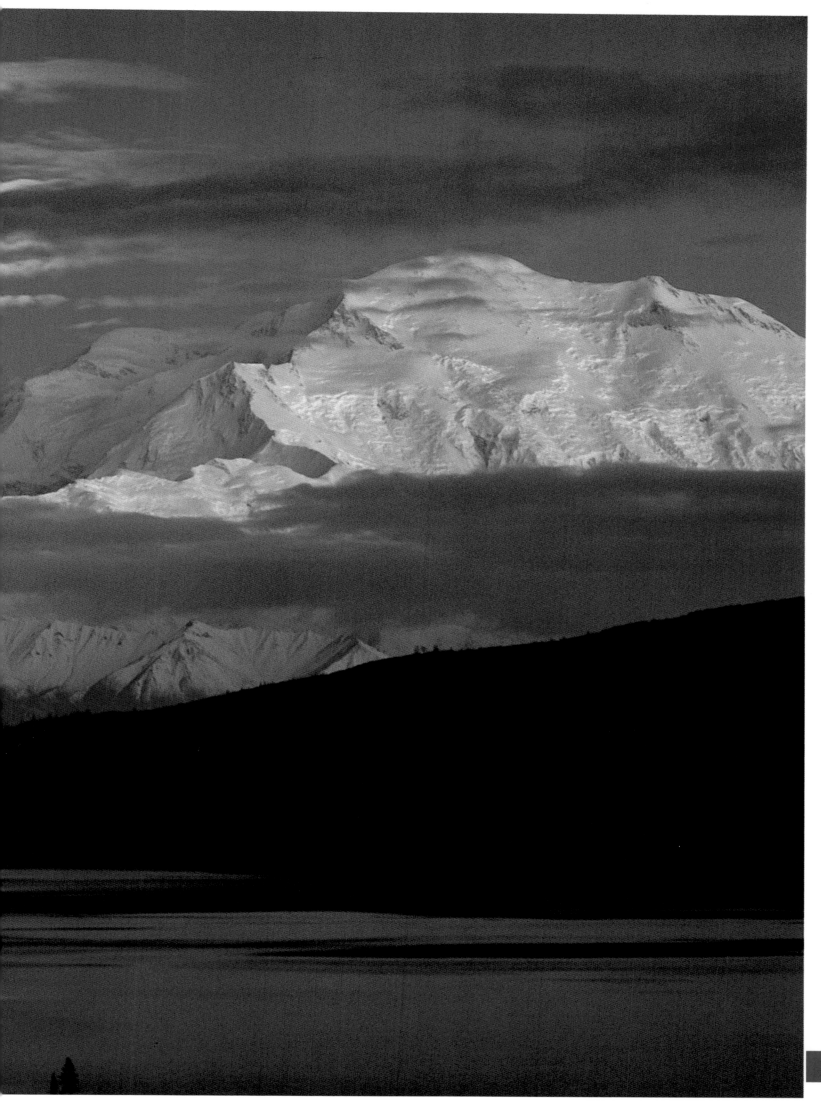

Moonrise over 20,320-foot Mount McKinley, highest peak in America, Denali National Park, Alaska TOM J. ULRICH

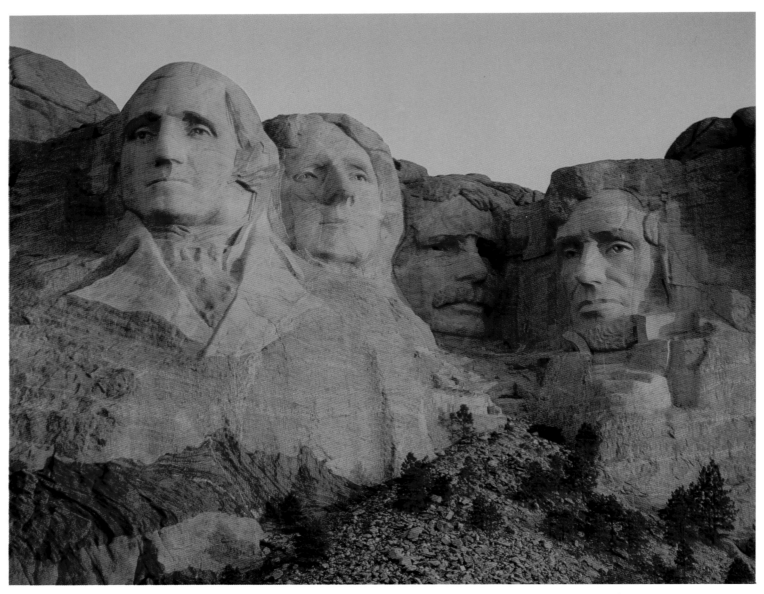

Presidents Washington, Jefferson, Roosevelt, and Lincoln created equally and permanently
at Mount Rushmore, South Dakota AIUPPY PHOTOGRAPHS

> **❝** *We hold these truths to be self-evident, that all
> men are created equal, that they are endowed by their
> Creator with certain unalienable Rights, that among
> these are Life, Liberty and the pursuit of Happiness.* **❞**

Thomas Jefferson,
Declaration of Independence

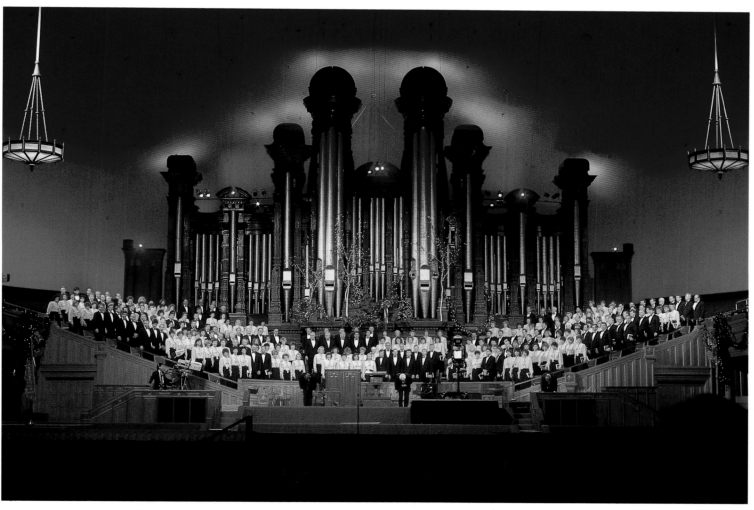

The Mormon Tabernacle Choir arrayed for song, Salt Lake City, Utah STEPHEN TRIMBLE

Pursuing happiness with Mickey at Disneyland,
California JAMES KIRK GARDNER

Hutterite girls pulling together near Forest River,
North Dakota ANNIE GRIFFITHS BELT

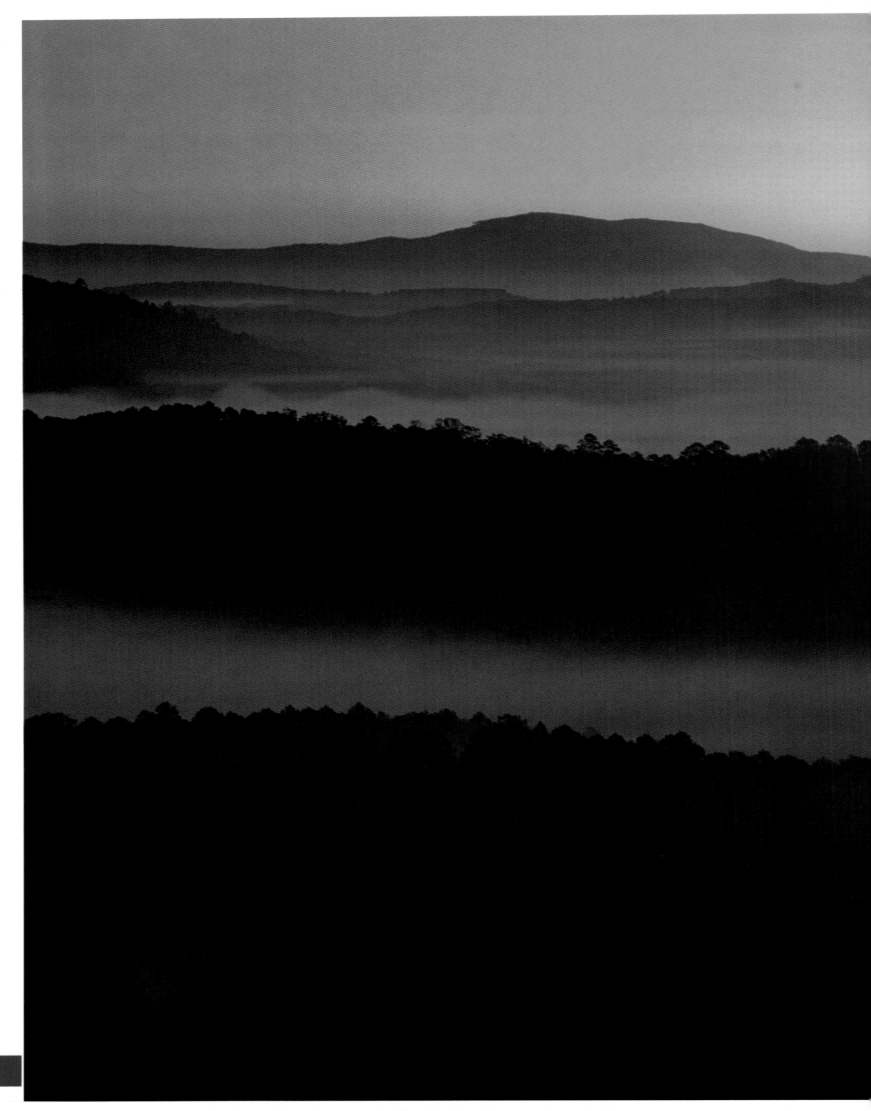

Sunrise coming to the fog-cloaked Ouachita Mountains in west-central Arkansas MATT BRADLEY

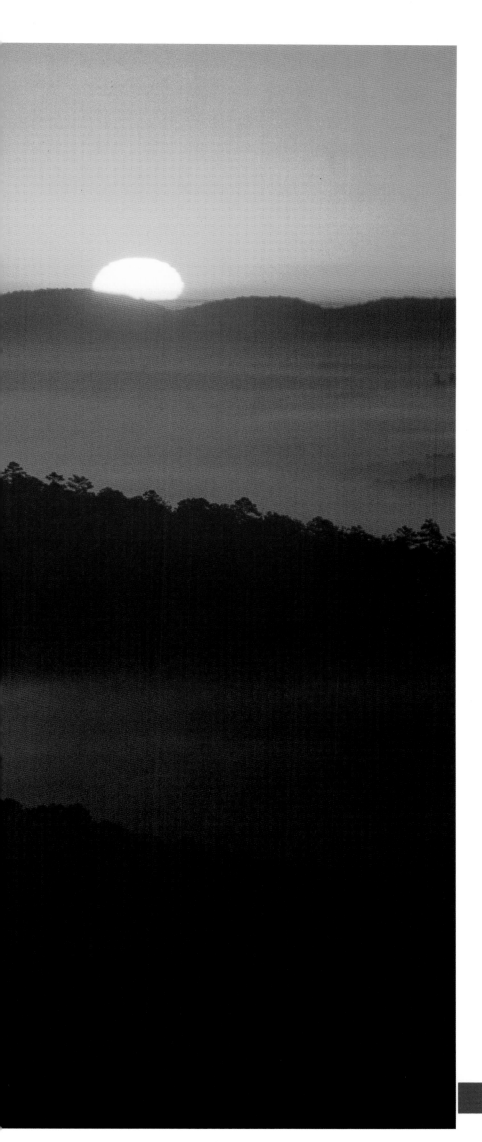

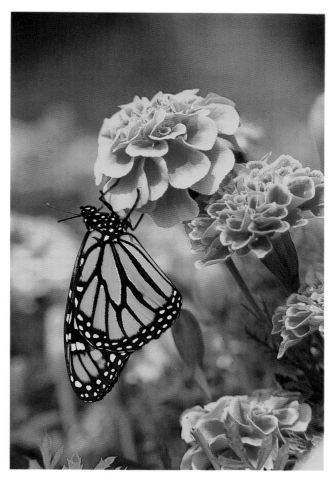

Monarch butterfly on a marigold, Decorah, Iowa
DAVID CAVAGNARO/DRK PHOTO

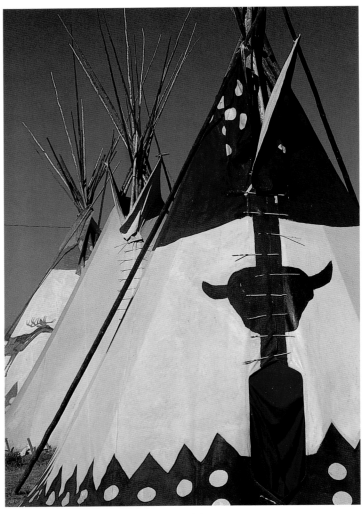

Blackfeet tipis at Browning, Montana CHRIS ROBERTS

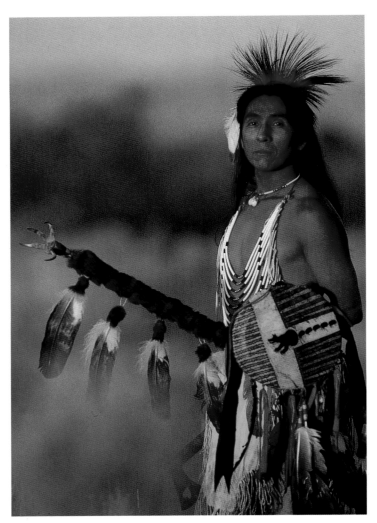

Shoshone-Bannock warrior in traditional dress, Shoshone, Idaho DAVID STOECKLEIN

❝ *So that they will respect the land, tell your children that the earth is rich with the lives of our kin. Teach your children what we have taught our children, that the earth is our mother. Whatever befalls the earth befalls the sons of the earth. Man did not weave the web of life, he is merely a strand in it. Whatever he does to the web, he does to himself.* **❞**

Chief Seattle,
to President Franklin Pierce

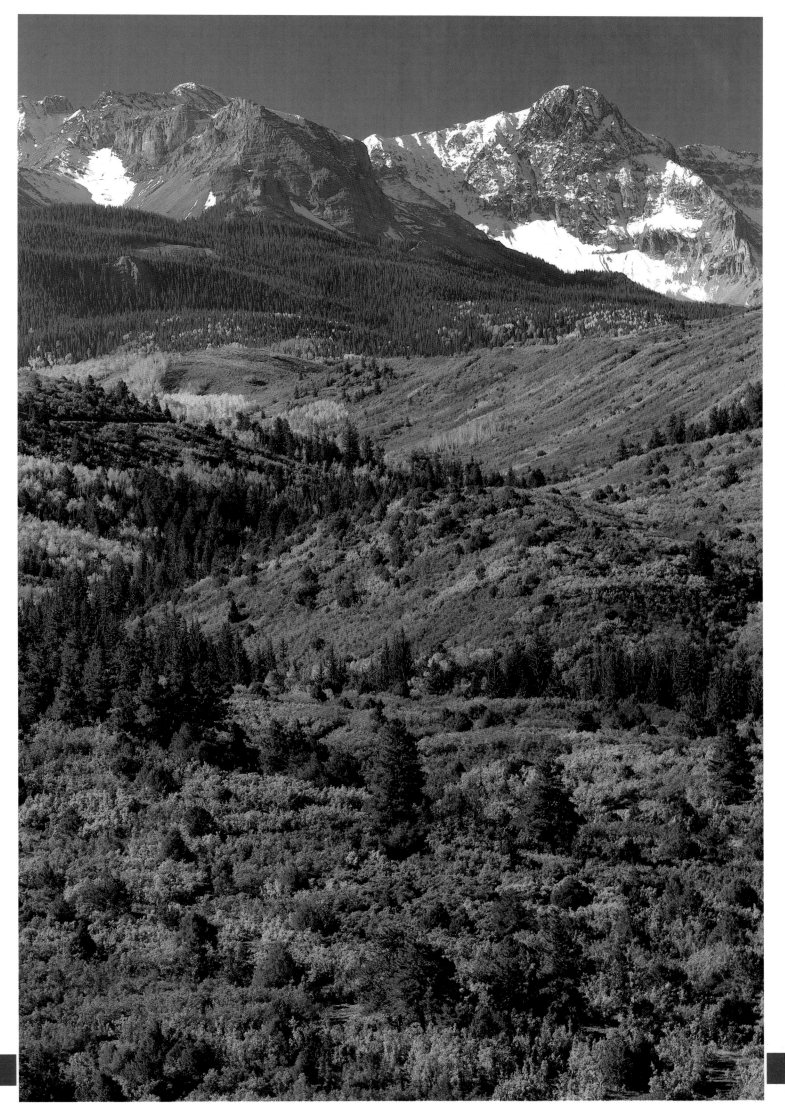

Autumn-colored foothills of the San Juan Range, Uncompahgre National Forest, Colorado WILLARD CLAY

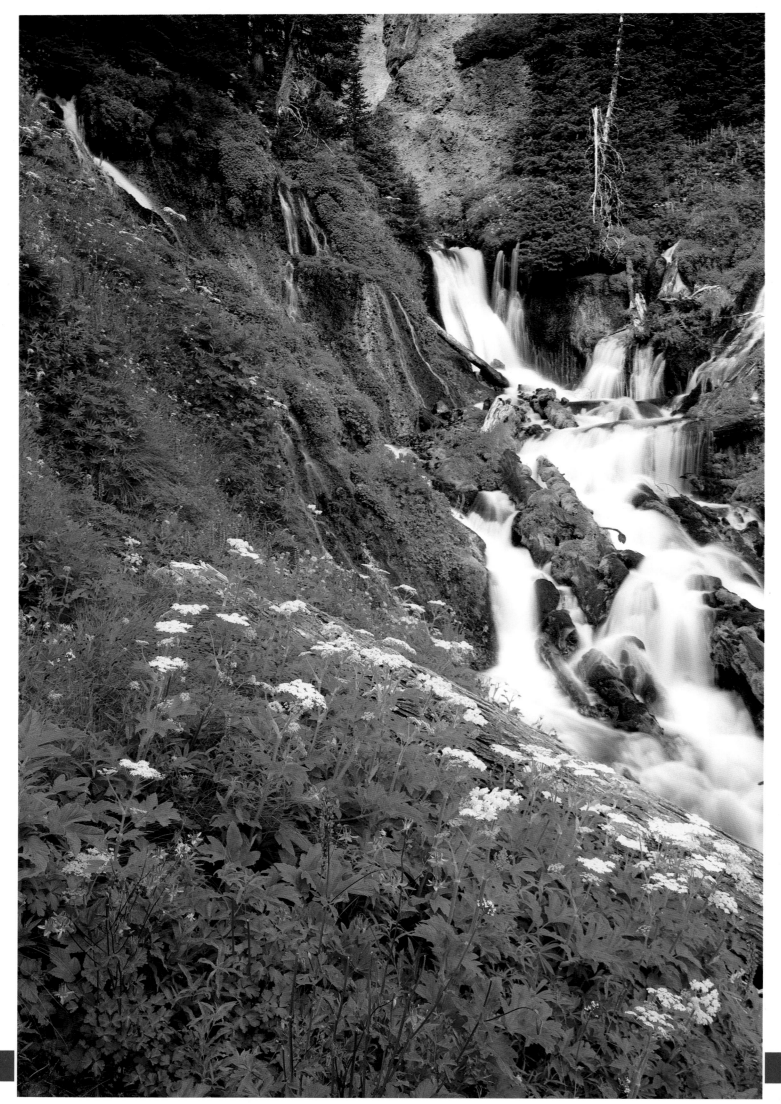

Linton Spring plunging through the 242,400-acre Three Sisters Wilderness, Willamette National Forest, Oregon LARRY ULRICH

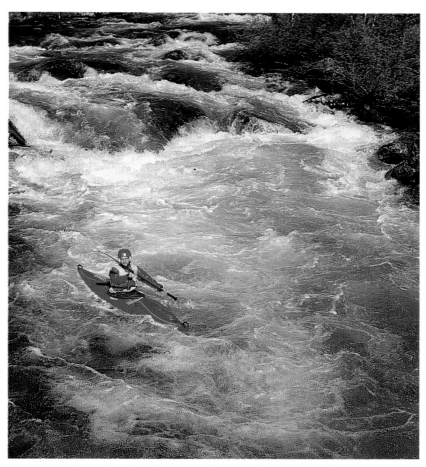

Navigating Fish Creek, a tributary of the Lochsa River
near Cougar, Idaho SCOTT SPIKER

> **" We are drawn toward
> wildness as water is toward the level.
> And there we find the something that
> we cannot name. We find ourselves,
> we say. But I suppose that what we
> really find is the void within
> ourselves, the loneliness, the surviving
> heart of wildness, that binds us to the
> living earth. "**

Paul Gruchow,
The Necessity of Empty Places

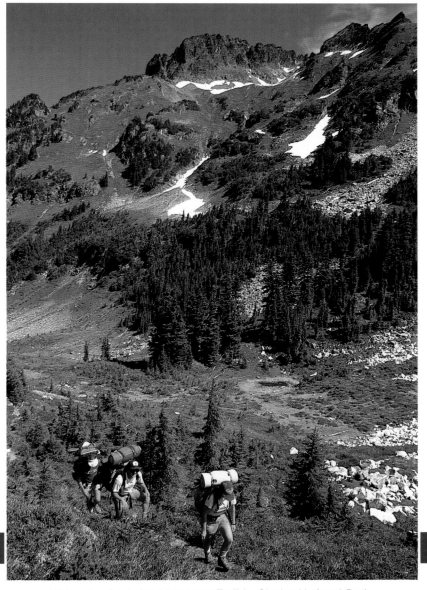

Hiking the Bachelor Meadows Trail in Glacier National Park,
Montana PETER COLE / NE STOCK PHOTO

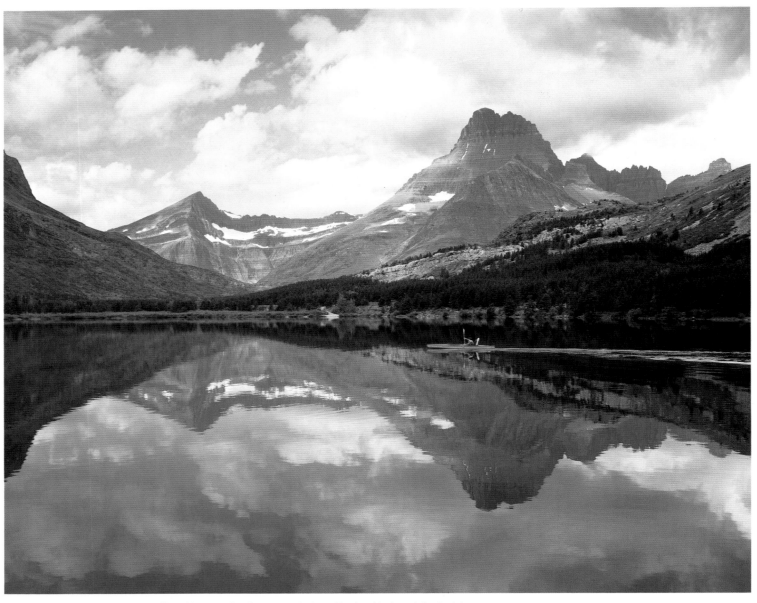

Kayaking on Swiftcurrent Lake, Glacier National Park, Montana JAMES RANDKLEV

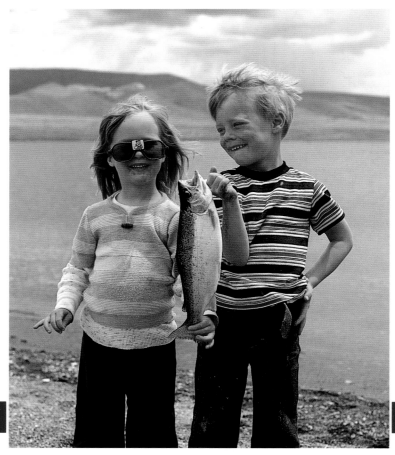

Siblings sharing the catch at Otter Creek Reservoir, Utah
JAMES KIRK GARDNER

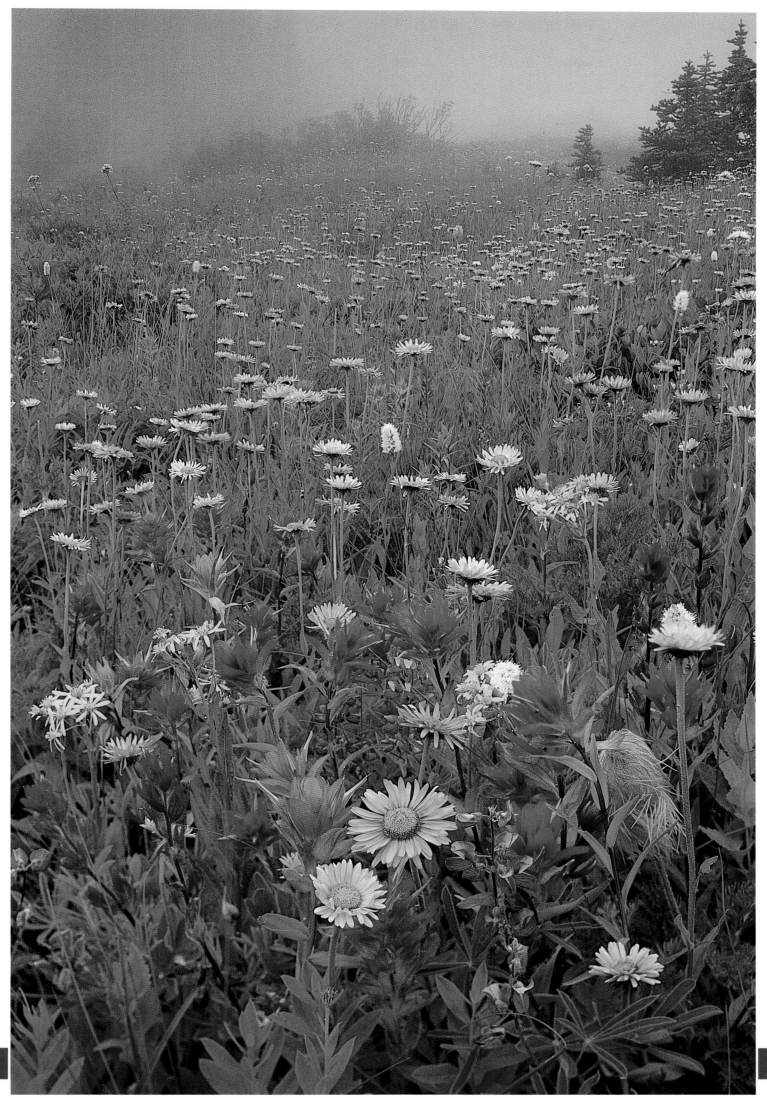

Wildflowers—Indian paintbrush, lupines, and alpine daisies—at Mount Rainier National Park, Washington ART WOLFE

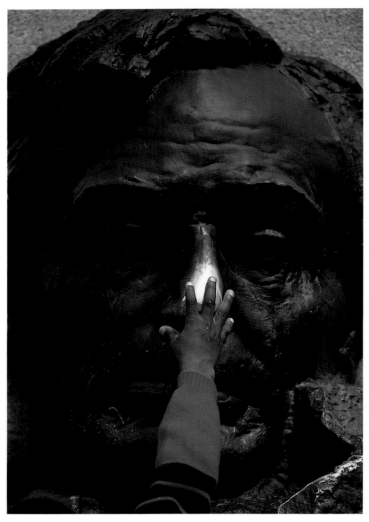

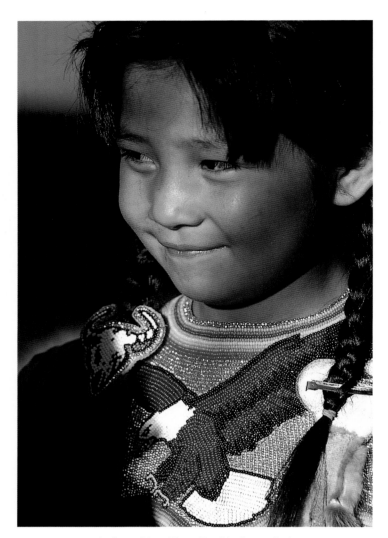

Paying homage at Lincoln's Tomb,
Springfield, Illinois RICHARD HAMILTON SMITH

Indian girl at Taos Pueblo Intertribal
Pow Wow, New Mexico KEN GALLARD

❝ *Our flag is red, white, and blue, but our nation
is a rainbow—red, yellow, brown, black, and white—and
we're all precious in God's sight. America is not like a
blanket—one piece of unbroken cloth, the same color, the same
texture, the same size. America is more like a quilt—many
patches, many pieces, many colors, many sizes, all woven and
held together by a common thread. . . . All of us count and all
of us fit somewhere.* **❞**

Jesse Jackson,
speech before the
Democratic National Convention,
July 16, 1984

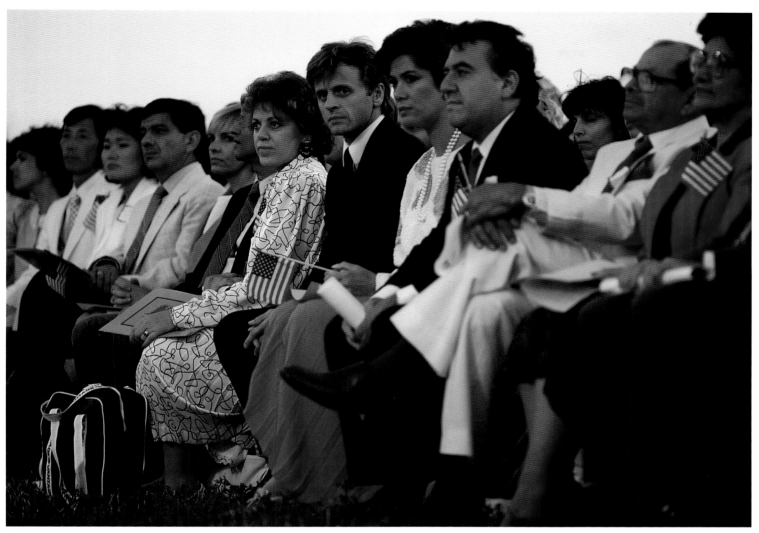

Naturalization ceremony with Russian ballet dancer Mikhail Baryshnikov, New York City ANNIE GRIFFITHS BELT / DRK PHOTO

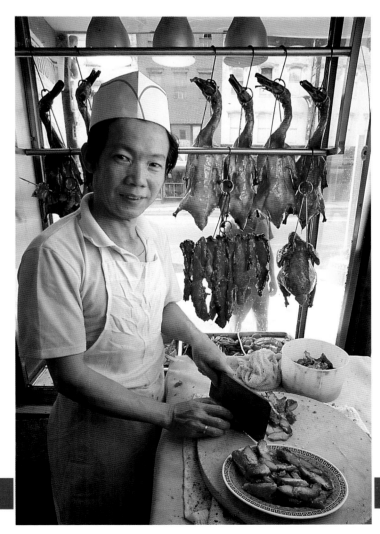

Chef in Washington, D.C. CATHERINE KARNOW

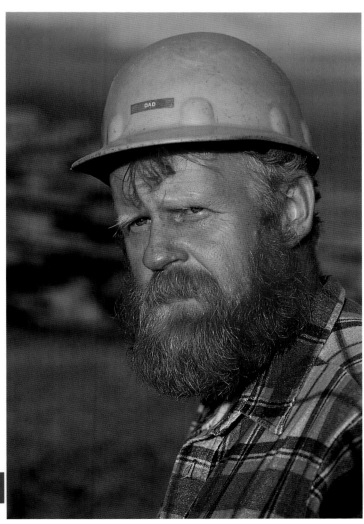

Logger in northwestern Montana LEE KAISER

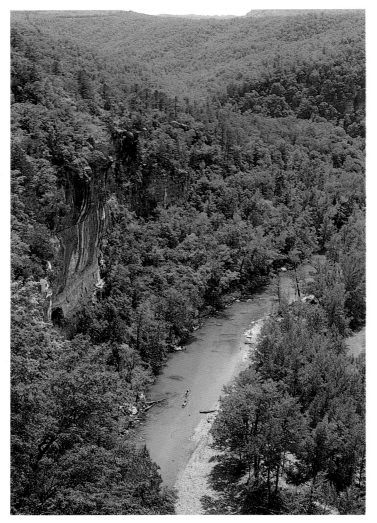

Canoeing the Buffalo National River, Arkansas MATT BRADLEY

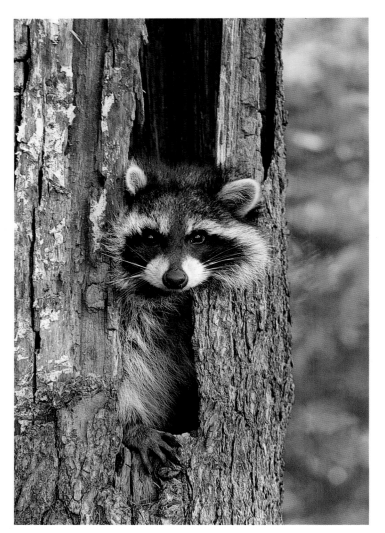

Raccoon at home in northern Georgia DANIEL J. COX

> *❝ . . . the peculiar history of the South has so greatly modified it from the general American norm that, when viewed as a whole, it decisively justifies the notion that the country is—not quite a nation within a nation, but the next thing to it. ❞*

W. J. Cash,
The Mind of the South

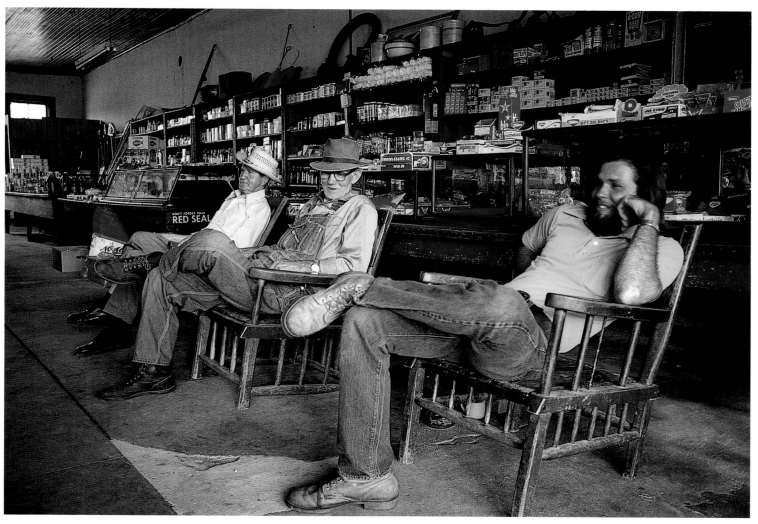

Analyzing the day's events at the Gilbert General Store, Gilbert, Arkansas MATT BRADLEY

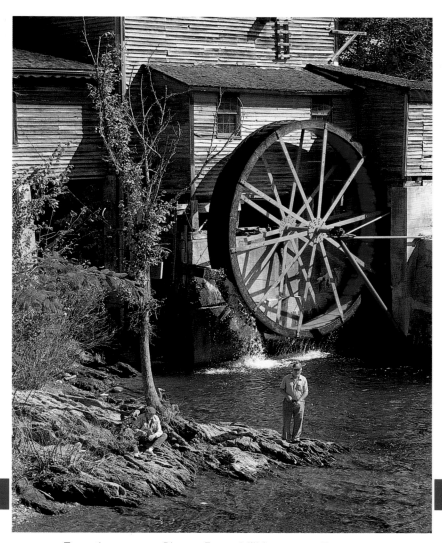

Tempting trout at Pigeon Forge Mill in eastern Tennessee
GREG L. RYAN / SALLY A. BEYER

Quilter at Madison, Mississippi
J. D. SCHWALM / STOCK SOUTH

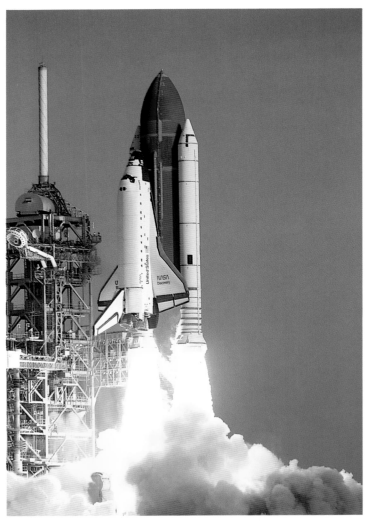

Space shuttle *Discovery* lifting off at Cape Canaveral, Florida
ALLEN FREDRICKSON / THIRD COAST STOCK SOURCE

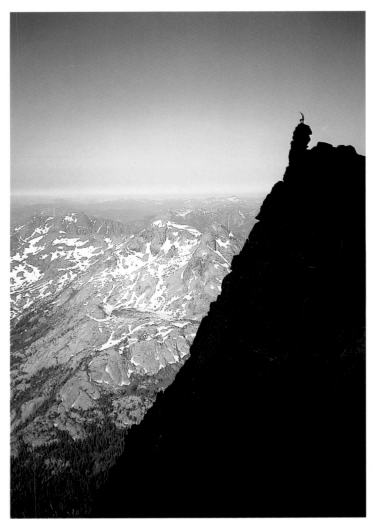

Celebrating the summit of 9,415-foot Mount Stuart in the Central
Cascades, Wenatchee National Forest, Washington CLIFF LEIGHT

❝ *Nothing so challenges the American spirit as tackling the biggest job on earth. . . . Americans are stimulated by the big job—the Panama Canal, . . . the tallest building in the world, the mightiest battleship.* **❞**

Lyndon B. Johnson,
speech to Congress,
April 30, 1941

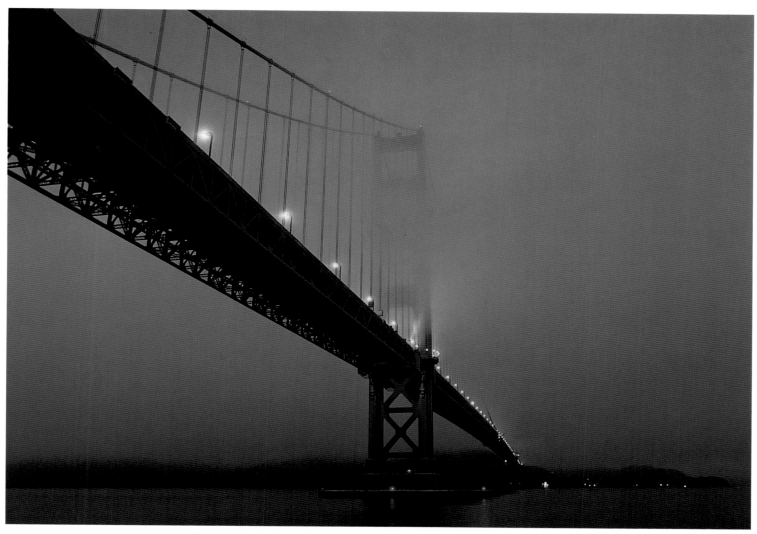

Golden Gate Bridge in morning fog, San Francisco, California CATHERINE KARNOW

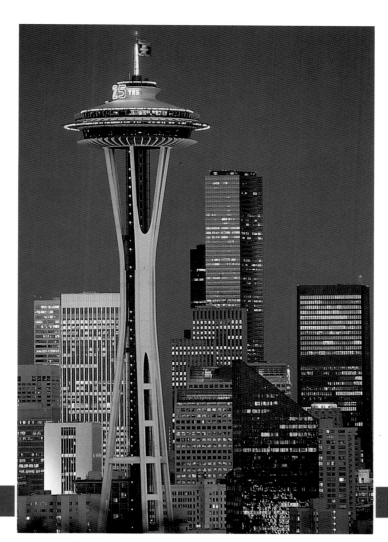

Space Needle piercing the skyline of Seattle,
Washington SCOTT SPIKER

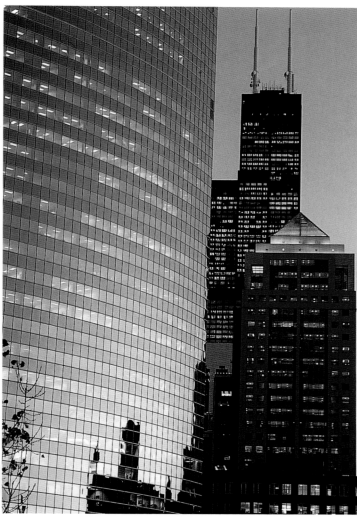

The twin-spired Sears Tower rising above massive
skyscrapers in downtown Chicago, Illinois
TERRY FARMER / PHOTOGRAPHIC RESOURCES

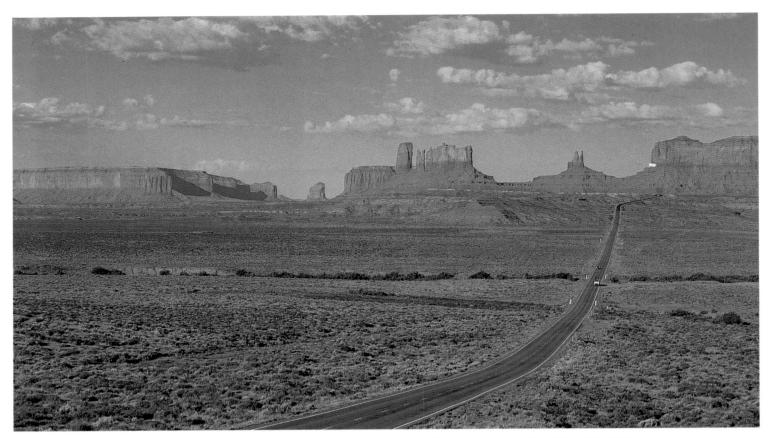

Highway 163 heading across the desert to Monument Valley, Arizona TOM BEAN / DRK PHOTO

> **❝** *One of the special pleasures about a back road in the West is that it sometimes ends dead against a wonderful and relatively unvisited wilderness.* **❞**
>
> **Wallace Stegner,**
> "Packhorse Paradise," in
> The Sound of Mountain Water

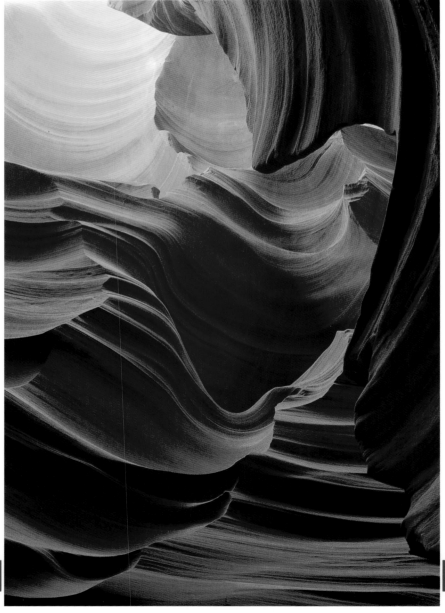

Water-sculpted canyon on the Colorado Plateau, Utah FRED HIRSCHMANN

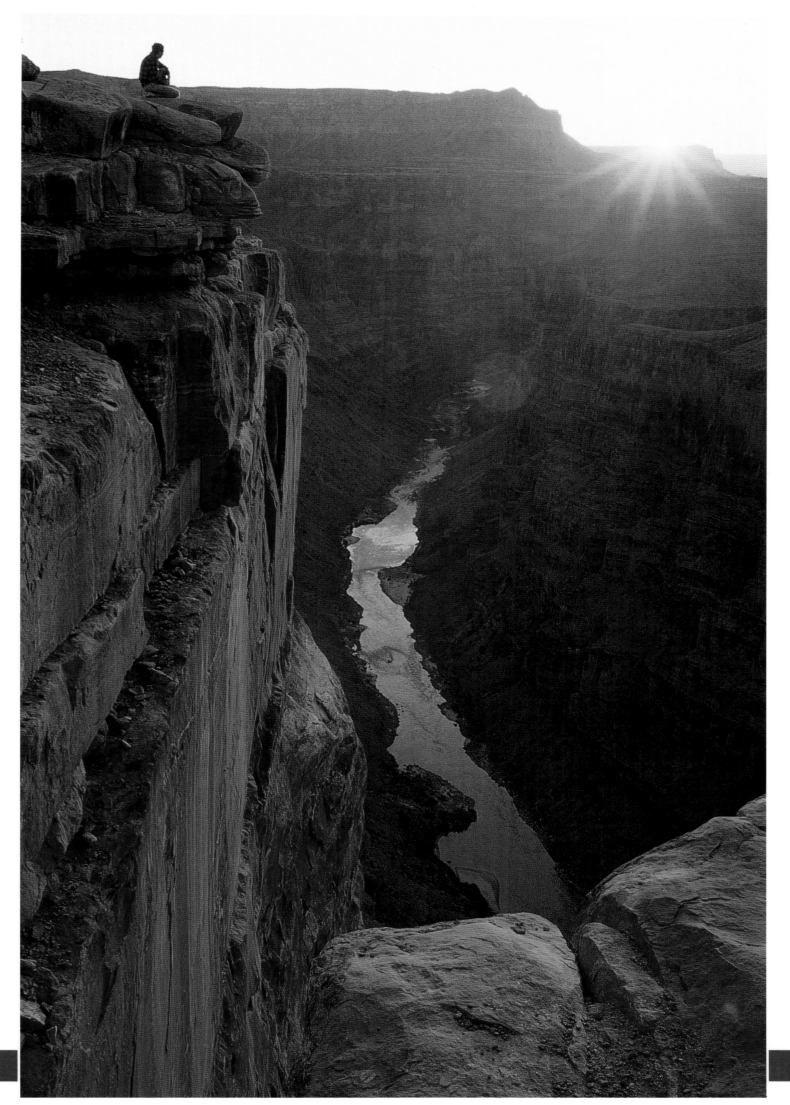

Greeting the sun at Toroweap Point, far above the Colorado River in Grand Canyon National Park, Arizona RANDALL K. ROBERTS

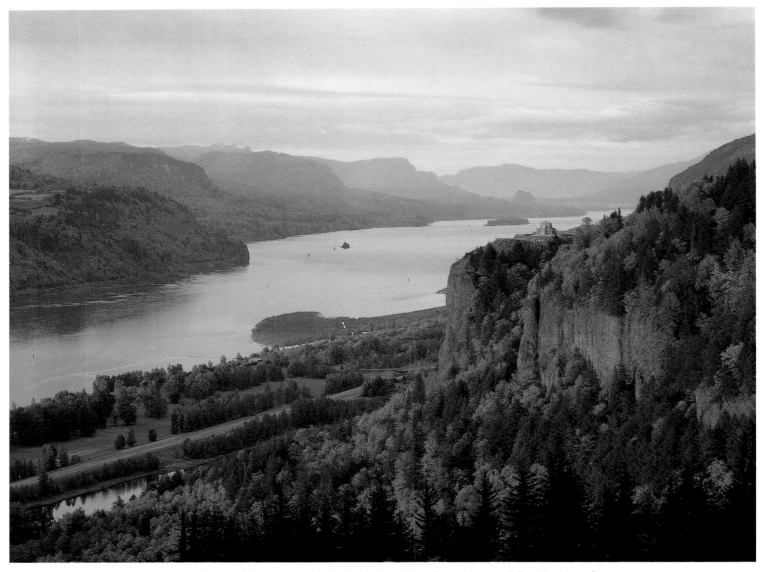

Evening light on the Vista House visitor center in the Columbia River Gorge National Scenic Area, Oregon STEVE TERRILL

" This is a glorious country. It has longer rivers and more of them, and they are muddier and deeper and run faster, and rise higher, and make more noise and fall lower... than anybody else's rivers. It has more lakes and they are bigger and deeper and clearer and wetter than those of any other country. "

American newspaper,
1850

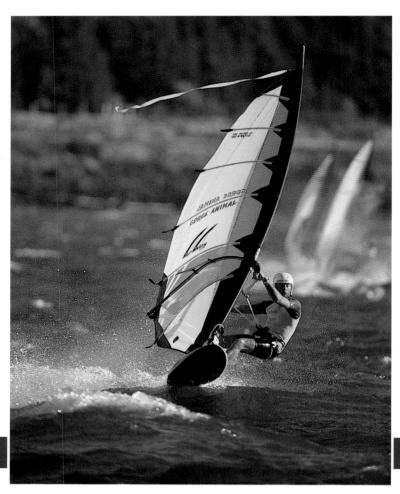

Sailboarding in the Columbia River Gorge, Washington / Oregon
SCOTT SPIKER

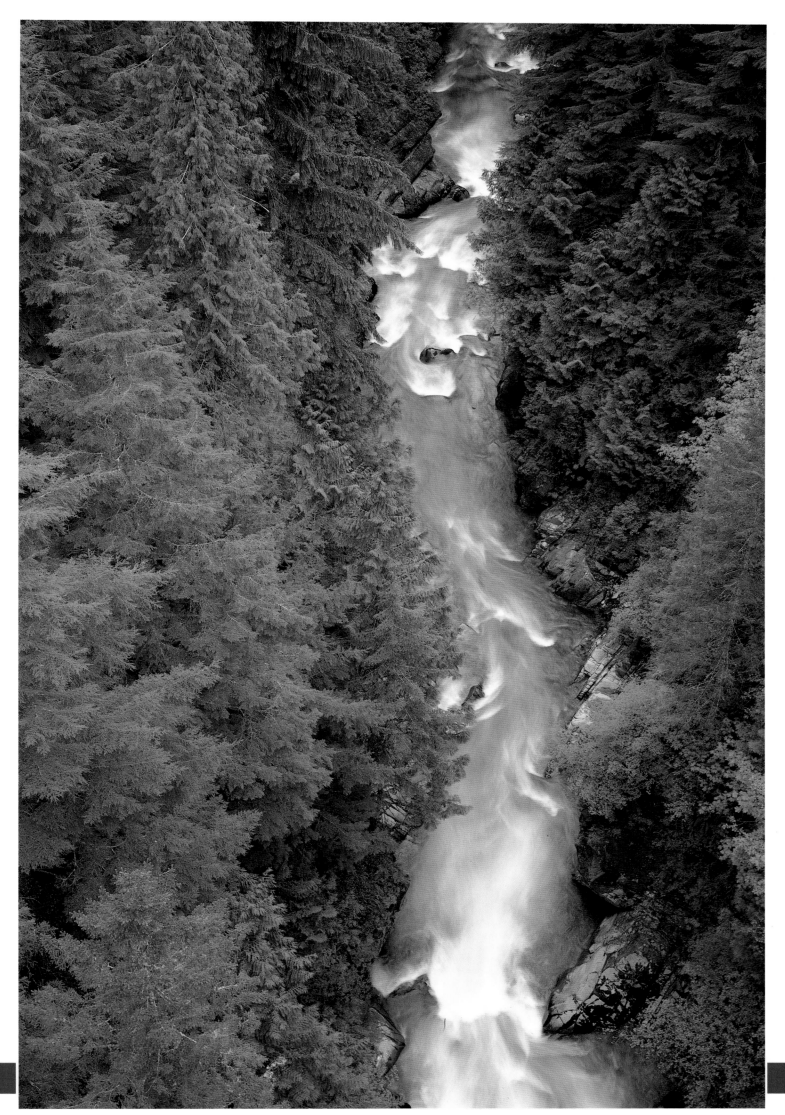

The rushing waters of the Carbon River in western Washington PAT O'HARA

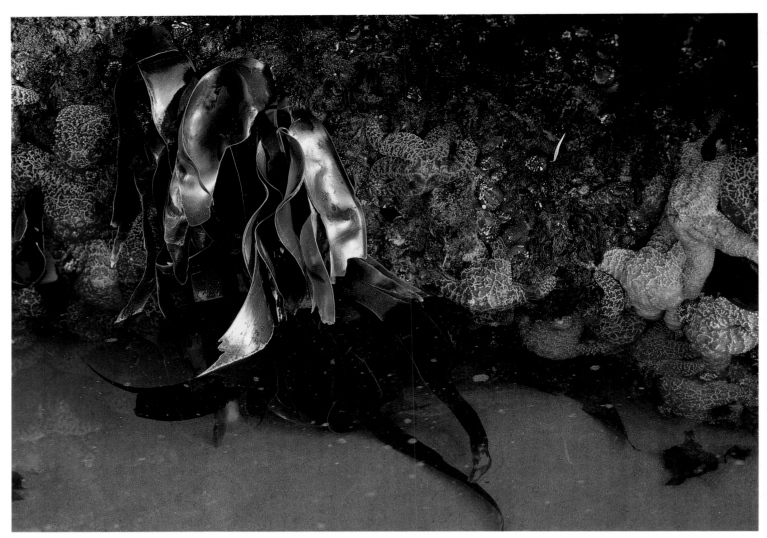

Starfish and kelp waiting for the tide to turn at Devil's Punchbowl State Park, Oregon DENNIS HENRY

> **66** *The shore has a dual nature, changing with the swing of the tides, belonging now to the land, now to the sea. On the ebb tide it knows the harsh extremes of the land world, being exposed to heat and cold, to wind, to rain and drying sun. On the flood tide it is a water world, returning briefly to the relative stability of the open sea.* **99**

Rachel Carson,
The Edge of the Sea

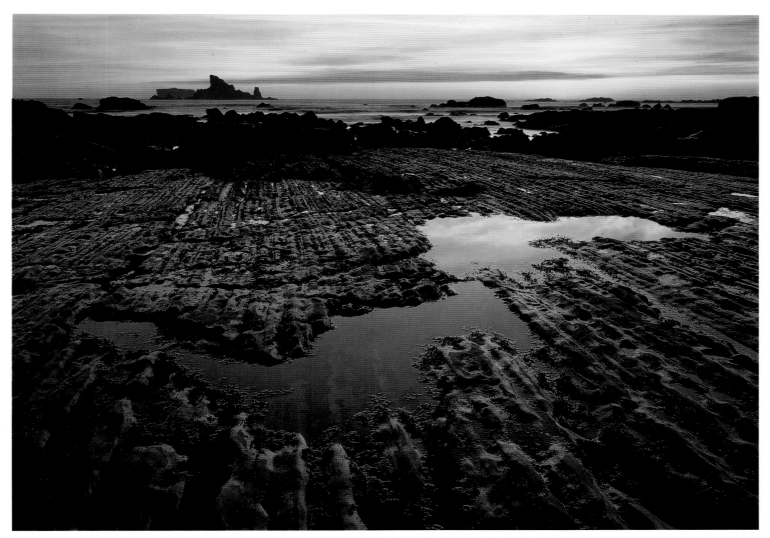

Sunset on the rocky shores of Rialto Beach, Olympic National Park, Washington CARR CLIFTON

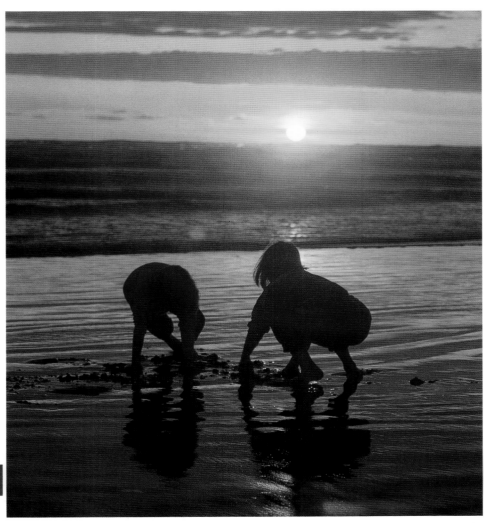

Digging for clams near Long Beach, Washington STEVE MASON / DRS PRODUCTIONS

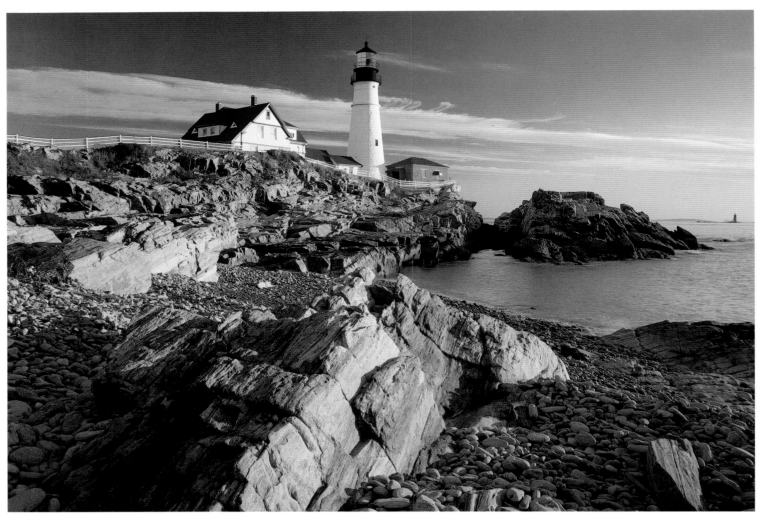

Portland Head Light marking a rocky point of Casco Bay, Portland, Maine LARRY ULRICH

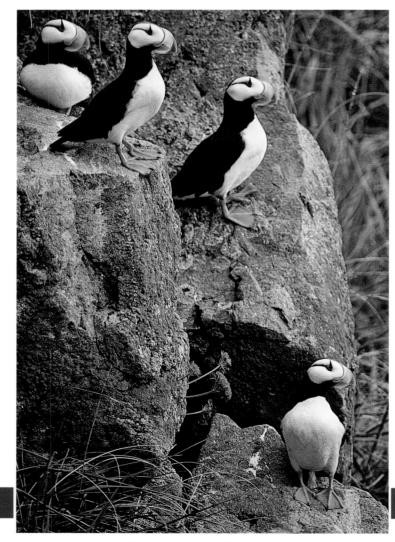

Horned puffins on parade, Pribilof Islands, Alaska
STEPHEN J. KRASEMANN / DRK PHOTO

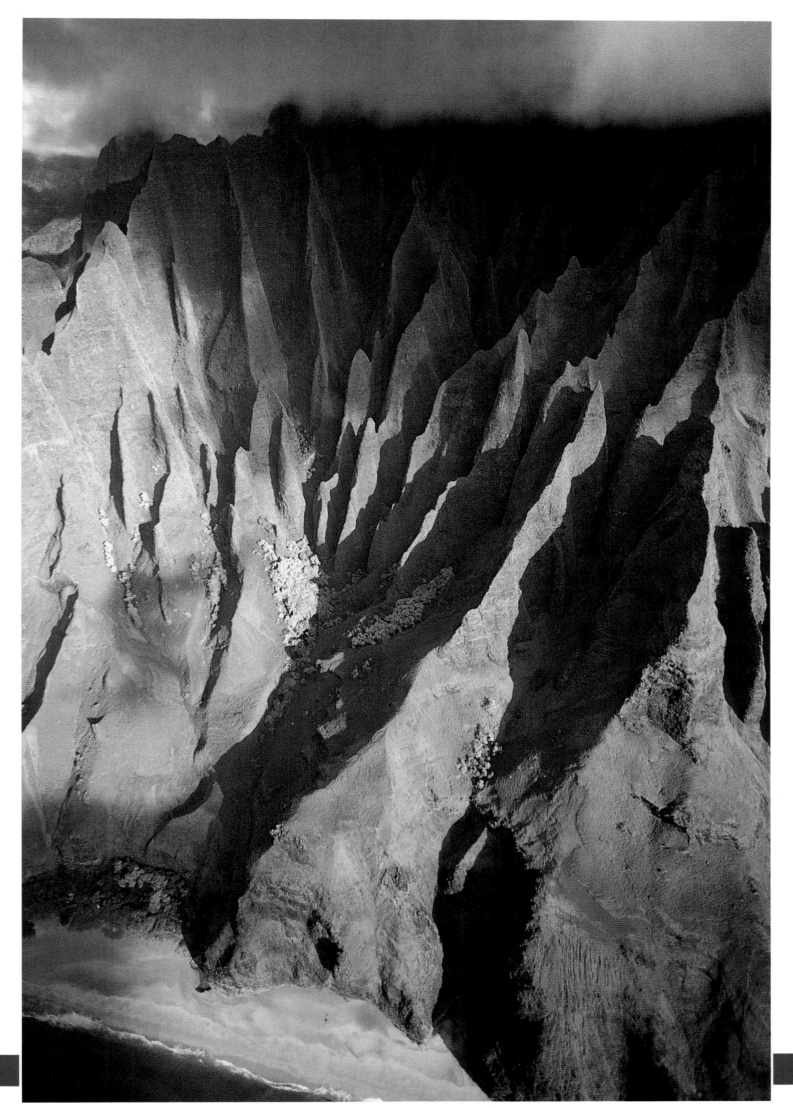

Na Pali Cliffs falling away about 2,000 feet to the Pacific on Kauai, Hawaii FRANS LANTING / MINDEN PICTURES

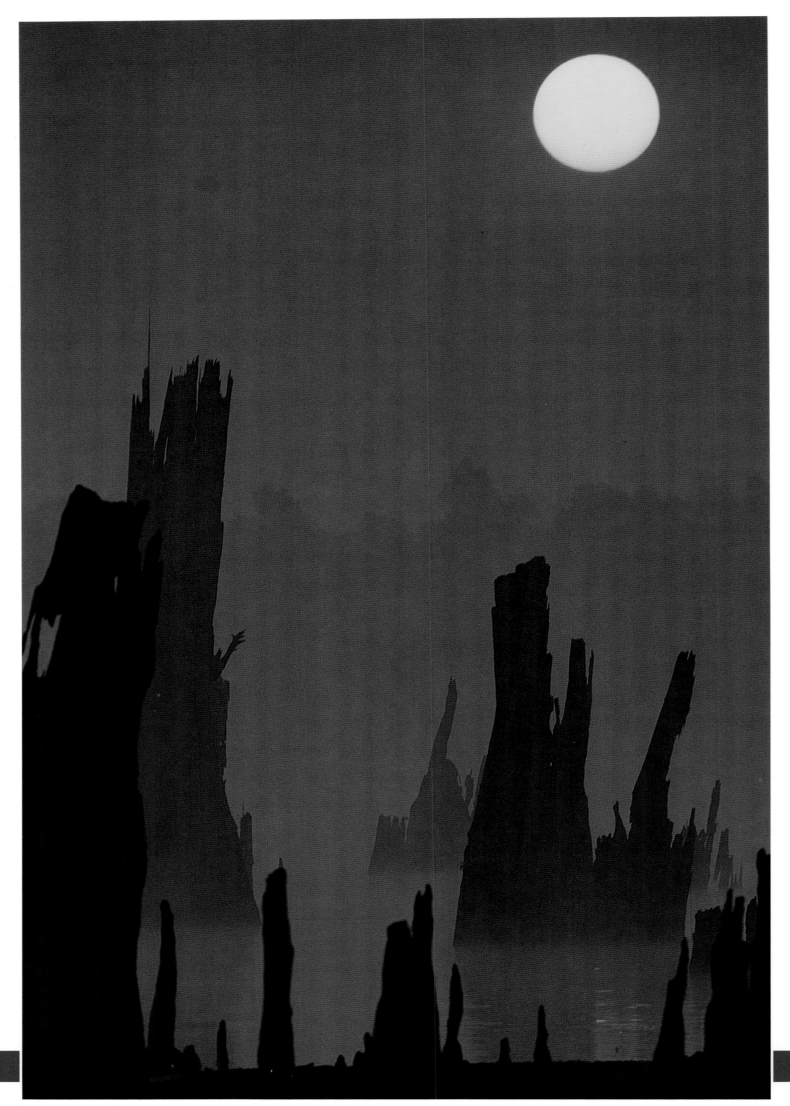

Sunrise illuminating a ghostly grove of cypress stumps in Atchafalaya Swamp, Louisiana EASTCOTT / MOMATIUK / DRK PHOTO

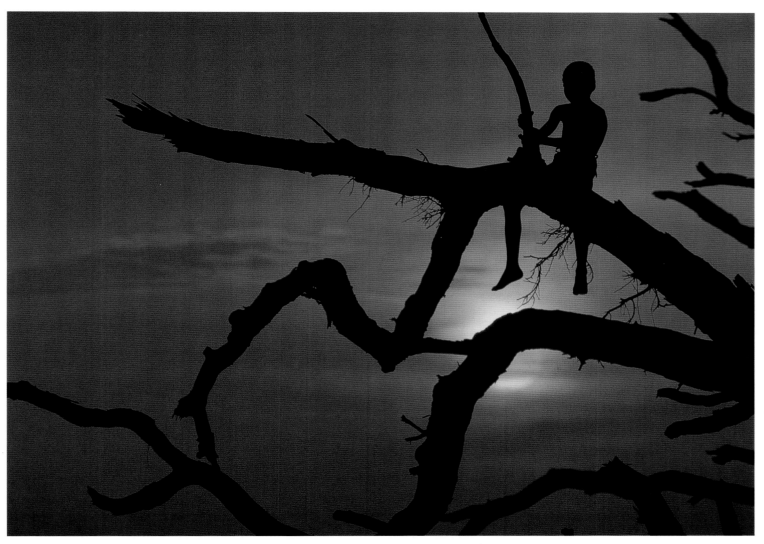

Waiting for the sea to swallow the sun, Daufuskie Island, South Carolina ANNIE GRIFFITHS BELT

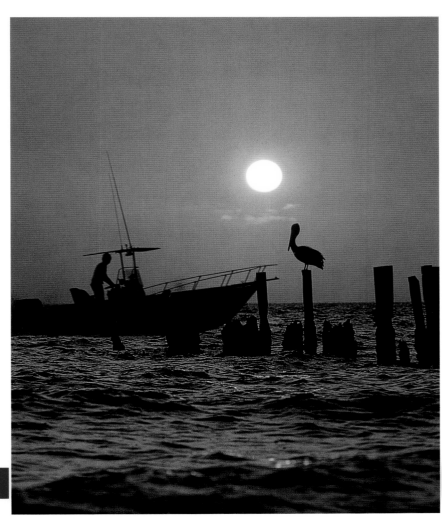

“ Knowledge is a mighty thing
To have in the hand,
But I would trade it all
If I could only understand. ”

Karen Paik, Grade 8,
Burlingame, California.
From ‘‘Understanding’’ in the
Young Writer’s Contest.

End of the day at Naples, Florida MICHAEL S. SAMPLE

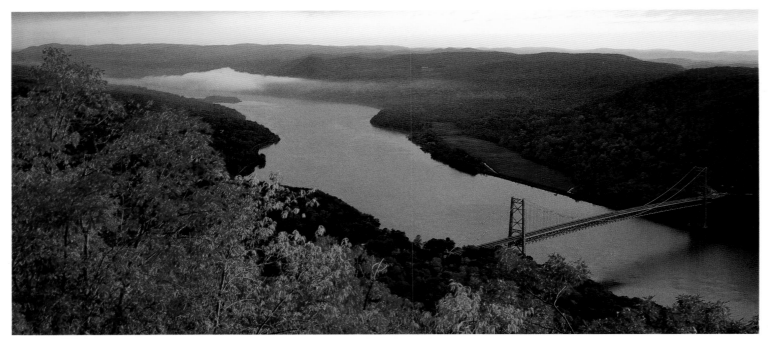

Autumn along the Hudson River near Bear Mountain State Park, New York CARR CLIFTON

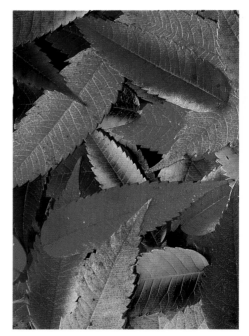

Staghorn sumac leaves S. NIELSEN

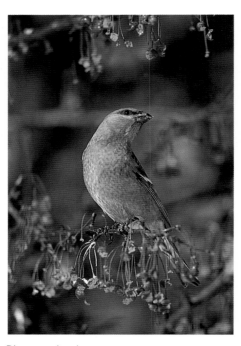

Pine grosbeak JOHN GERLACH / DRK PHOTO

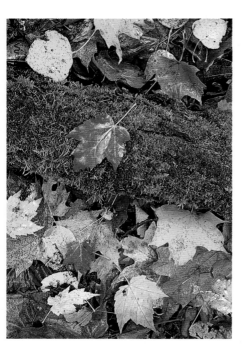

Maple leaves DOUGLAS MERRIAM

❝ *Autumn is the American season. In Europe the leaves turn yellow or brown, and fall. Here they take fire on the trees and hang there flaming. We think this frost-fire is a portent somehow: a promise that the continent has given us. Life, too, we think, is capable of taking fire in this country.* **❞**

Archibald MacLeish,
''Sweet Land of Liberty'' Collier's,
July 8, 1955

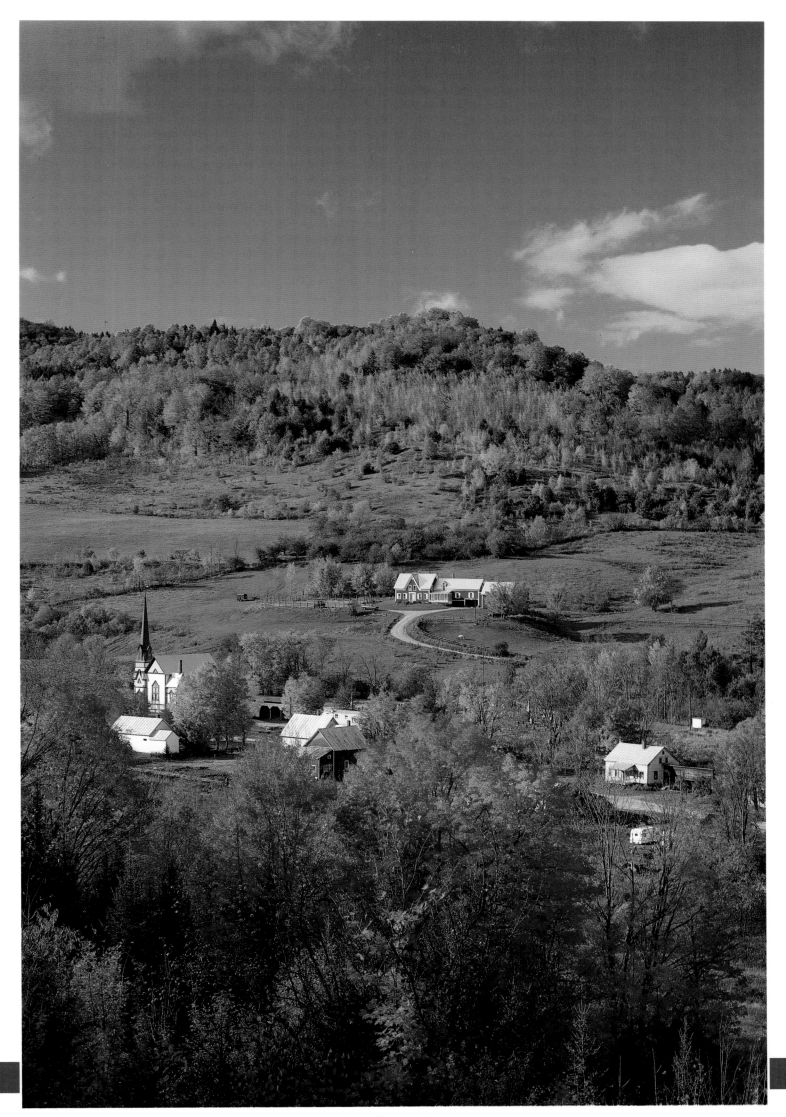

October colors at East Orange, Vermont JEFF GNASS

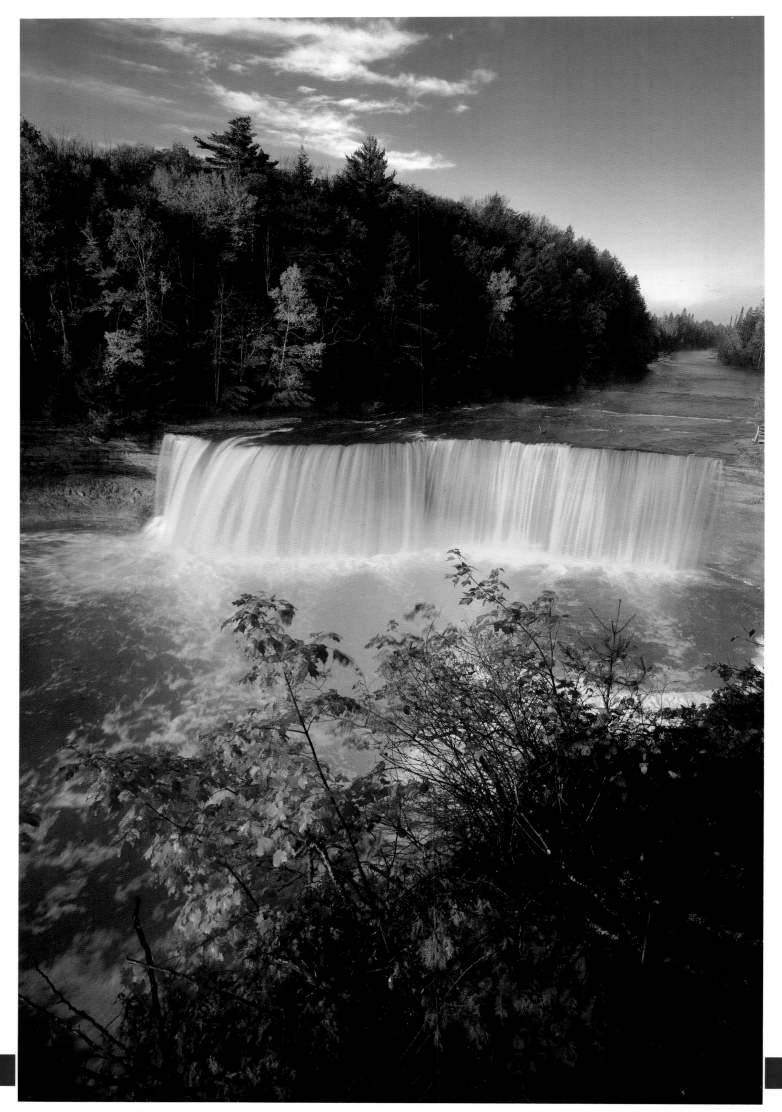

Upper Falls of the Tahquamenon River in Tahquamenon Falls State Park, northern Michigan DAVID MUENCH

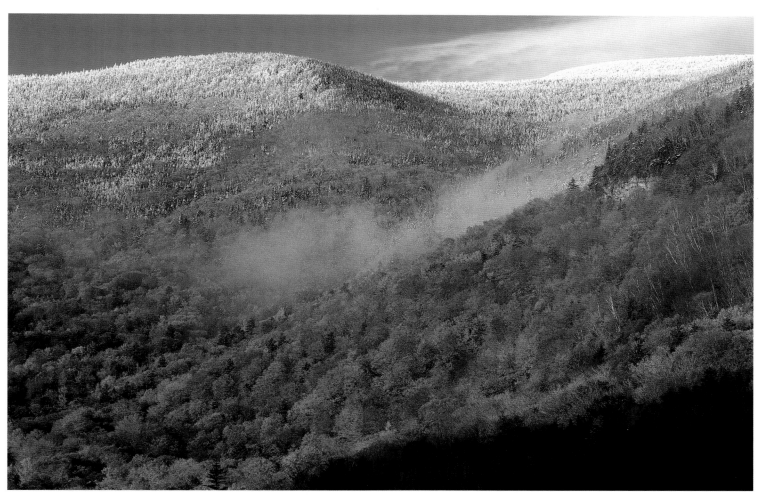

Autumn yielding to winter on the White Mountains in New Hampshire STEPHEN TRIMBLE

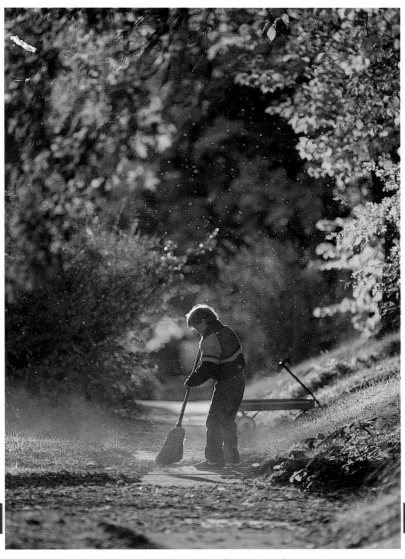

Little Red Wagon Sidewalk Sweeping Service in
Moscow, Idaho SCOTT SPIKER

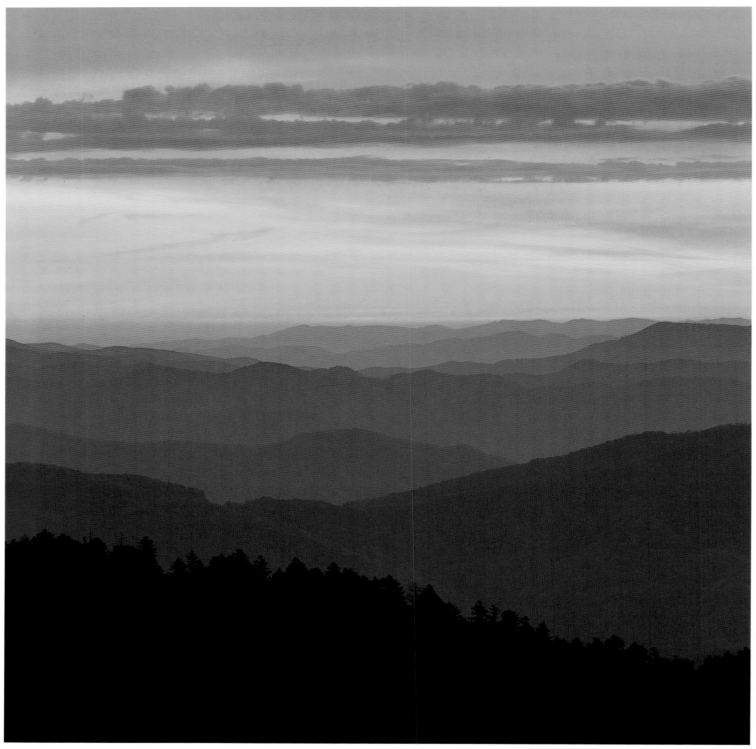

Dawn over the Appalachian Mountains, Great Smoky Mountains National Park, Tennessee / North Carolina LARRY ULRICH

Mountains are giant, restful, absorbent. You can heave your spirit into a mountain and the mountain will keep it, folded, and not throw it back as some creeks will. The creeks are the world with all its stimulus and beauty; I live there. But the mountains are home.

Annie Dillard,
Pilgrim at Tinker Creek

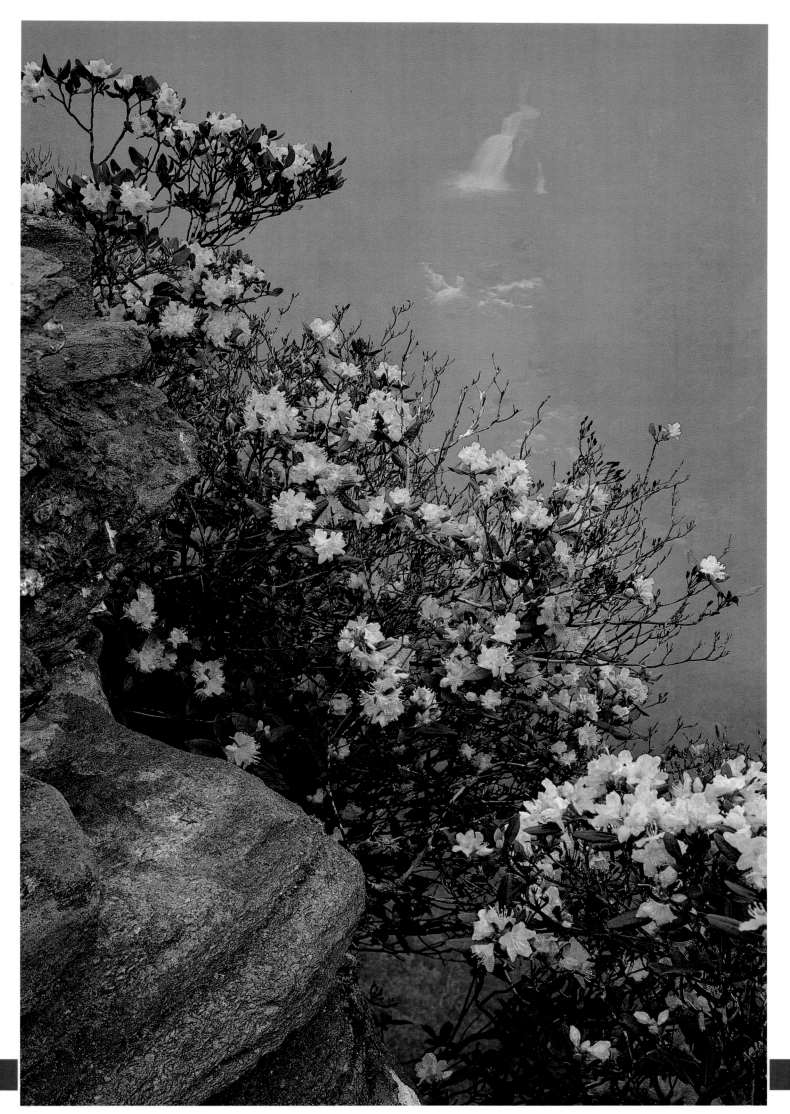

Pink azaleas and Linville Falls along the Blue Ridge Parkway, North Carolina CARR CLIFTON

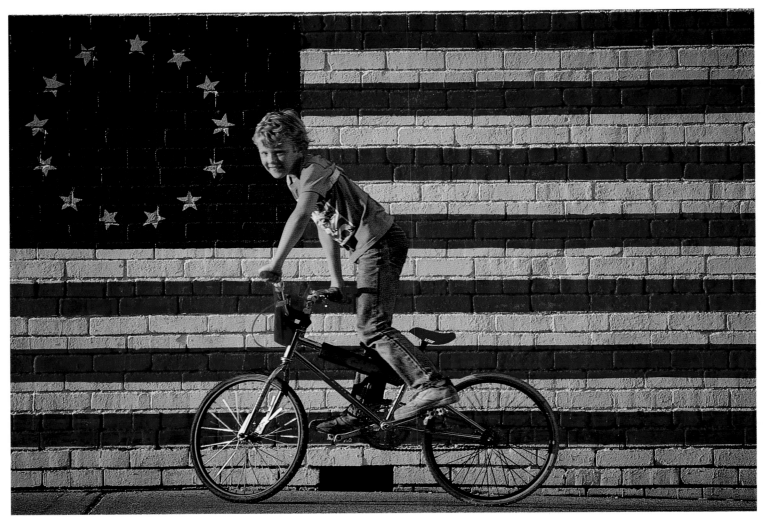

A boy and his bike and the stars and stripes in Atwood, Illinois RICHARD HAMILTON SMITH

 66 *Summer is vacation time, sweet clover time, swing and see-saw time, watermelon time, swimming and picnic and camping and Fourth-of-July time It is fishing time, canoeing time, baseball time. It is, for millions of Americans, 'the good old summertime.'* **99**

Edwin Way Teale,
Journey into Summer

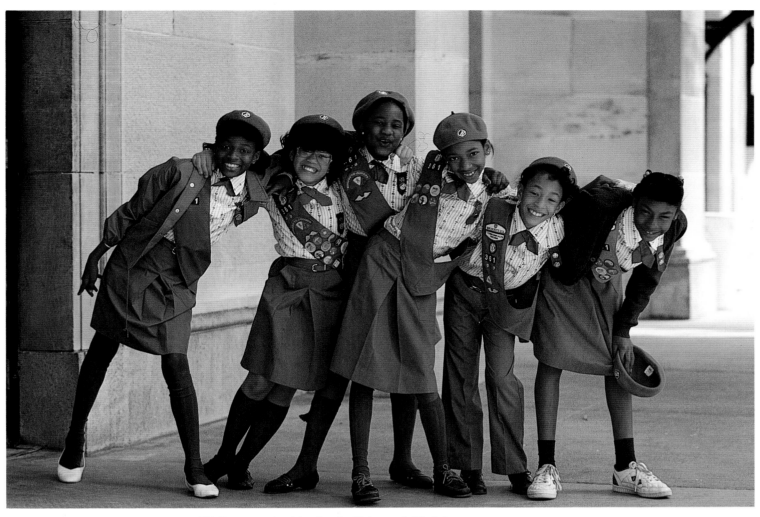

Girl Scouts united for fun in Richmond, Virginia CATHERINE KARNOW

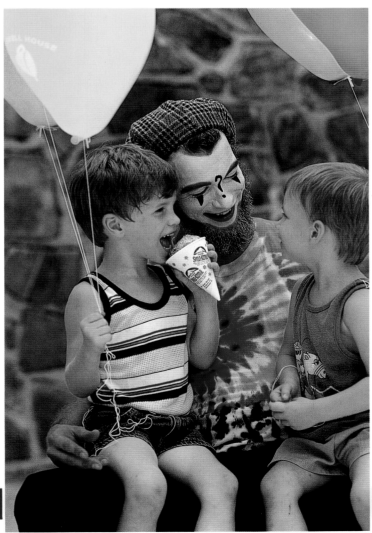

Silent humor at the Little Rock Zoo, Arkansas MATT BRADLEY

Taking watermelons seriously in Tucson, Arizona
FRANK OBERLE / PHOTOGRAPHIC RESOURCES

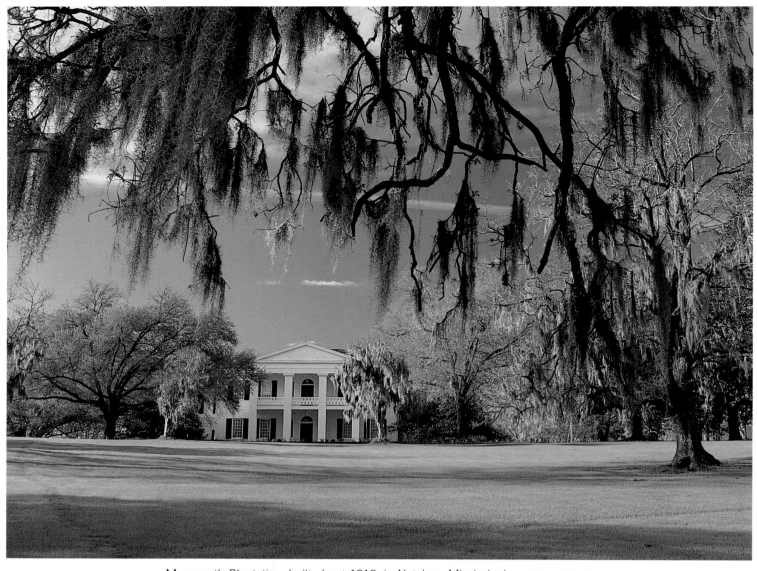

Monmouth Plantation, built about 1818, in Natchez, Mississippi MATT BRADLEY

Pink and white dogwood blossoms near Decatur, Alabama ANNE HEIMANN

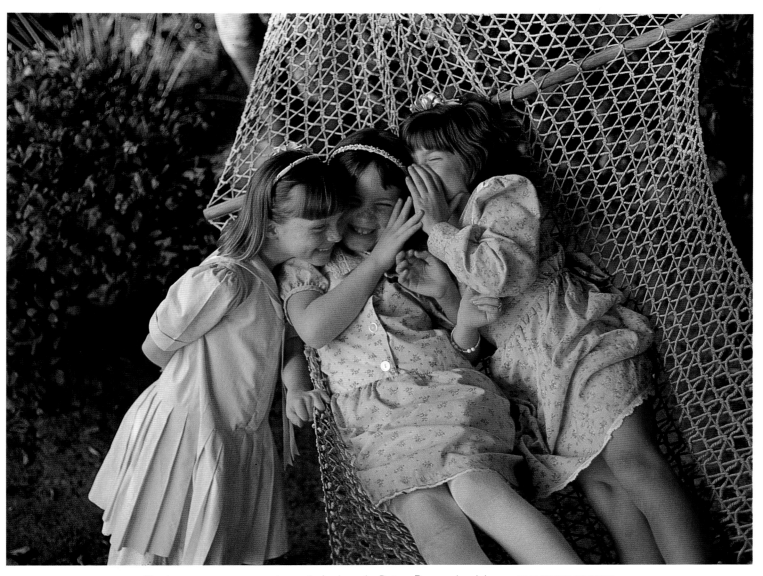

Sharing a summer secret—and giggles—in Baton Rouge, Louisiana CATHERINE KARNOW

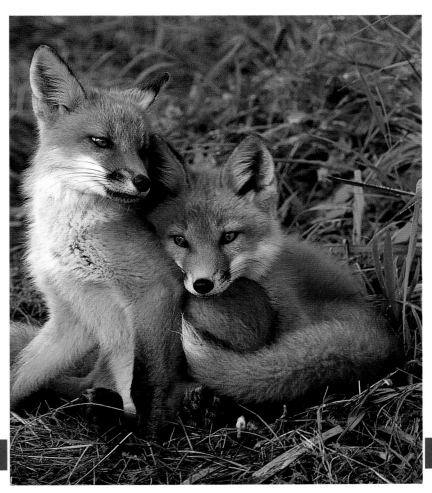

Red fox pups sharing a moment near Roanoke, Virginia
STEPHEN J. KRASEMANN / DRK PHOTO

*" How the petals of a daisy all
 gather to make one—
How the children of the
 summer join together to
 have fun
How they all belong together
Is how I'd like to be. "*

Erika Laughlin, Grade 8,
Mandeville, Louisiana.
From "How They All Belong Together"
in the Young Writer's Contest.

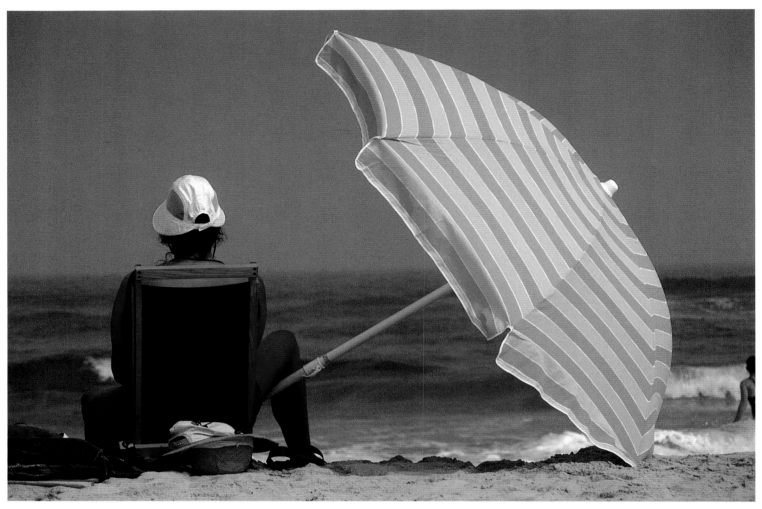

A pastel day on the Jersey Shore, New Jersey DAVID LORENZ WINSTON

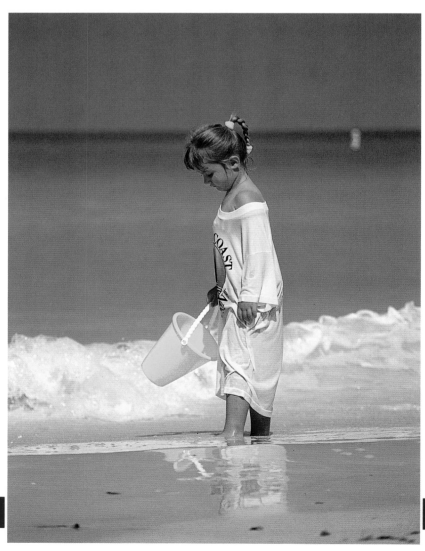

Bucket brigade patrolling Bradenton Beach, Florida
PAUL E. CLARK/N. E. STOCK PHOTO

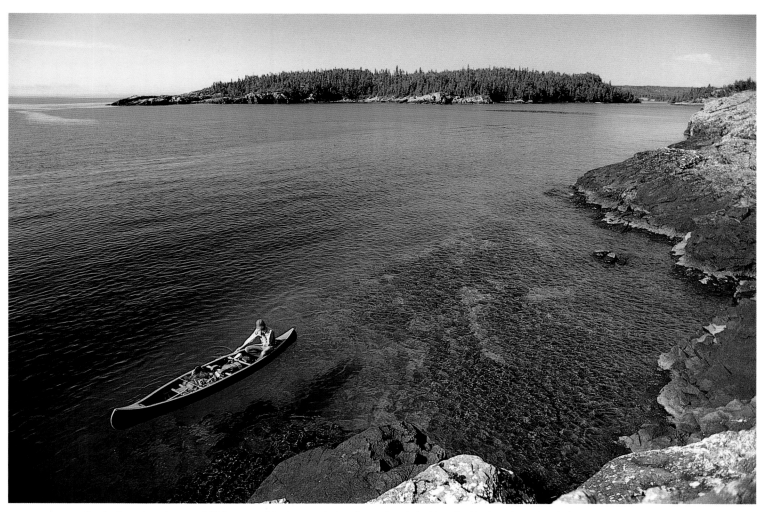

Exploring the shore of Chippewa Harbor on Lake Superior, Isle Royale National Park, Michigan DANIEL J. COX

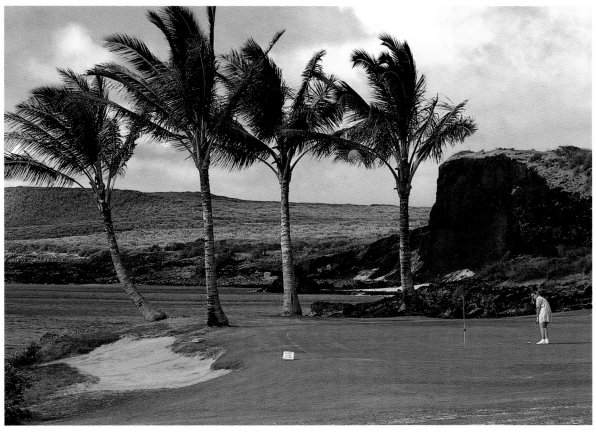

Putting for par by the Pacific, Molokai, Hawaii ALLEN DEAN STEELE / STOCK SOUTH

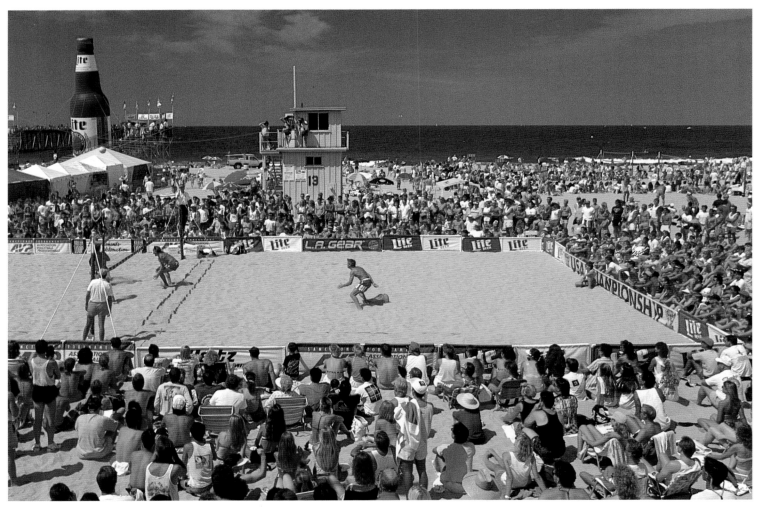

National Volleyball Championships at Hermosa Beach, California CATHERINE KARNOW

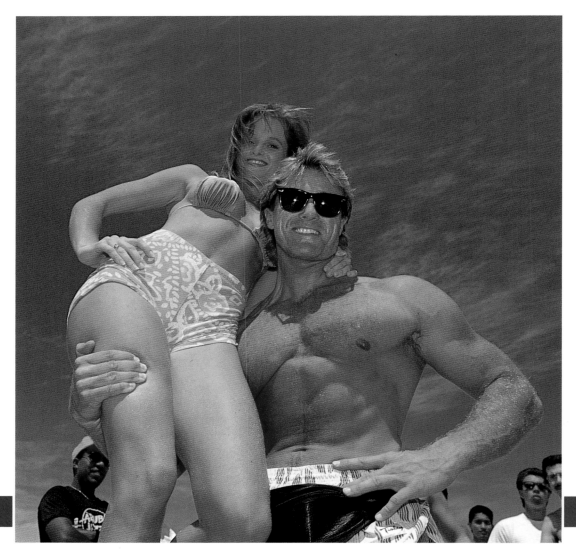

Lifting weights on Hermosa Beach, California CATHERINE KARNOW

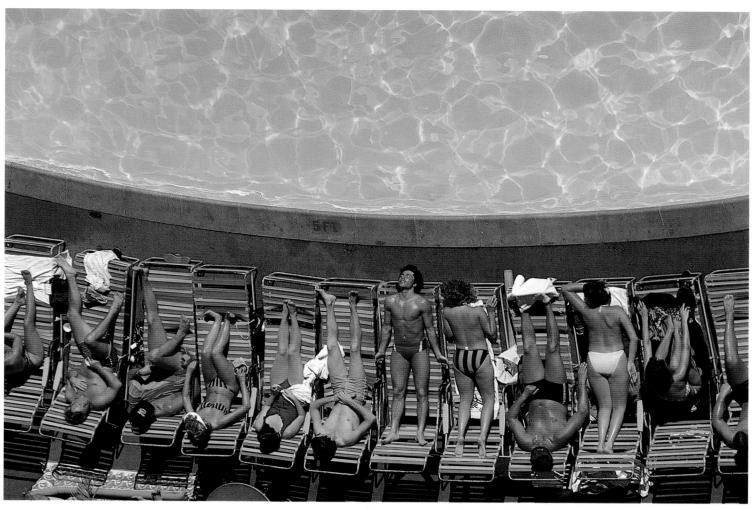

Tanning line at poolside, Honolulu, Hawaii STEPHEN TRIMBLE

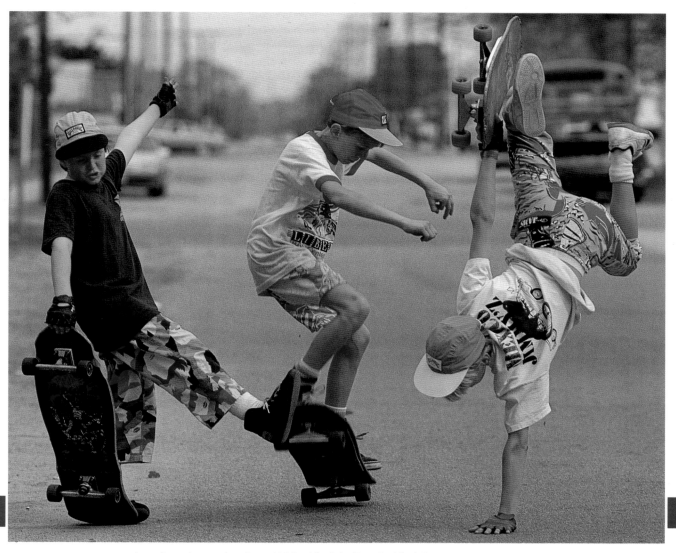

American freestyle, circa 1990s, Virginia Beach, Virginia CATHERINE KARNOW

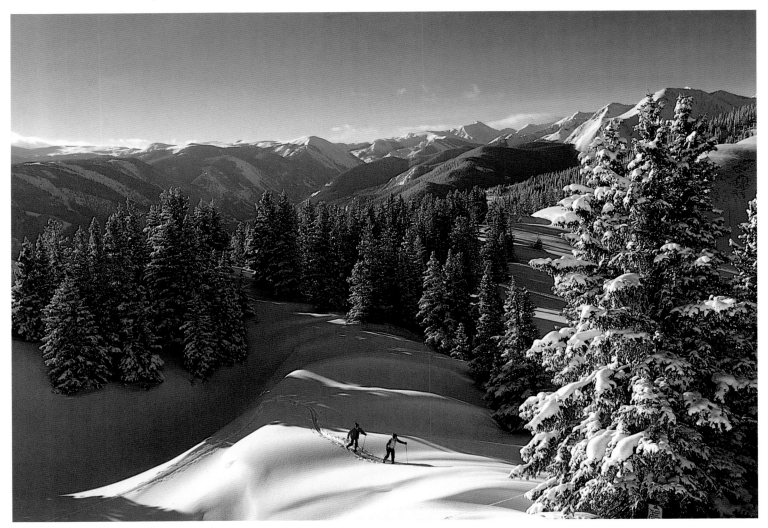

Cross-country skiers making tracks on fresh snow near Aspen, Colorado ANNIE GRIFFITHS BELT

" Winter has settled down over the Divide again; the season in which Nature recuperates, in which she sinks to sleep between the fruitfulness of autumn and the passion of spring. "

Willa Cather,
O Pioneers!

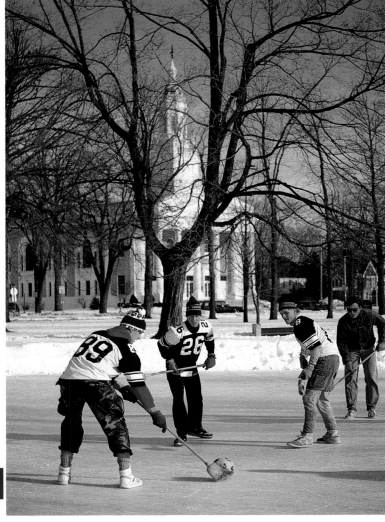

Who needs hockey when you can have broomball?
Appleton, Wisconsin RICHARD HAMILTON SMITH

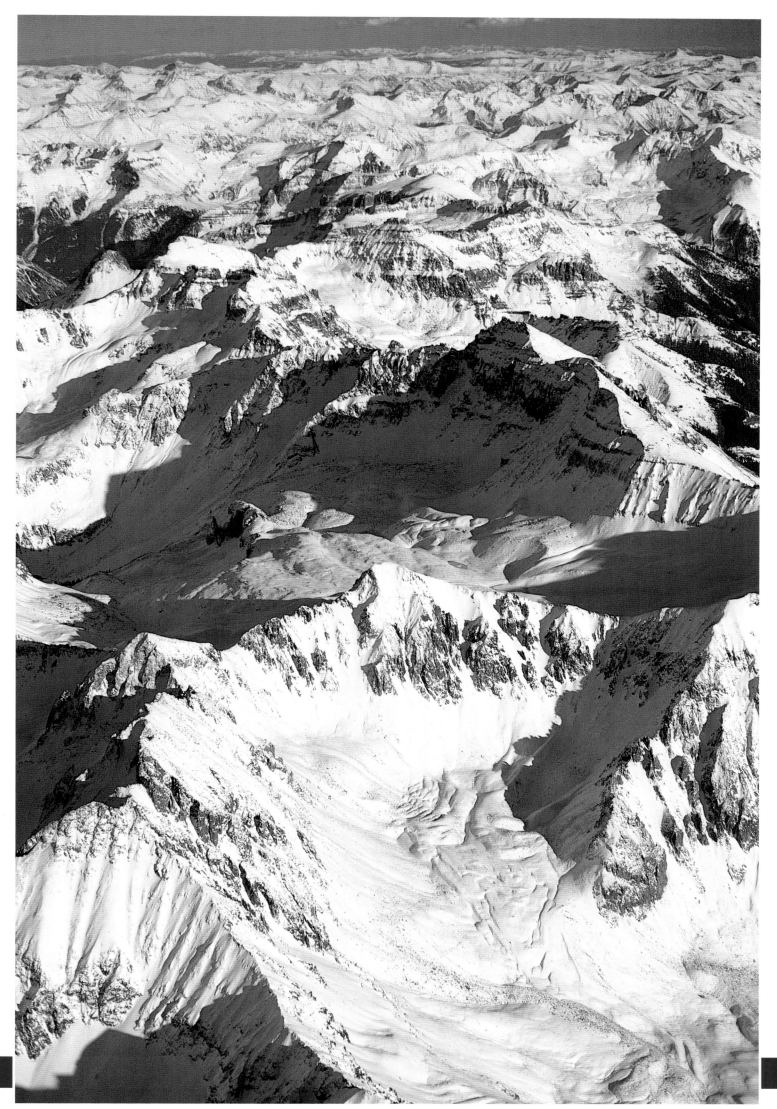

Winter settling on the Continental Divide in the San Juan Mountains, Colorado TOM TILL

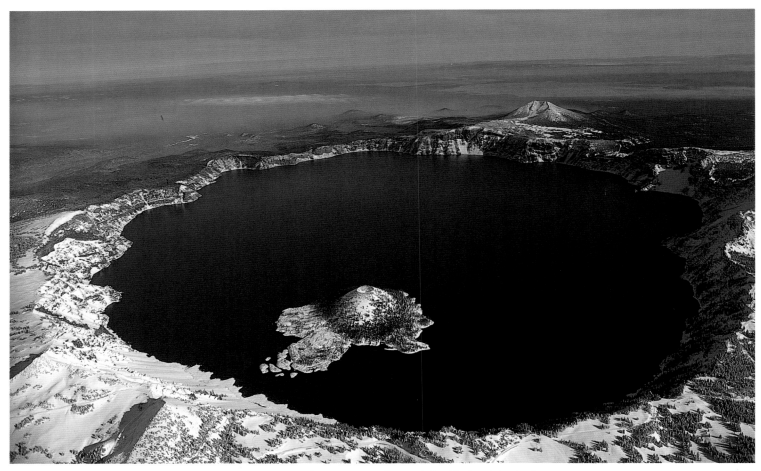

Winter on Crater Lake, atop an ancient volcano, Crater Lake National Park, Oregon GREG VAUGHN

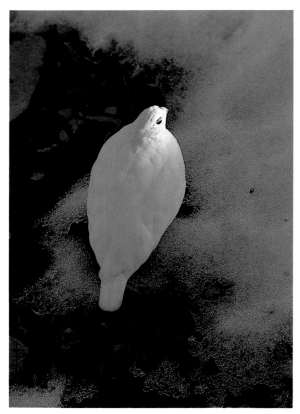

White-tailed ptarmigan dressed for winter, Bob Marshall Wilderness, Montana MICHAEL S. SAMPLE

Pure blue sky, pure white snow, pure fun at Taos Ski Valley, New Mexico KEN GALLARD

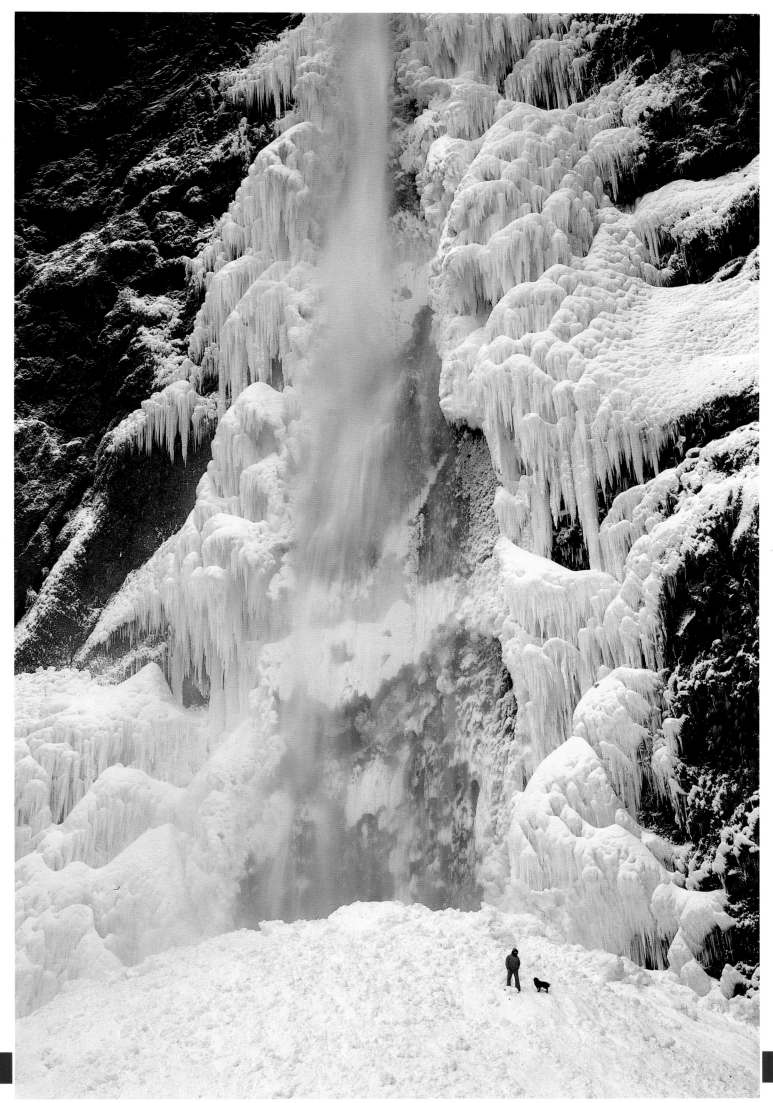

Multnomah Falls transformed into an icefall, Columbia River Gorge, Oregon RUSSELL LAMB

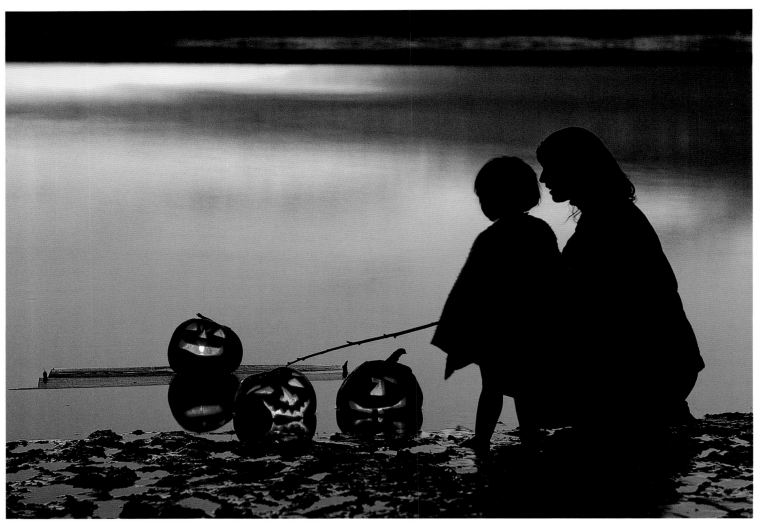

Launching a flotilla of Halloween pumpkins in Marin County, California DAVID CAVAGNARO/DRK PHOTO

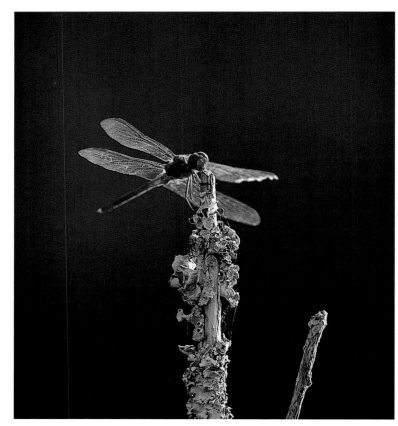

Autumn-colored dragonfly in North Carolina LARRY R. DITTO

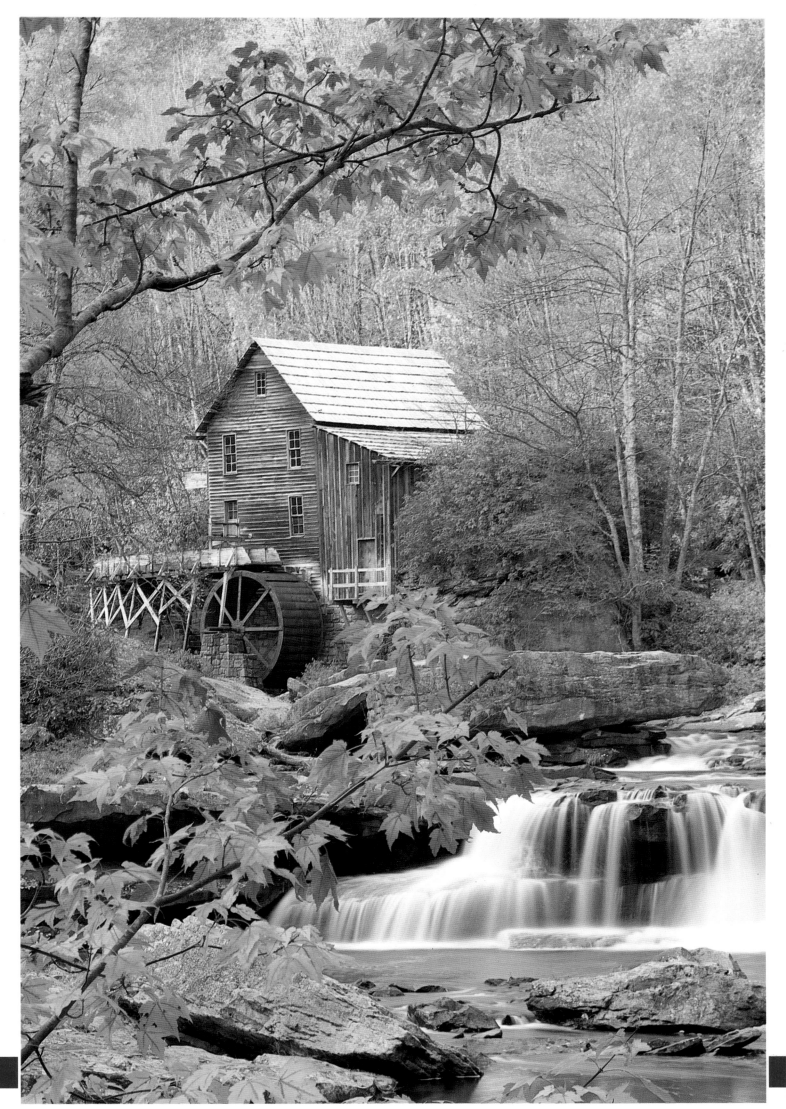

Autumn at Glade Creek Grist Mill in Babcock State Park, Allegheny Mountains, West Virginia LARRY ULRICH

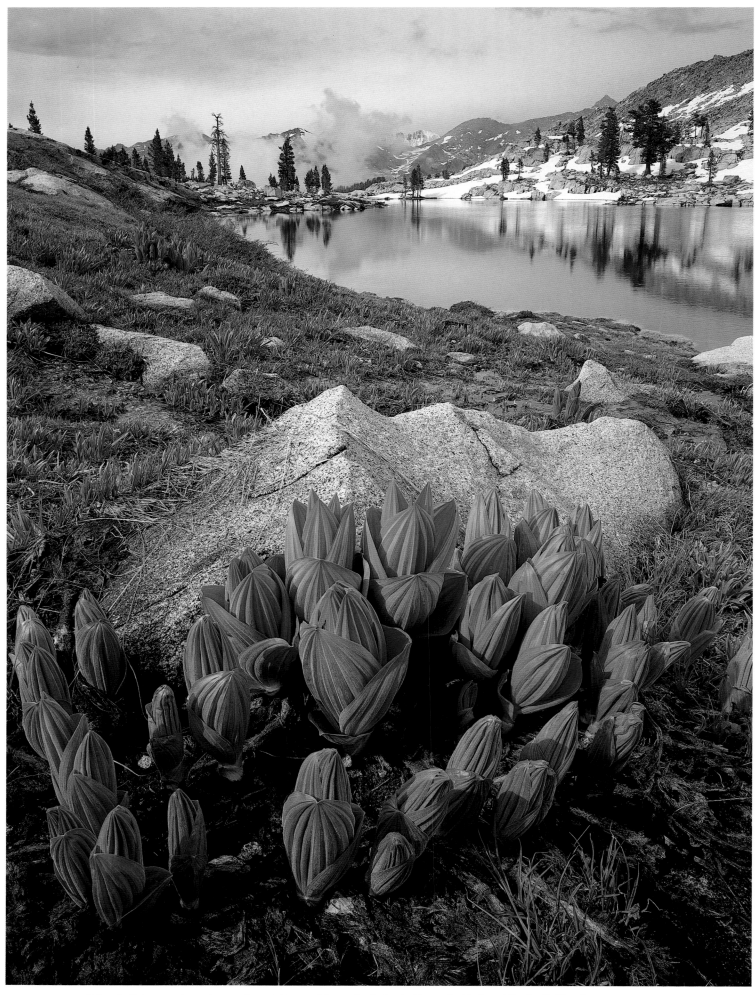

False hellebore advancing spring at Upper Mosquito Lake in Sequoia National Park, California CARR CLIFTON

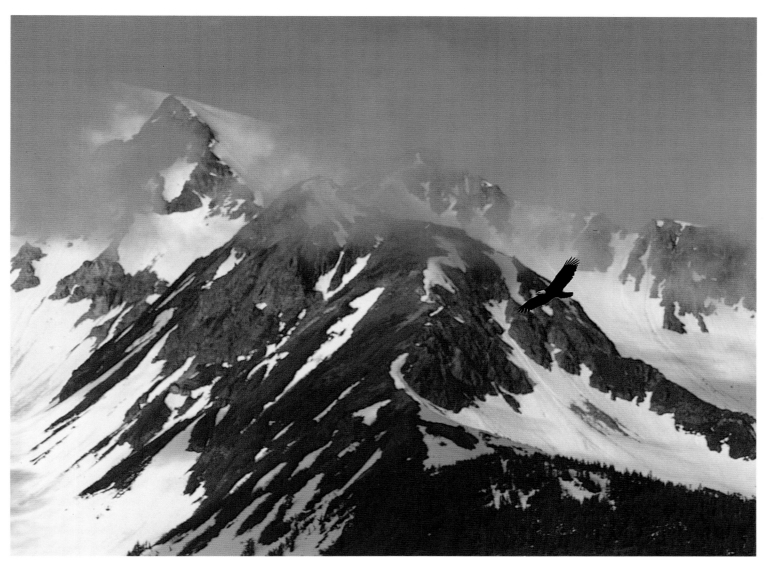

Bald eagle soaring over the Chilkat Bald Eagle Refuge, Haines, Alaska TOM MANGELSEN

“ *It is the eagle active, soaring in a vast, windy sky on a day of brilliant sunshine, that becomes transcendently the symbol of all freedom. . . .* ”

Edwin Way Teale,
Wandering through Winter

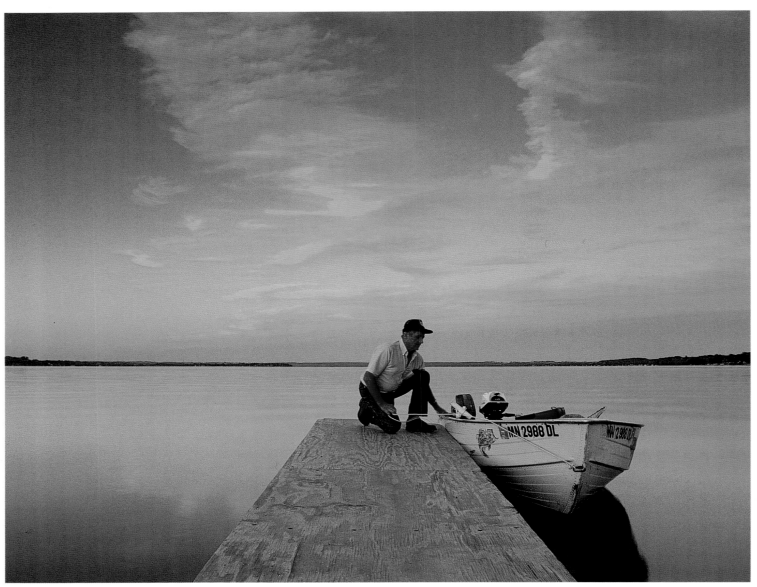

Ending a day of fishing on Lake Minnewaska, Minnesota GREG L. RYAN / SALLY A. BEYER

" *We need the tonic of wildness. . . . At the same time that we are earnest to explore and learn all things, we require that all things be mysterious and unexplorable, that land and sea be infinitely wild, unsurveyed and unfathomed by us because unfathomable. We can never have enough of Nature.* **"**

Henry David Thoreau,
Walden

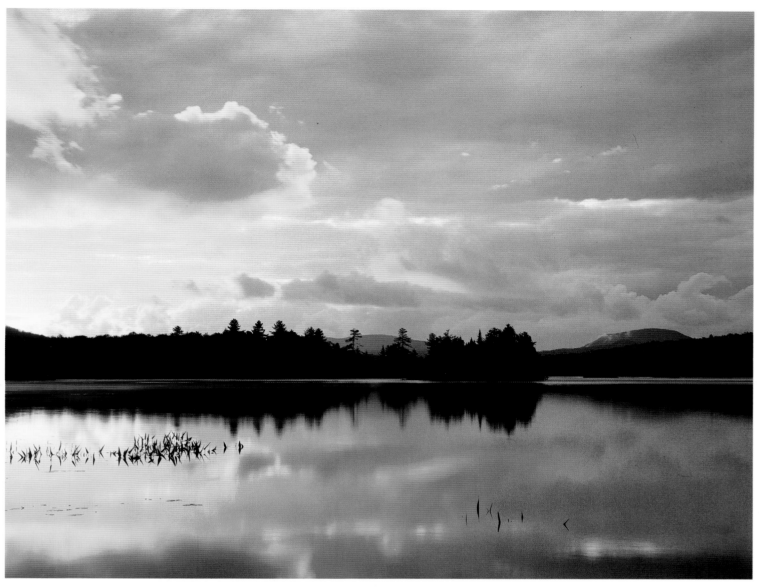

Sunset at Lake Durant, Adirondack Park and Preserve, New York CARR CLIFTON

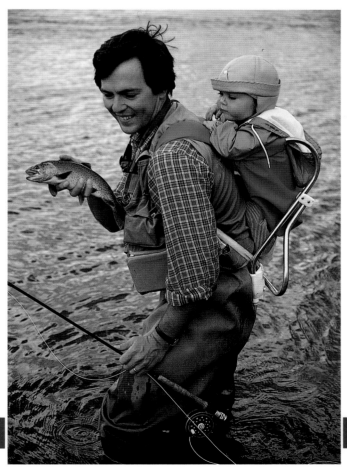

Two generations fishing for cutthroat trout, Yellowstone National
Park, Montana / Wyoming / Idaho LINDA CAUBLE

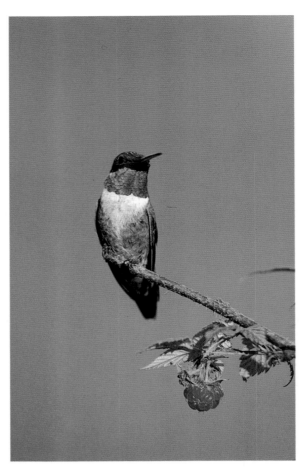

Ruby-throated hummingbird, ruby-colored raspberry,
near Eagle River, Wisconsin
STEPHEN J. KRASEMANN / DRK PHOTO

A waterfall is like silver beads
Tumbling off rocks, and if you
Watch long enough you will
* wonder*
Where it leads and what you'll
Find if you follow.

Its cool breeze is like a small
Hand brushing by your cheek.
You want it to come back and
Touch you again.

Kristina Beyer, Grade 6,
St. Paul, Minnesota.
From "Waterfall" in the
Young Writer's Contest.

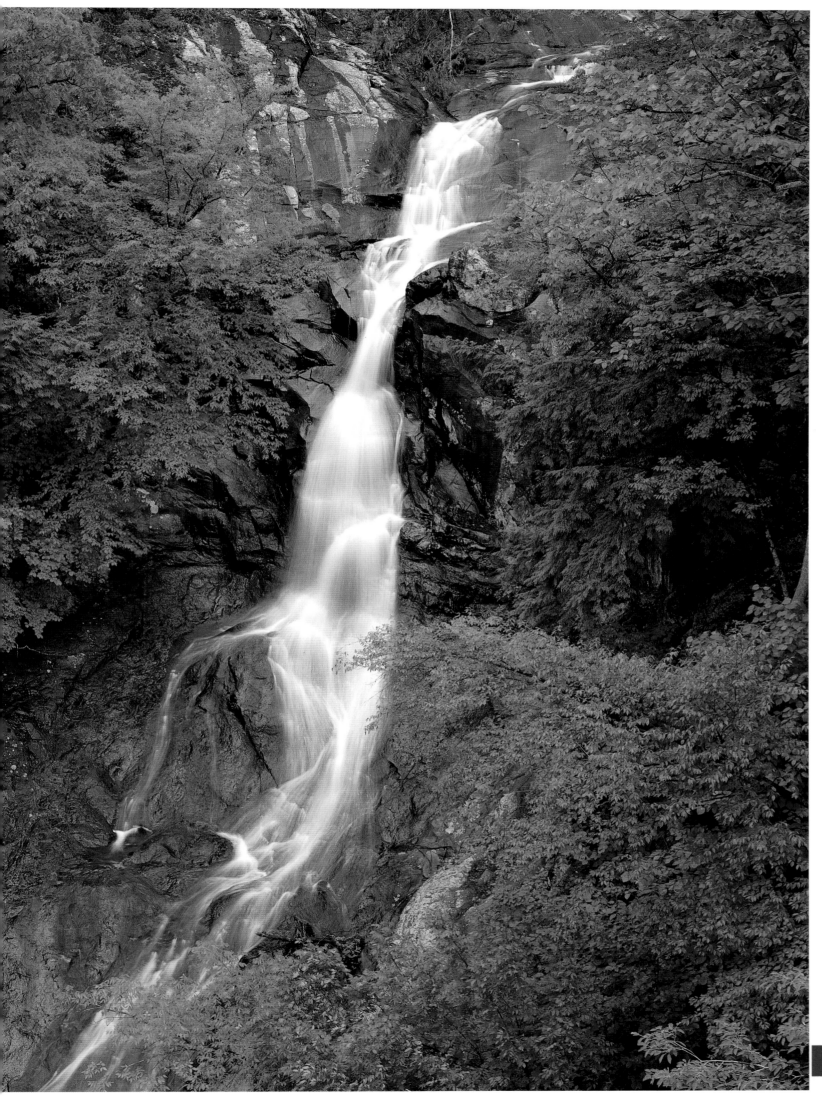

White Oak Run cascading through White Oak Canyon, Shenandoah National Park, Virginia WILLARD CLAY

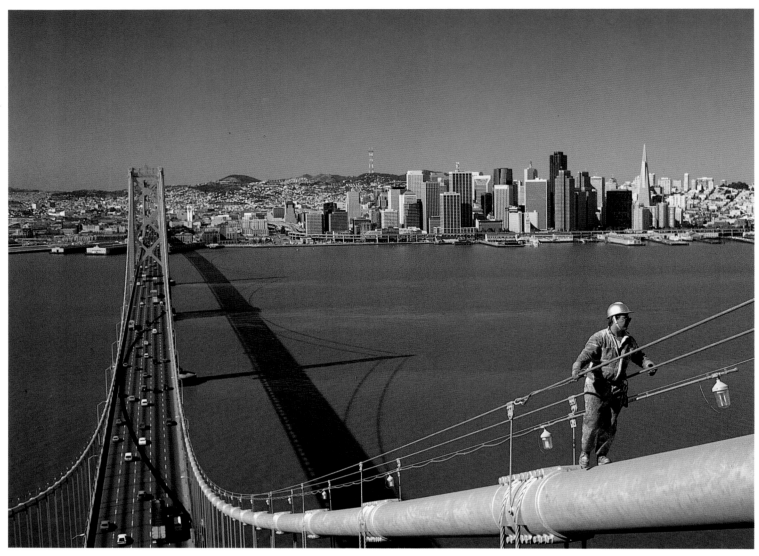

Inspecting the Bay Bridge between San Francisco and Oakland, California CURTIS MARTIN / PHOTOGRAPHIC RESOURCES

" ...the genius of the United States is not best or most in its executives or legislatures, nor in its ambassadors or authors or colleges or churches or parlors, nor even in its newspapers or inventors... but always most in the common people. "

Walt Whitman,
preface to Leaves of Grass

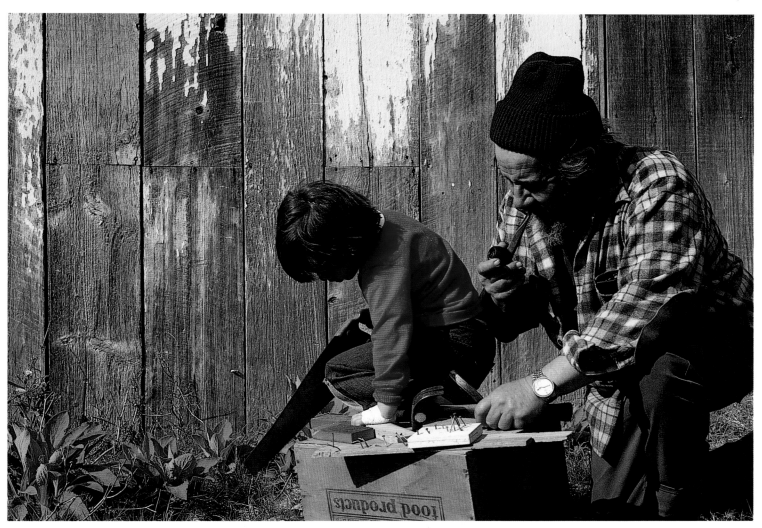

Grandpa's apprentice, Marin County, California DAVID CAVAGNARO

Celebrating the fiftieth birthday of the Huntsville Museum of Art,
Huntsville, Alabama ROB OUTLAW

Cheerful farmer near Poolesville, Maryland CATHERINE KARNOW

Sharing a laugh in Highland County, Virginia CATHERINE KARNOW

Sculpting bronze art in Helena, Montana
GENE FISCHER

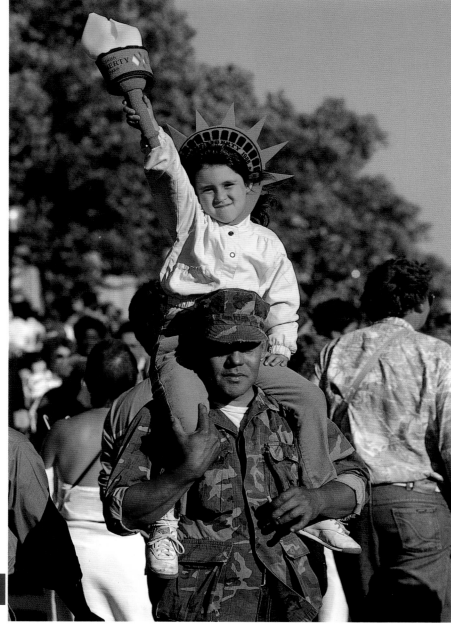

A living Statue of Liberty, New York City ANNIE GRIFFITHS BELT

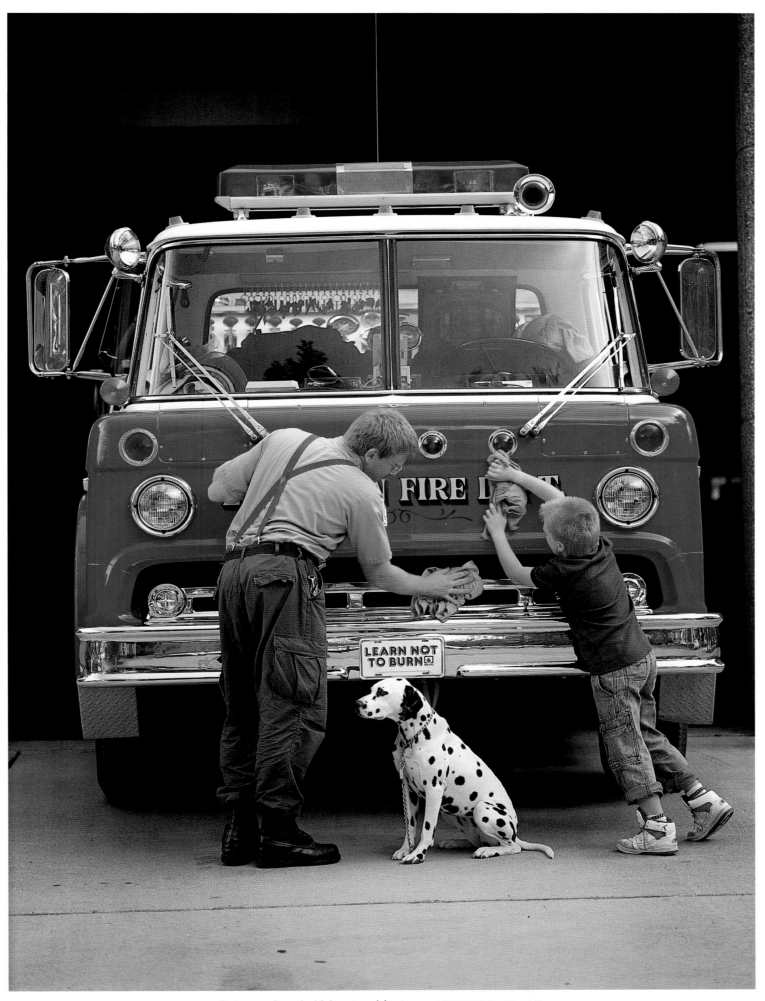

Between fires in Livingston, Montana AIUPPY PHOTOGRAPHS

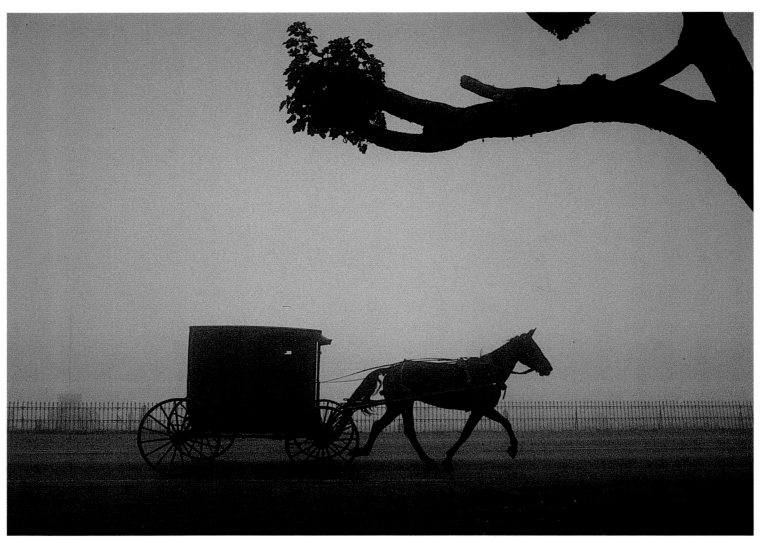

Old Order Mennonite carriage, Caernarvon Township, Pennsylvania ROBERT F. LEAHY

> **" The United States is a country unique in the world because it was populated not merely by people who live in it by the accident of birth, but by those who willed to come here. "**
>
> John Gunther,
> Inside U.S.A.

A Cub Scout of America,
Los Angeles, California CATHERINE KARNOW

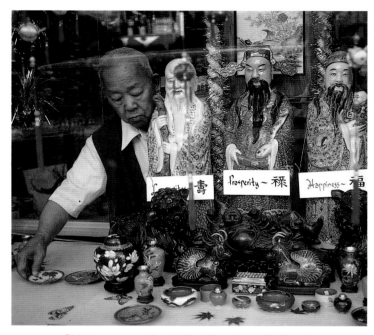

Chinatown merchant, San Francisco, California
MARK & JENNIFER MILLER

Tuning up for St. Patrick's Day Parade, St. Paul, Minnesota
ANNIE GRIFFITHS BELT

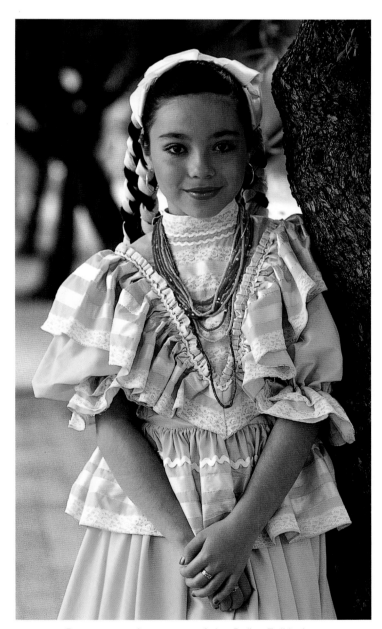

Between performances of the Ballet Folklorico,
Tucson, Arizona MATT BRADLEY

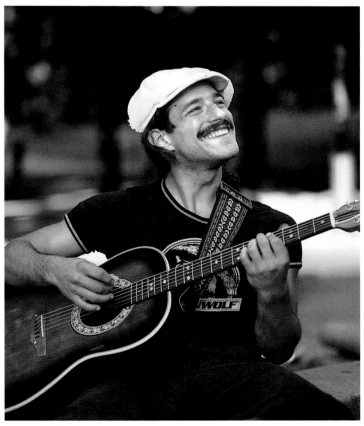

Strumming in Central Park, New York City CATHERINE KARNOW

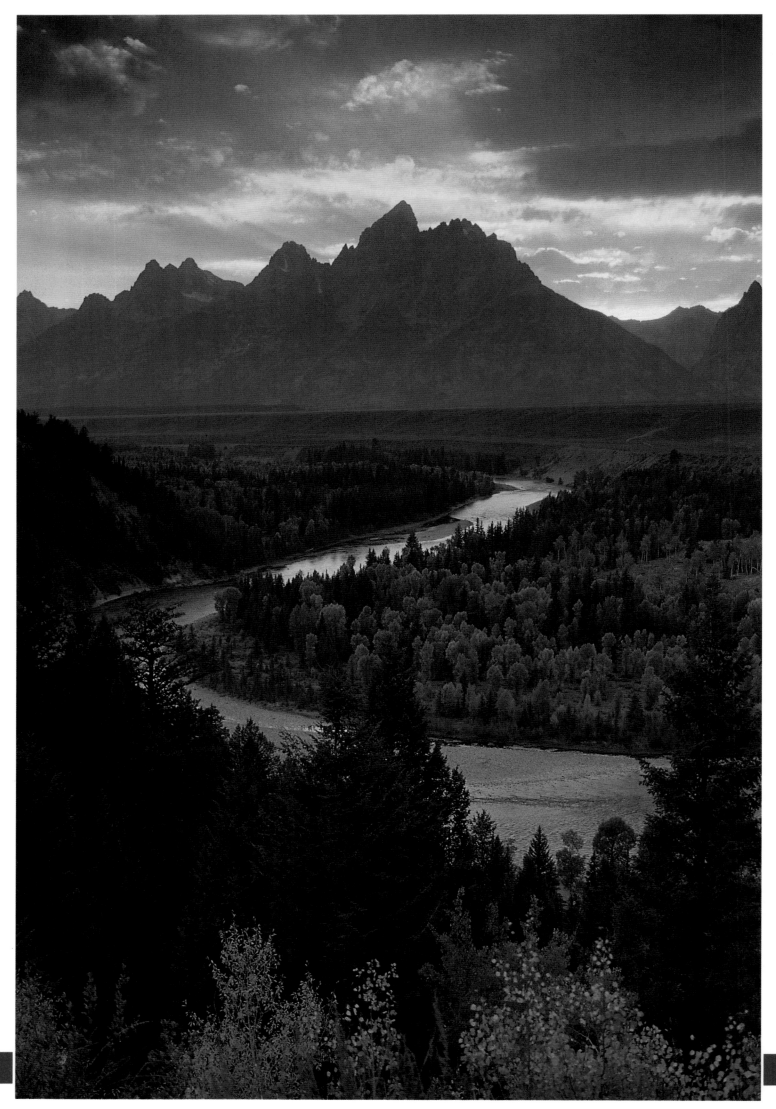

Autumn sunset over the Grand Tetons and the Snake River, Grand Teton National Park, Wyoming W. PERRY CONWAY

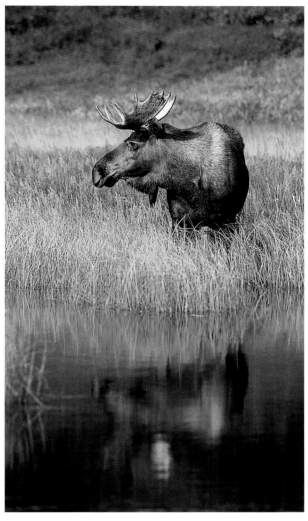

Bull moose, Yellowstone National Park,
Montana / Wyoming / Idaho TOM MANGELSEN

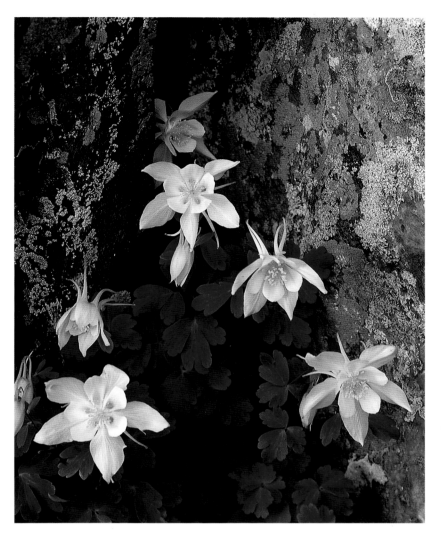

Blue columbine, San Juan National
Forest, Colorado LARRY ULRICH

❝ *Wilderness is the raw material out of which man has hammered the artifact called civilization.* **❞**

Aldo Leopold,
A Sand County Almanac

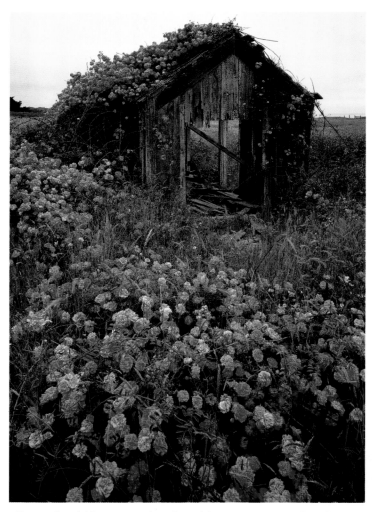

Roses flourishing at an abandoned homestead near Fort Bragg
in northern California CARR CLIFTON

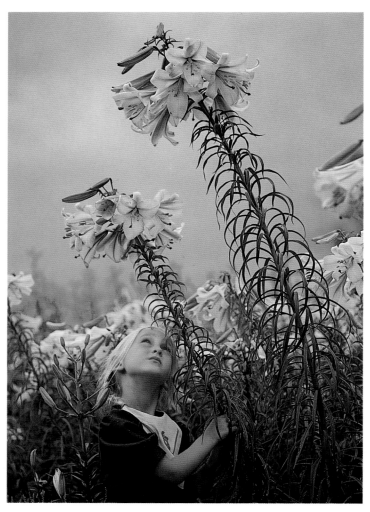

Six-foot-tall black dragon lilies and four-foot-tall admirer,
Decorah, Iowa DAVID CAVAGNARO

> *Every rose on the little tree*
> *is making a different face at me.*
> *Some look surprised when I go by;*
> *others droop as if they were shy*
> *Some have their heads thrown back to sing*
> *and all the buds are listening.*
> *I wonder if the gardener knows,*
> *or if he calls each just a rose?*

Jamie Krause, Grade 8,
Cleveland, North Carolina.
From "The Little Rose Tree"
in the Young Writer's Contest.

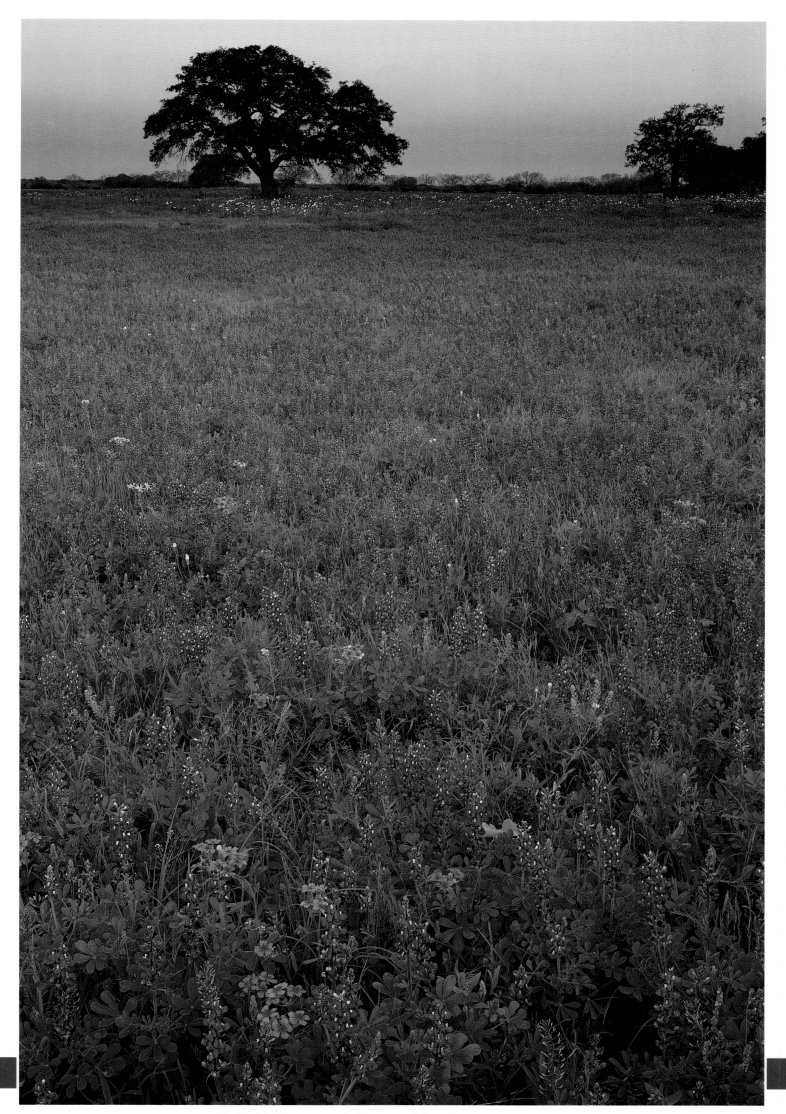

Native bluebonnets and phlox near Gillett, Texas WILLARD CLAY

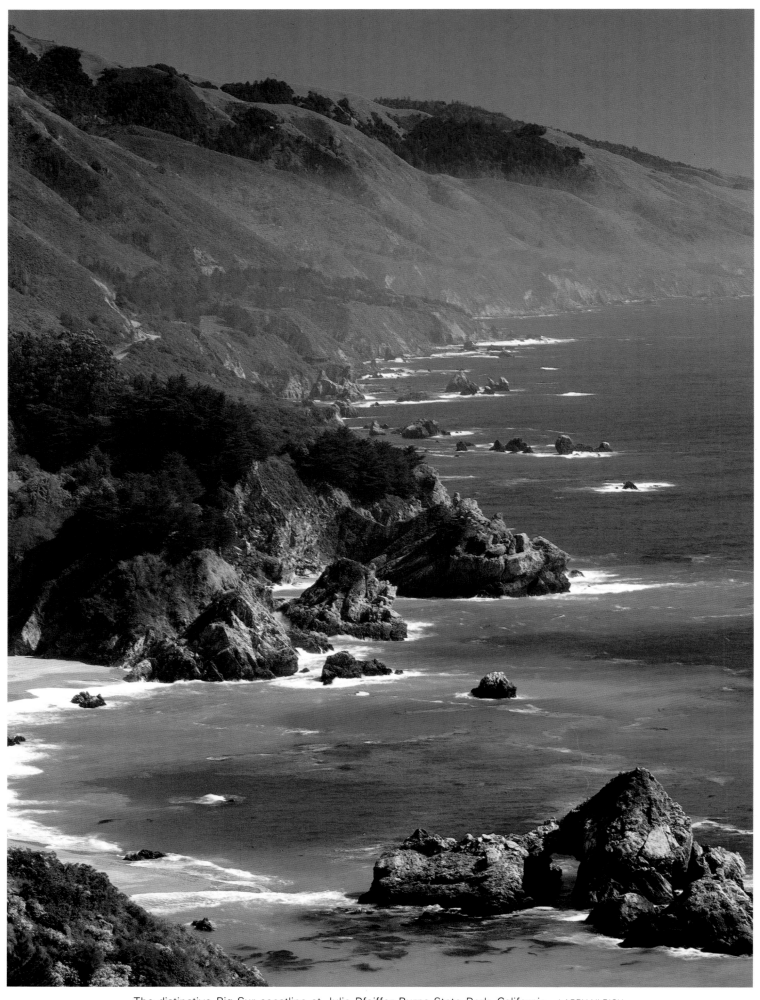

The distinctive Big Sur coastline at Julia Pfeiffer Burns State Park, California LARRY ULRICH

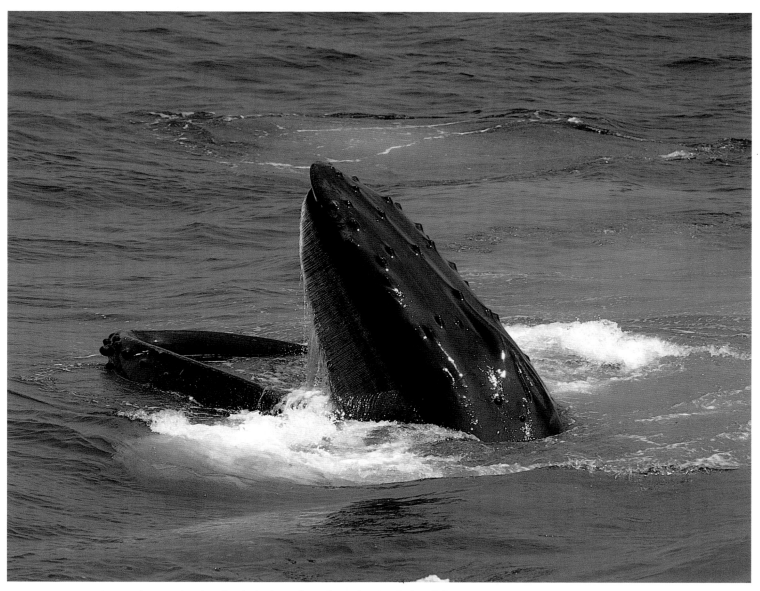

A mouth-watering lunch of plankton for a humpback whale off Portsmouth, New Hampshire TED LEVIN

It tempted; it beckoned; it called to me,
To that part of my soul I could not suppress.
It lodged deep within my heart, I confess,
The wildness, the glory, of the sea.

Clarissa Martinez, Grade 8,
Bethesda, Maryland.
From "The Sea" in the
Young Writer's Contest.

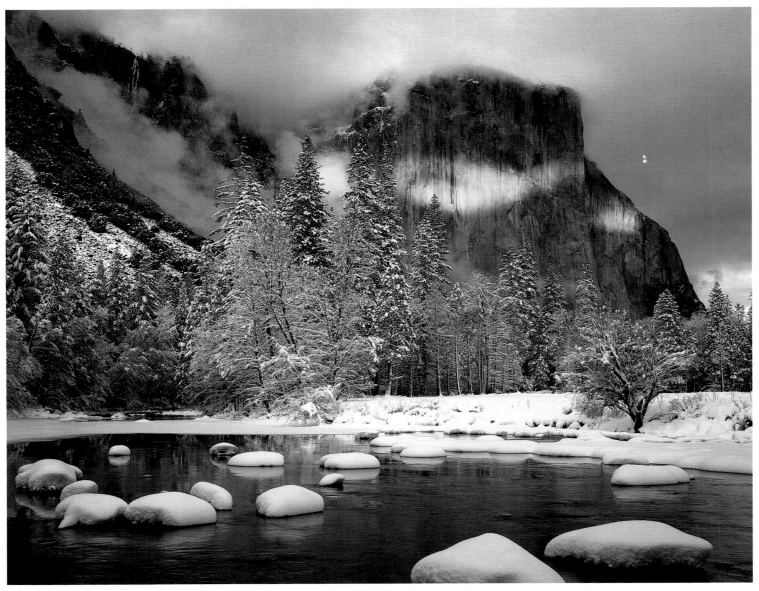
Winter sun on El Capitan, a granite monolith above the Merced River in Yosemite National Park, California JAMES RANDKLEV

❝ *The sun illuminates only the eye of the man, but shines into the eye and heart of the child. The lover of nature is he whose inward and outward senses are still truly adjusted to each other; who has retained the spirit of infancy even into the era of manhood.* **❞**

Ralph Waldo Emerson,
Nature

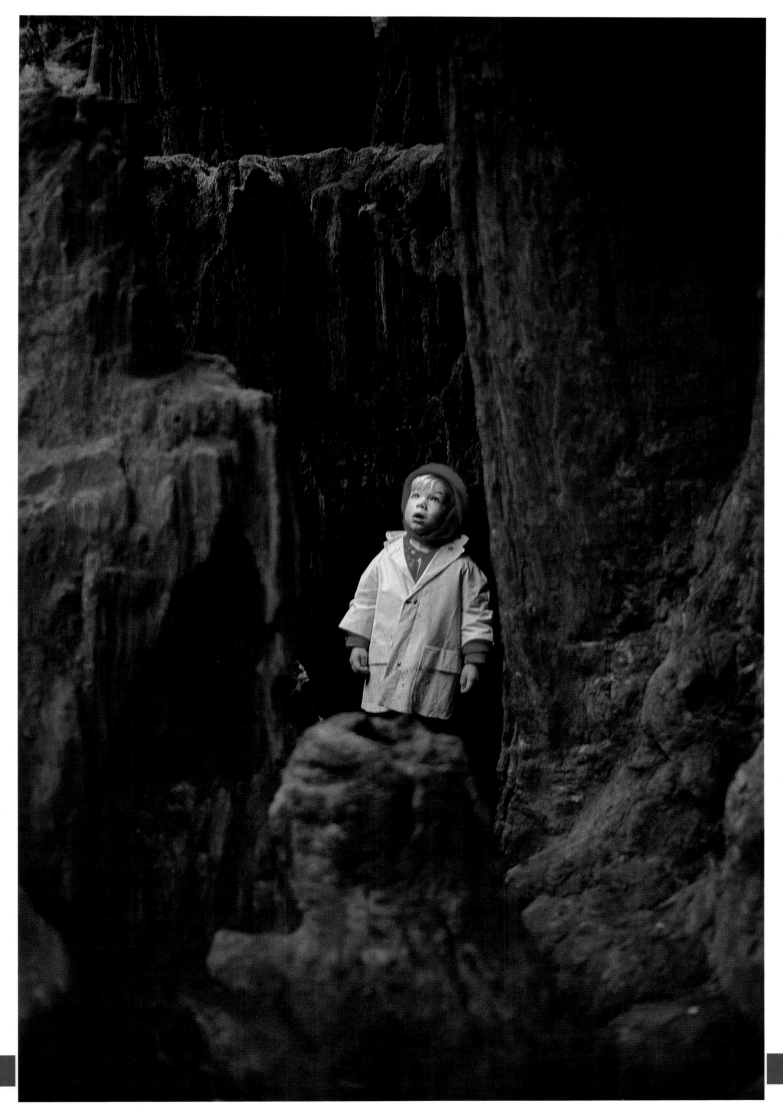

Shining into the eye of an awestruck child in a grove of majestic redwoods, Yosemite National Park, California TOM MYERS

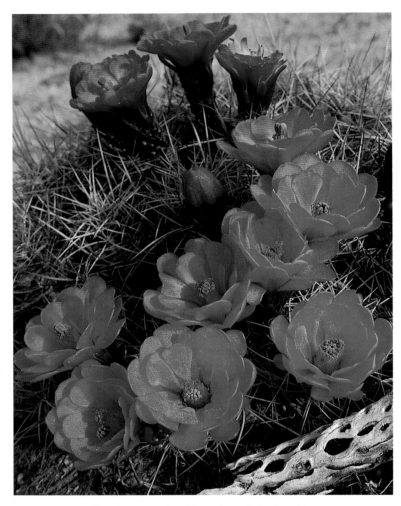

Claret cup cactus blooming at Joshua Tree
National Monument, California JEFF FOOTT

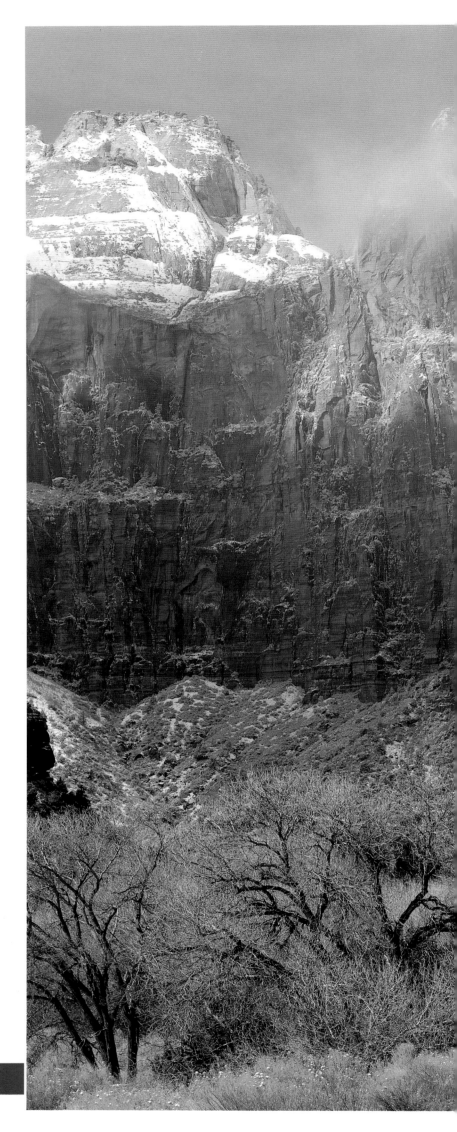

" *For all the toll the desert takes
of a man it gives compensations, deep
breaths, deep sleep, and the communion
of the stars.* "

Mary Austin,
The Land of Little Rain

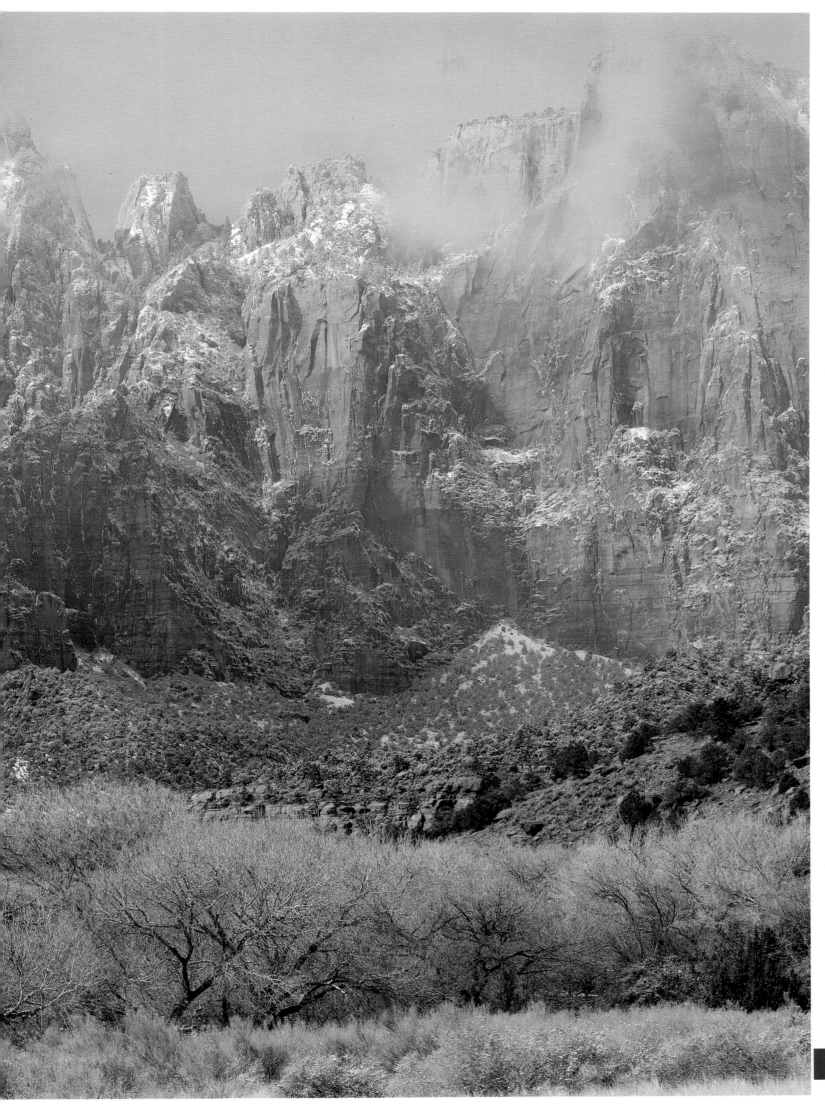

Clearing after a rare winter snowstorm, Zion National Park, Utah CHARLES GURCHE

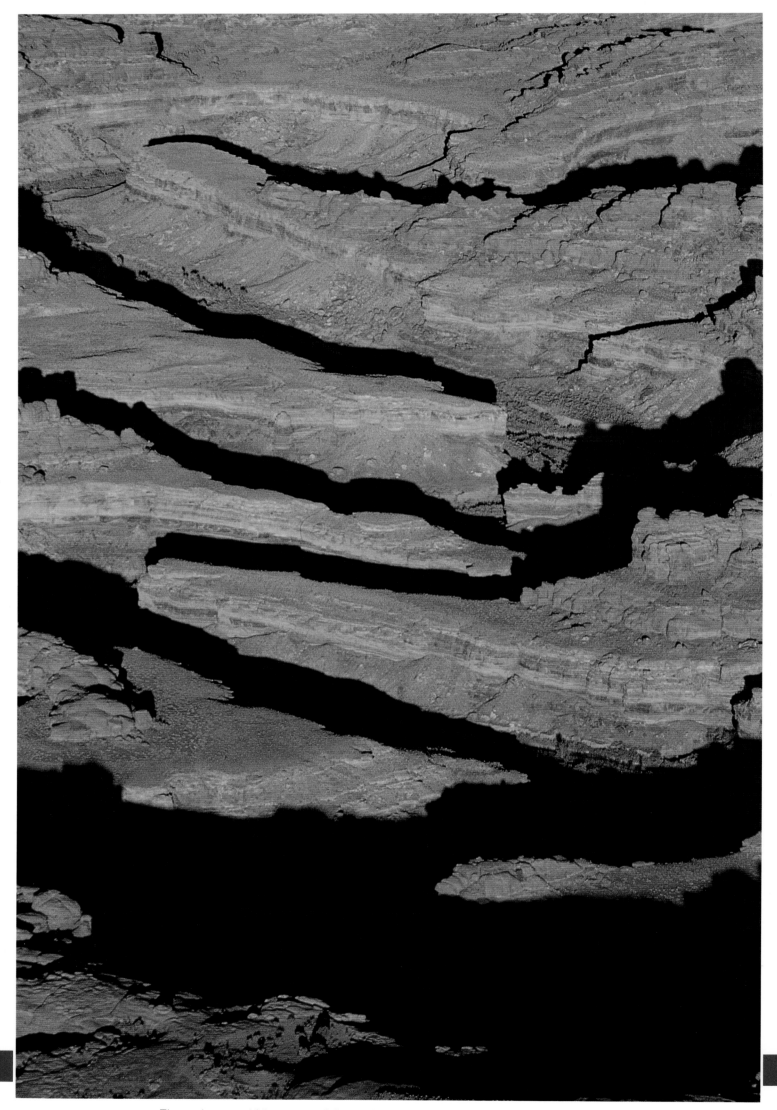

The aptly named Maze area of Canyonlands National Park, Utah BALLENGER / TULLEY

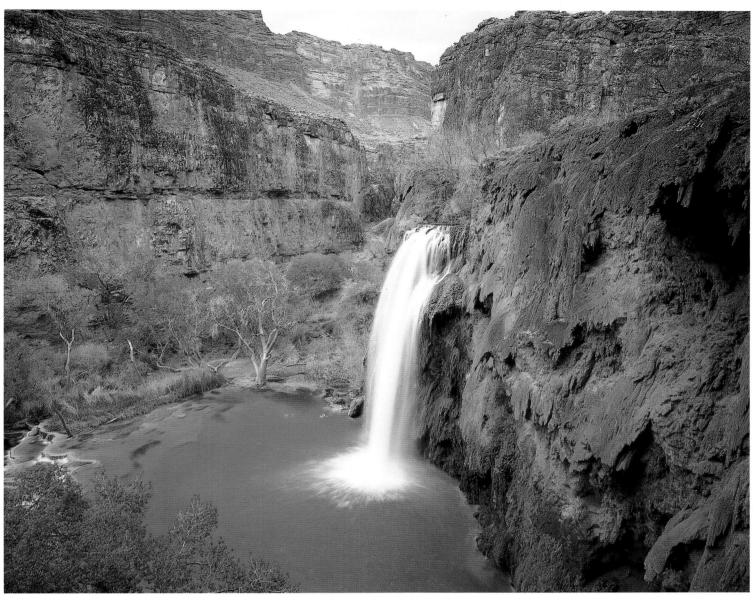

An oasis near the Grand Canyon—Havasu Falls on the Havasupai Indian Reservation, Arizona LARRY ULRICH / DRK

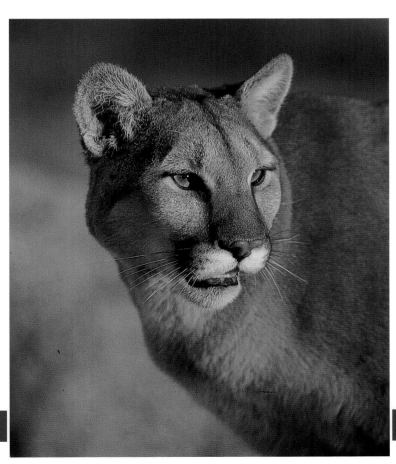

Mountain lion, New Mexico CHASE SWIFT

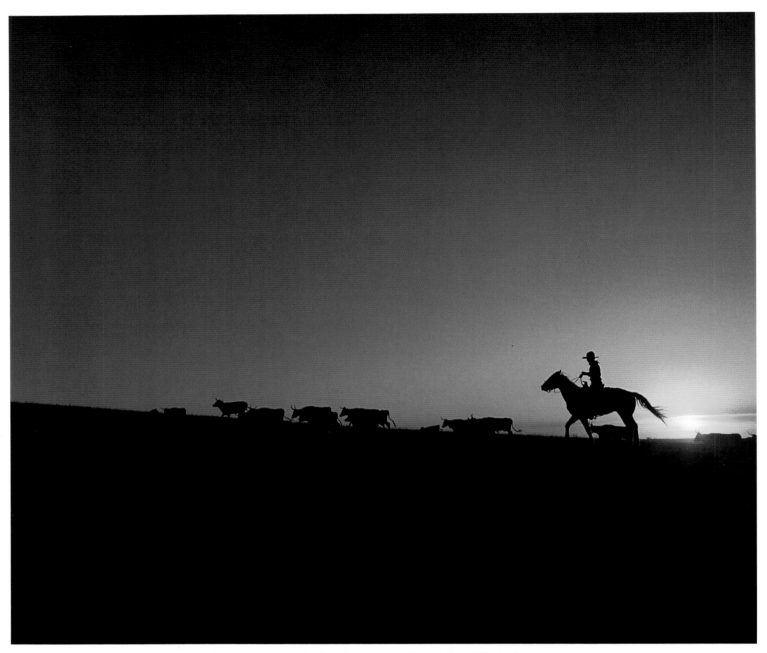

Herding longhorns at sunset in "cowboy country" near Fort Worth, Texas BUDDY MAYS

There is an easy comfort given to believers of the Western dream, knowing that cowboys are, at this very moment, galloping around somewhere, roping sick stock, and sleeping out under the stars.

Kurt Markus,
Buckaroo

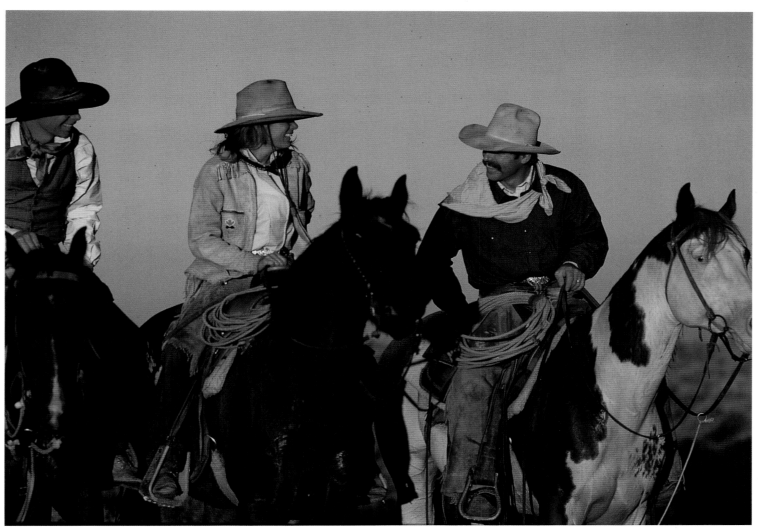

Taking a break from a wild-horse roundup near Shoshone, Idaho DAVID STOECKLEIN

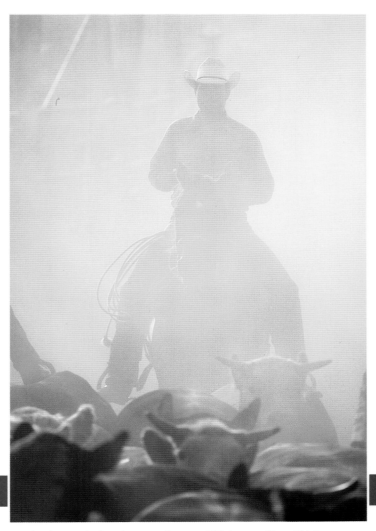

At the end of a dusty trail, near Oklahoma City, Oklahoma
RICHARD HAMILTON SMITH

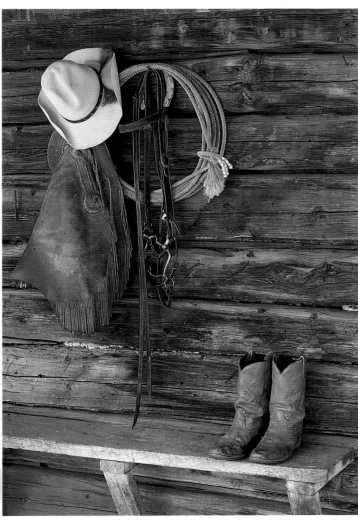

Cowboy gear ready to go at the 63 Ranch,
Livingston, Montana AIUPPY PHOTOGRAPHS

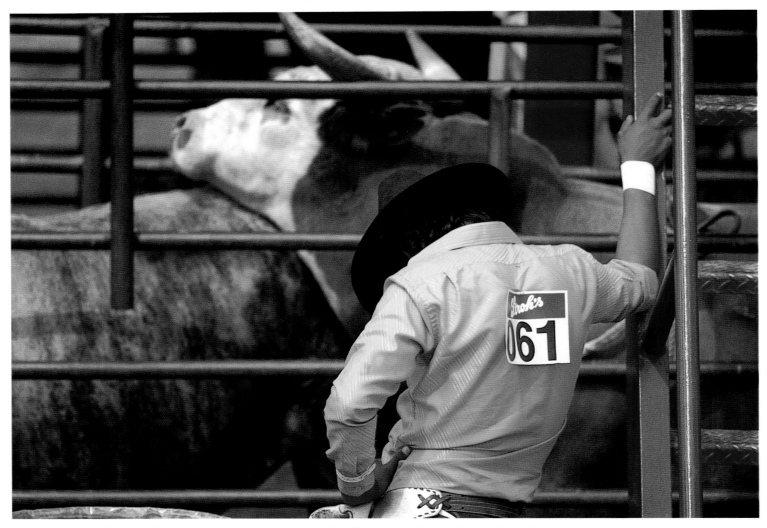

Bull rider's mental warm-up at the Intertribal Ceremonial Rodeo, Gallup, New Mexico STEPHEN TRIMBLE

" *You're down in the chute, your hands are all sweaty.*
Warm up your rope, everything is ready.
Tighten your hat,
Scoot up real slow,
And with a nod of your head, you're rearing to go. **"**

Ryan Grandi, Grade 7,
Albuquerque, New Mexico.
From "Eight-Second Ride"
in the Young Writer's Contest.

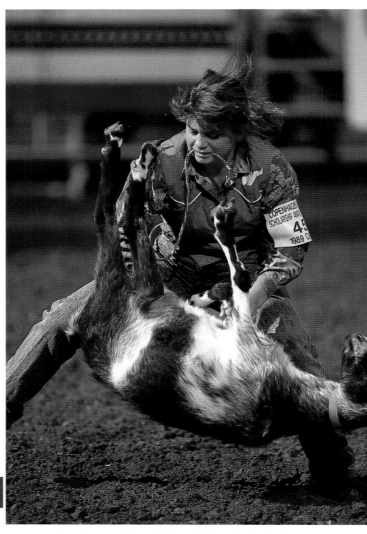

Goat-tying at the College National Finals Rodeo,
Montana State University, Bozeman, Montana WILLIAM R. SALLAZ

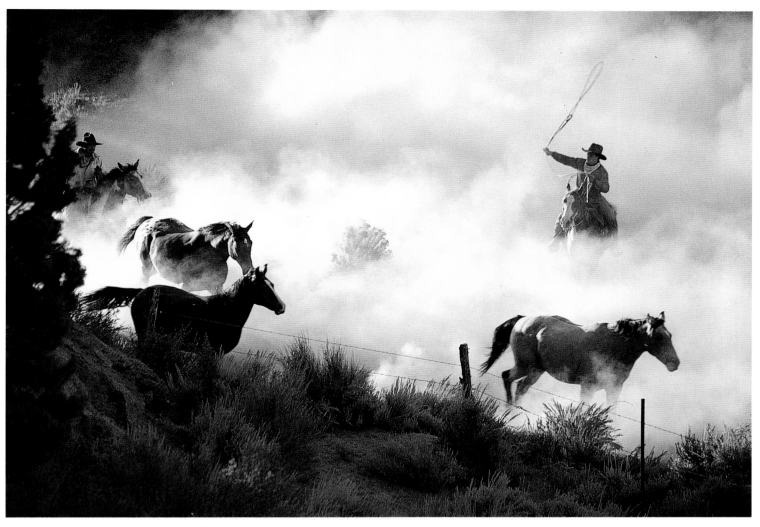

Rounding up horses near Tumalo, Oregon LAURA HOUSE / VISIONS FROM NATURE

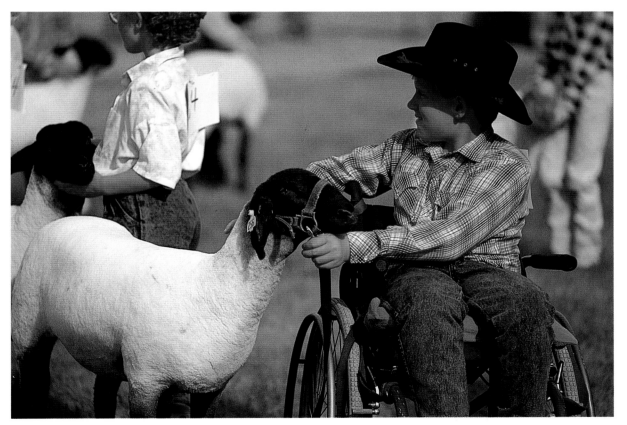

Waiting for the judges at the 4-H County Fair, Burley, Idaho BOB FIRTH / FIRTH PHOTO BANK

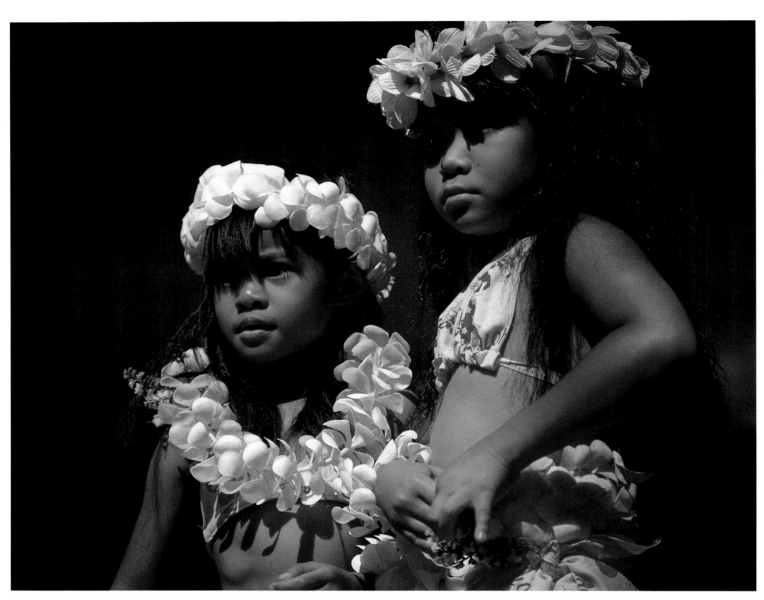

Continuing a tradition at the Ala Moana Center in Honolulu, Hawaii STEPHEN TRIMBLE

 No alien land in all the world has any deep strong charm for me but that one, no other land could so longingly and so beseechingly haunt me, sleeping and waking, through half a lifetime, as that one has done. Other things leave me, but it abides; other things change, but it remains the same. For me its balmy airs are always blowing, its summer seas flashing in the sun; the pulsing of its surfbeat is in my ear

Mark Twain,
Mark Twain's Letters from Hawaii

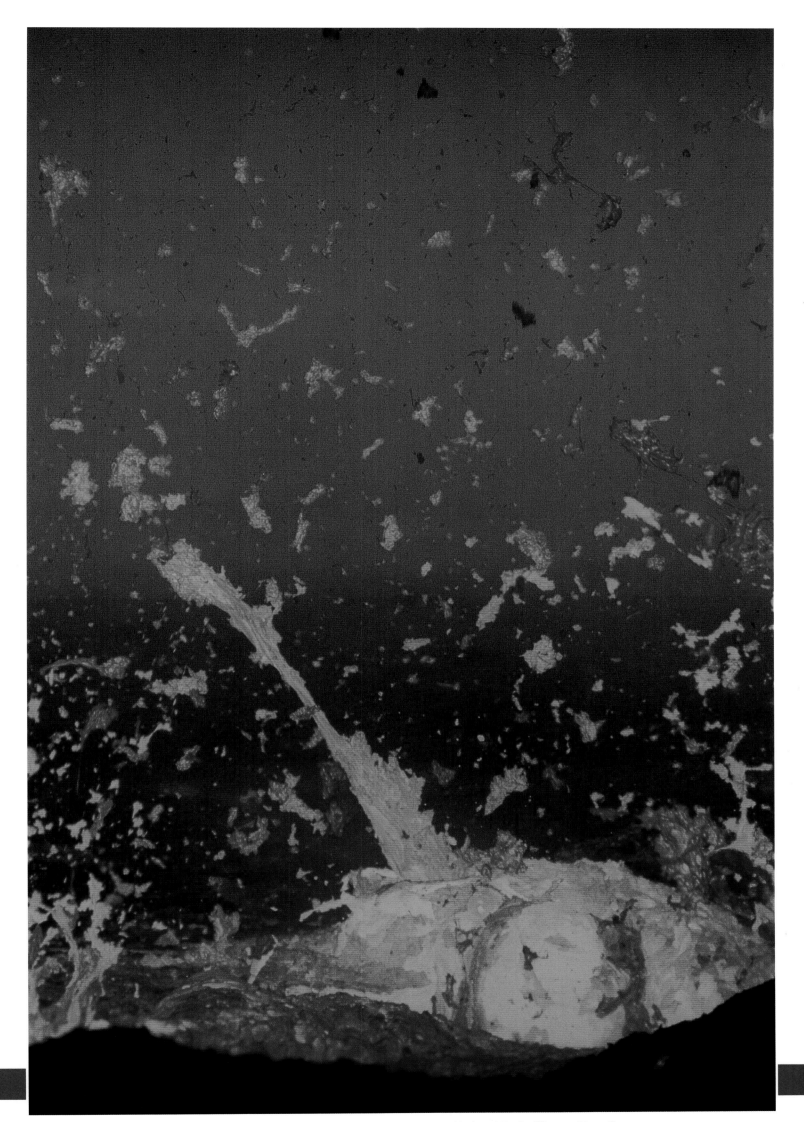

Making new land, the Pu'u 'O'o rift eruption, Hawaii Volcanoes National Park, Kilauea, Hawaii GREG VAUGHN

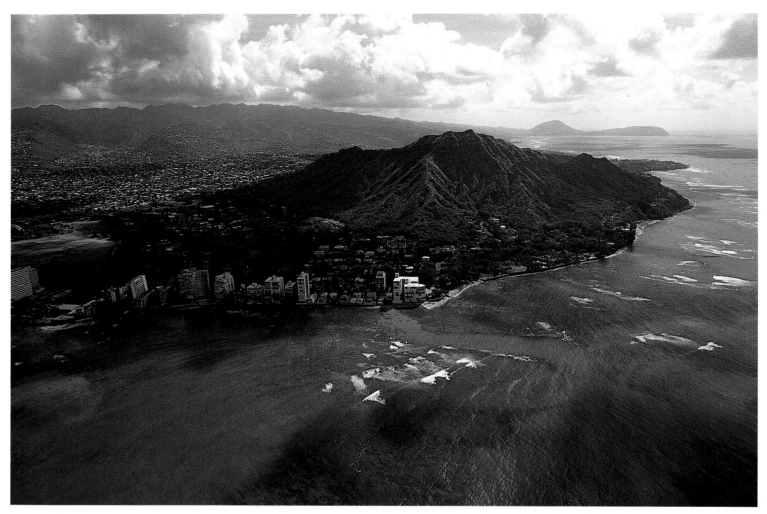

Diamond Head rising from the Pacific, Honolulu, Hawaii PETE SALOUTOS / PHOTOGRAPHIC RESOURCES

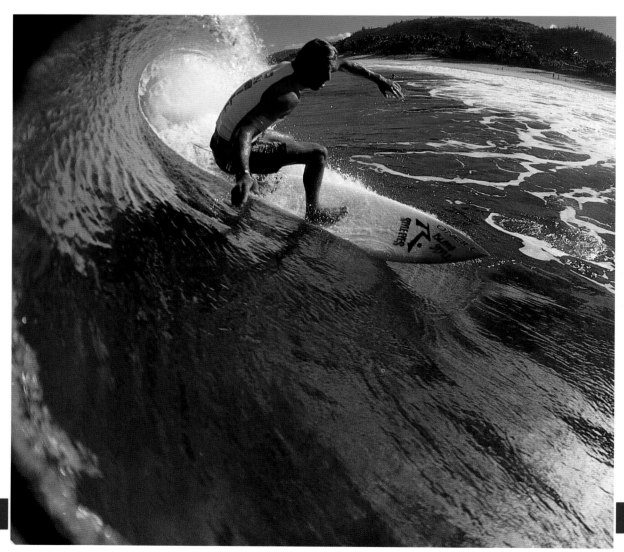

Racing the curl in Hawaii LARRY PIERCE / PHOTOGRAPHIC RESOURCES

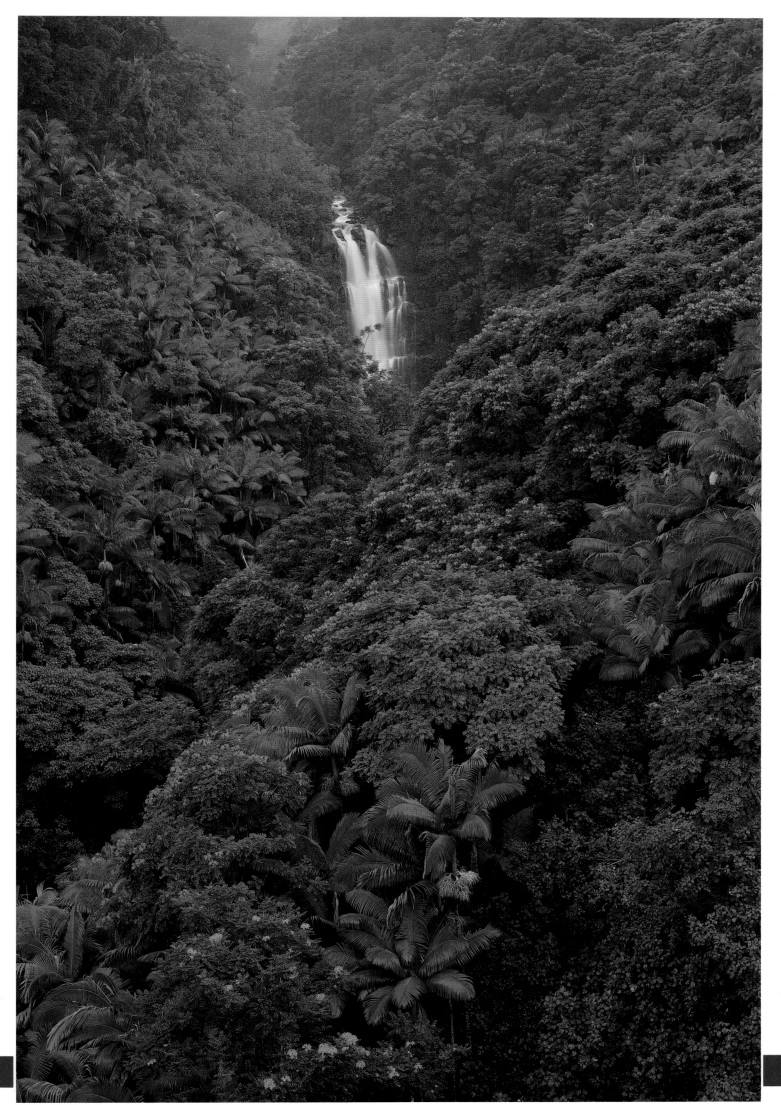

Nanue Falls with flowering tulip trees and royal palms, Hamakua Coast, Hawaii LARRY ULRICH / DRK PHOTO

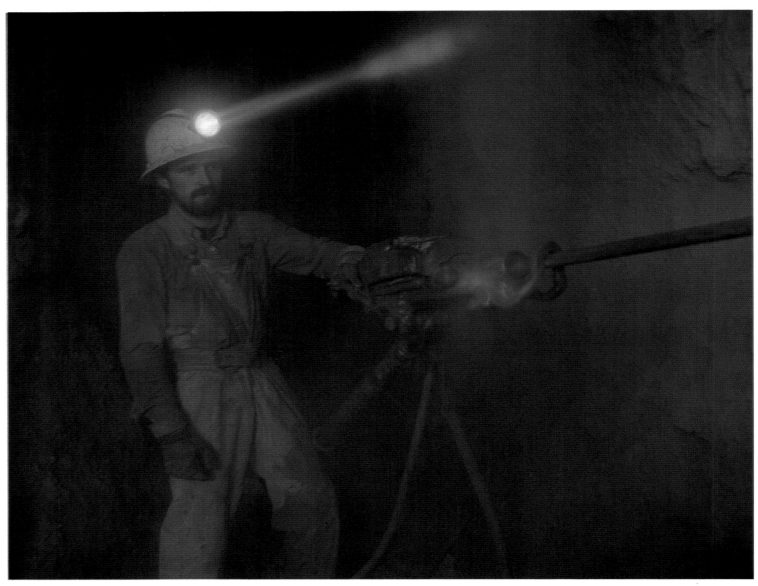

Drilling for silver near Kellogg, Idaho SCOTT SPIKER

❝ *A truly American sentiment recognizes the dignity of labor and the fact that honor lies in honest toil.* **❞**

Grover Cleveland,
letter accepting nomination for the presidency,
August 18, 1884

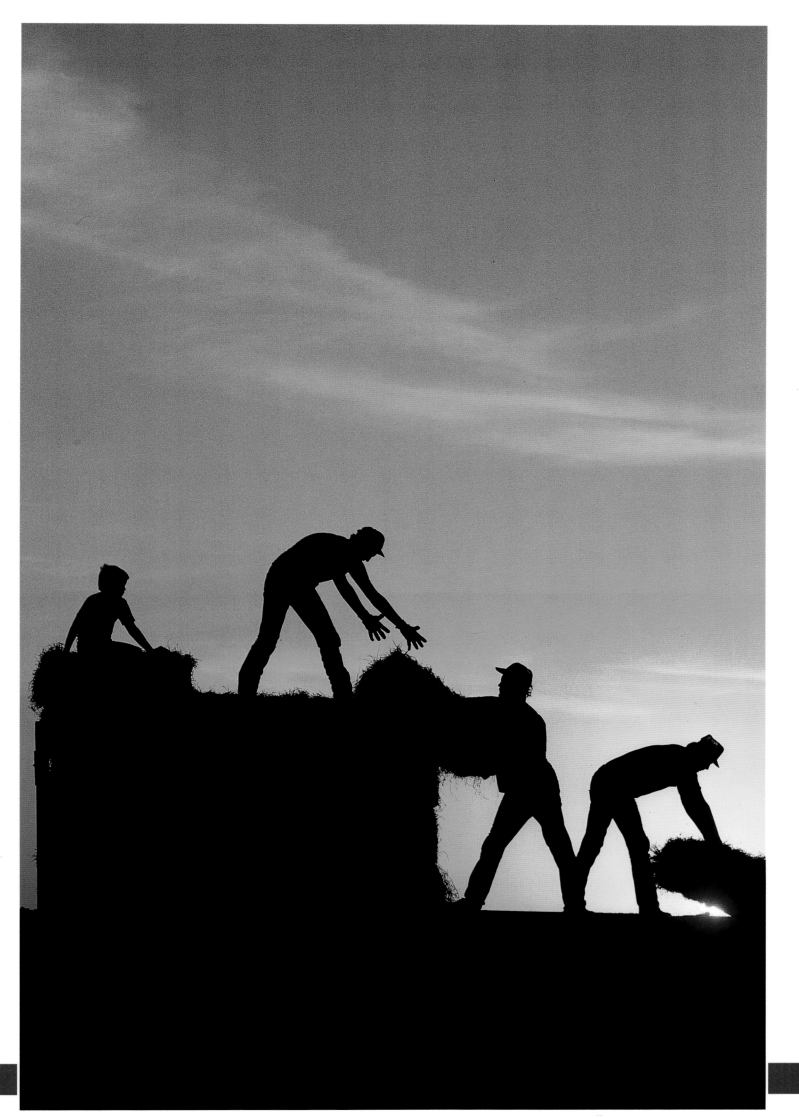

Hay-bale brigade in southern Minnesota ANNIE GRIFFITHS BELT

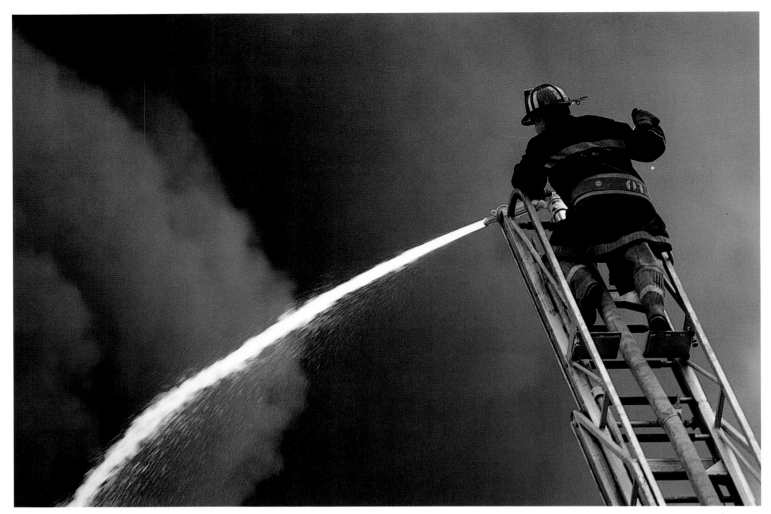

Where there's smoke there's a firefighter, St. Louis, Missouri DOUG MINER / PHOTOGRAPHIC RESOURCES

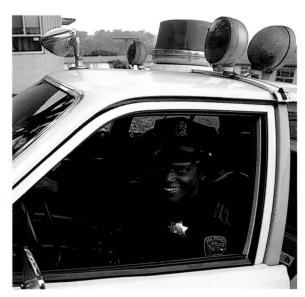

Enjoying a patrol in San Francisco, California
GALEN ROWELL

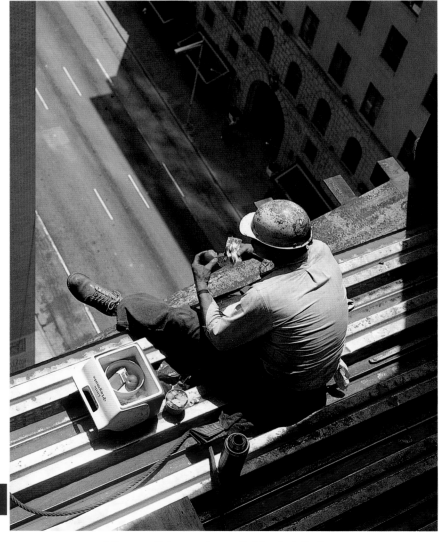

Alfresco dining on the unfinished ninth floor,
Dallas, Texas DOUG MILNER / DRK PHOTO

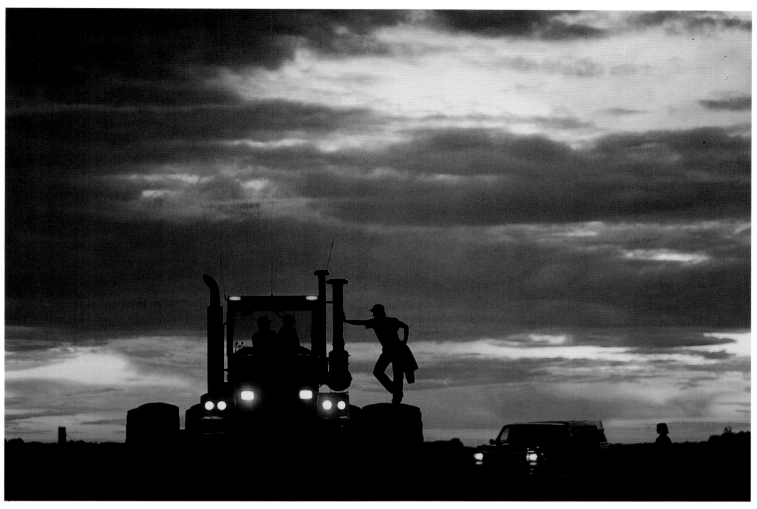

Talking over the day's work in the Red River Valley near Wahpeton, North Dakota ANNIE GRIFFITHS BELT / DRK PHOTO

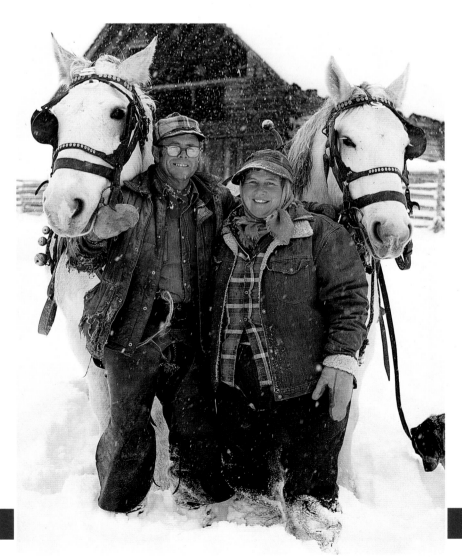

Teamwork in Steamboat Springs, Colorado
FRANK OBERLE / PHOTOGRAPHIC RESOURCES

❝ *I am inclined to think that being a success is tied up very closely with being one's own kind of individual.* **❞**

Eleanor Roosevelt,
You Learn by Living

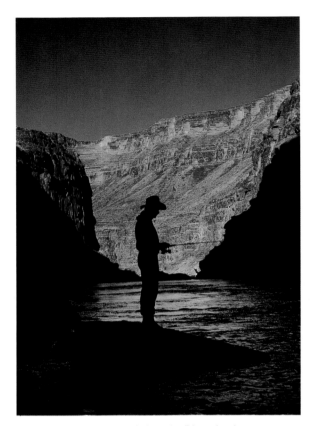

Fishing the Colorado River in the
Grand Canyon, Arizona RON SANFORD

66 *America is rather like life.
You can usually find in it what
you look for.... It will probably
be interesting, and it is sure to be
large.* **99**

E. M. Forster,
"The United States,"
in Two Cheers for Democracy

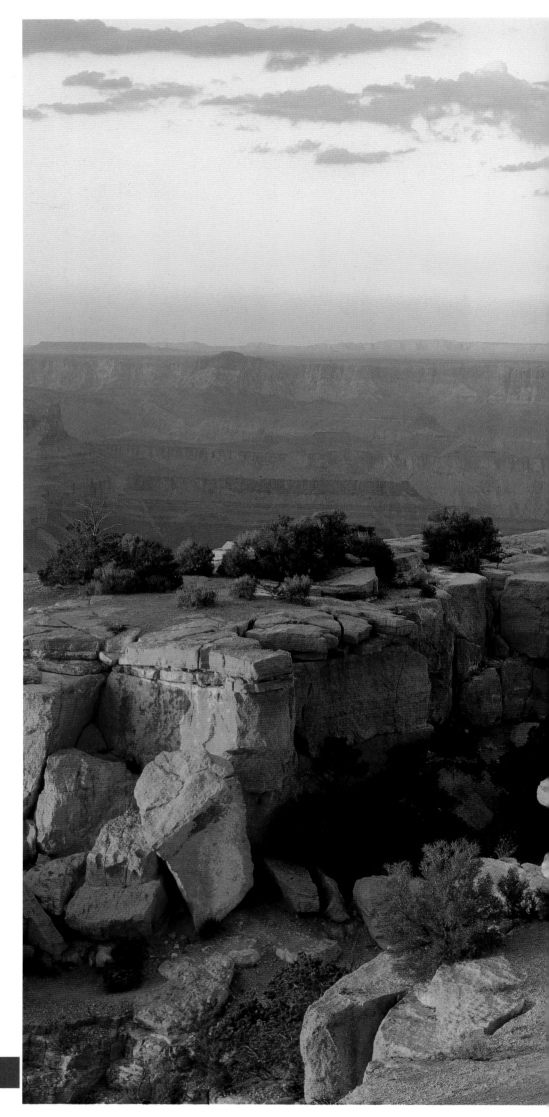

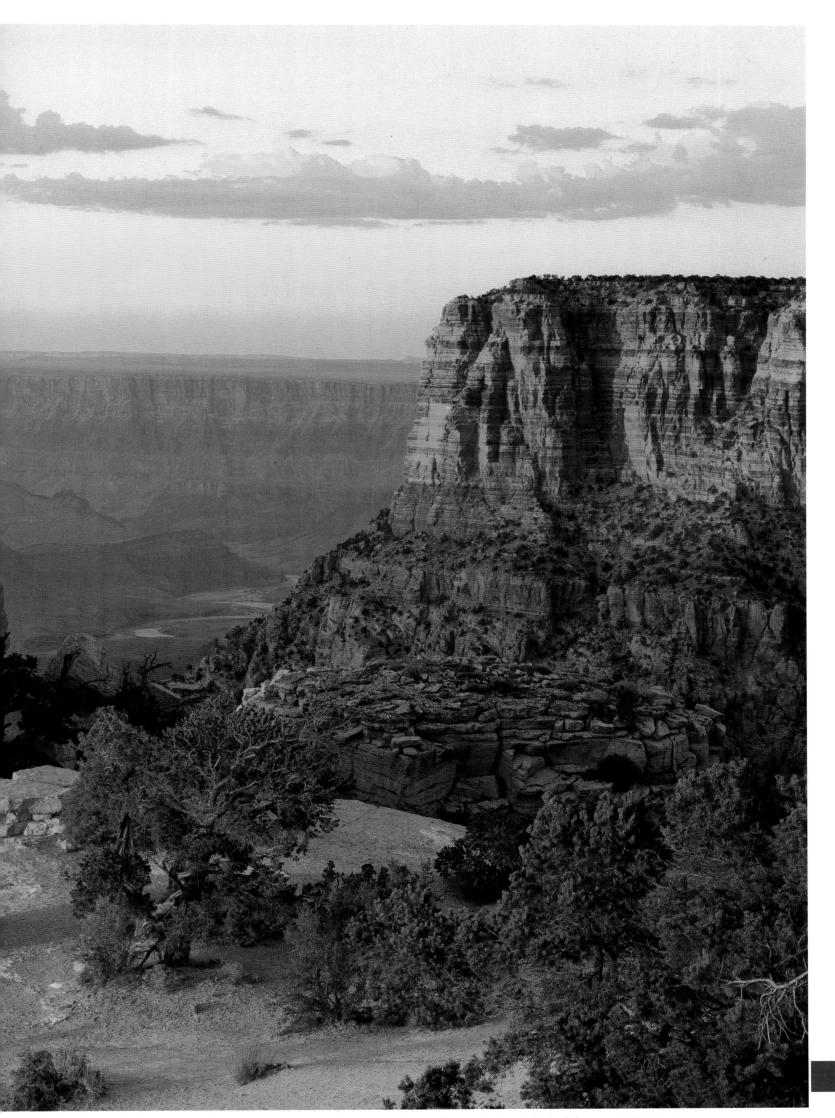

Evening light on the Grand Canyon from the South Rim, Grand Canyon National Park, Arizona MARK MILLER

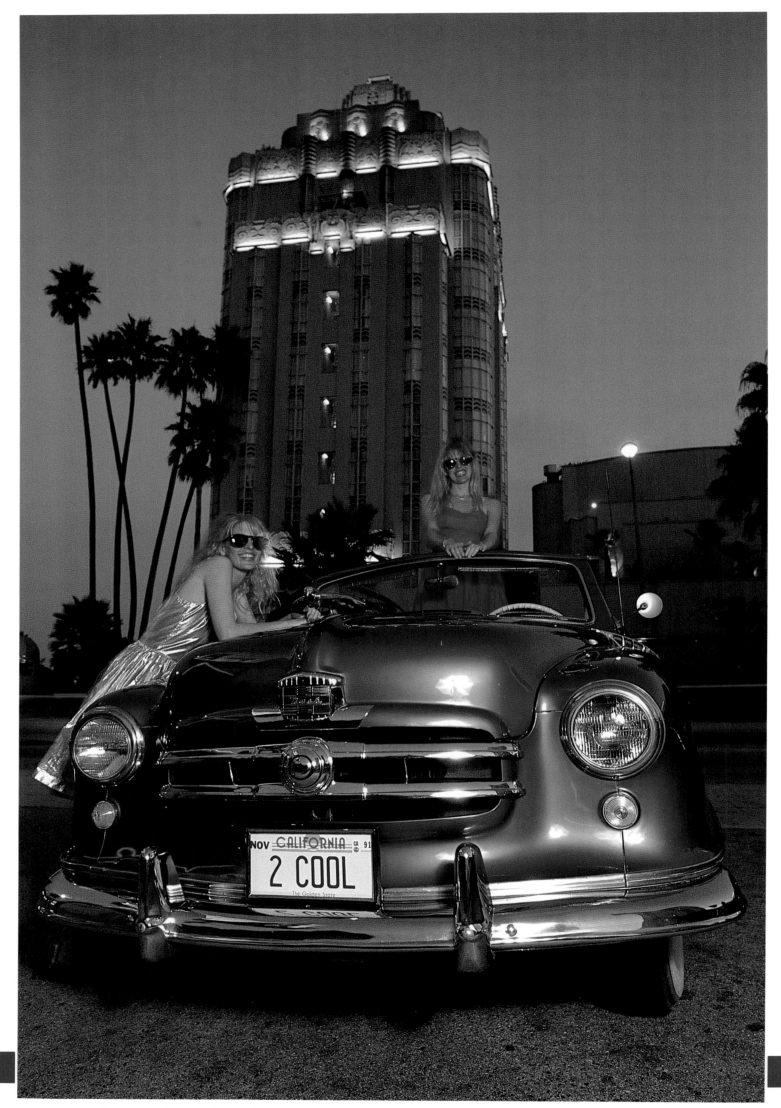

Too cool in front of the St. James Club on Sunset Boulevard, Los Angeles, California CATHERINE KARNOW

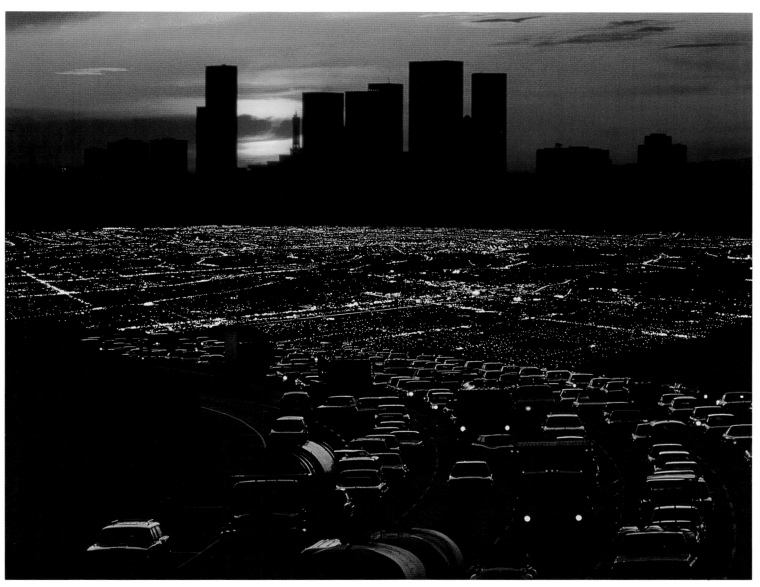

Evening migration out of Los Angeles, California PETE SALOUTOS / PHOTOGRAPHIC RESOURCES

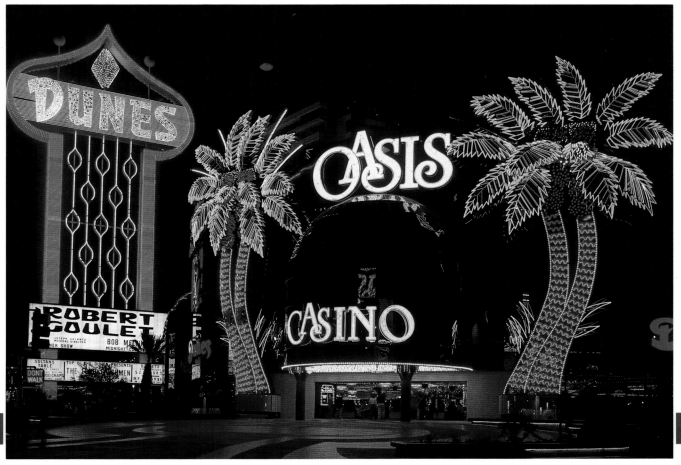

Neon oasis in the desert, Las Vegas, Nevada JOHN ELK III

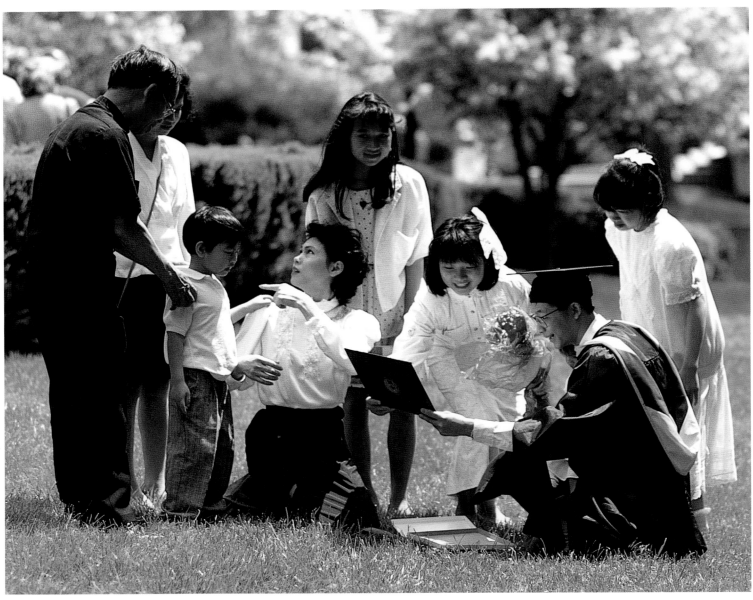

Vietnamese family celebrating graduation at Tufts University, Medford, Massachusetts FRANK SITEMAN / NE STOCK PHOTO

66 *Education is our passport to the future, for tomorrow belongs to the people who prepare for it today.* **99**

Malcolm X,
Jet

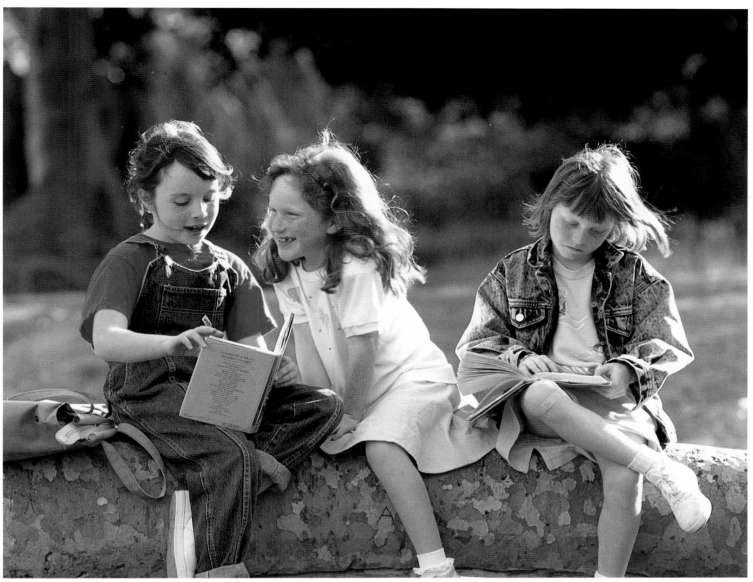

Sharing the joys of reading, Los Angeles, California CATHERINE KARNOW

A formula for the future, Edgewater High School in Orlando, Florida
BILL BACHMANN / NE STOCK PHOTO

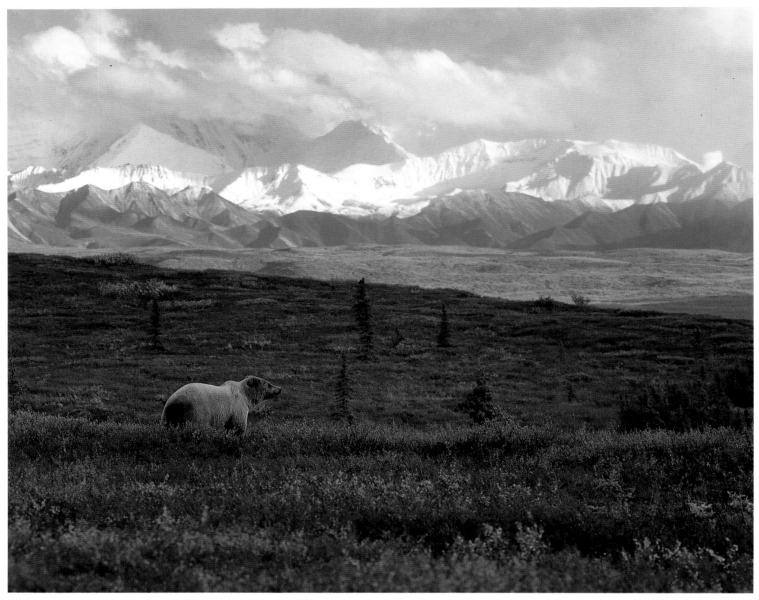

Symbol of the last frontier, a grizzly bear patrolling the Alaskan tundra, Denali National Park KIM HEACOX

" We are a people born to the frontier. It has been a part of our thinking, waking, and sleeping since men first landed on this continent. The frontier is the line that separates the known from the unknown wherever it may be, and we have a driving need to see what lies beyond. It was this that brought people to America. "

Louis L'Amour,
Frontier

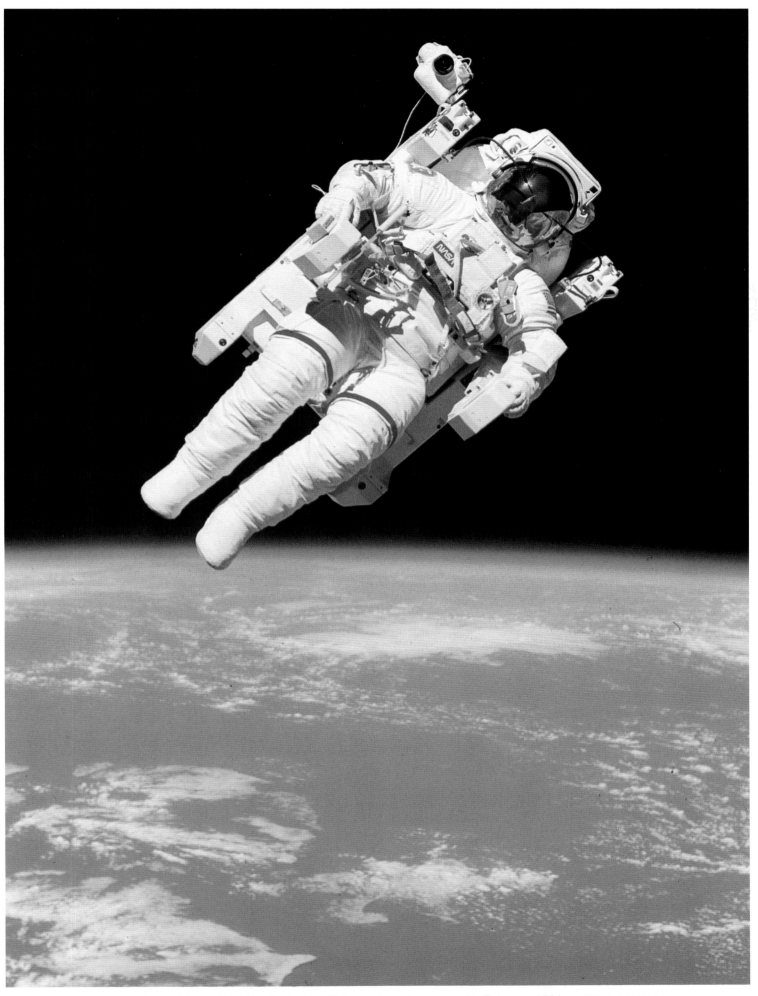

Astronaut Bruce McCandless II enjoying the first untethered space walk, February 1984 COURTESY OF NASA

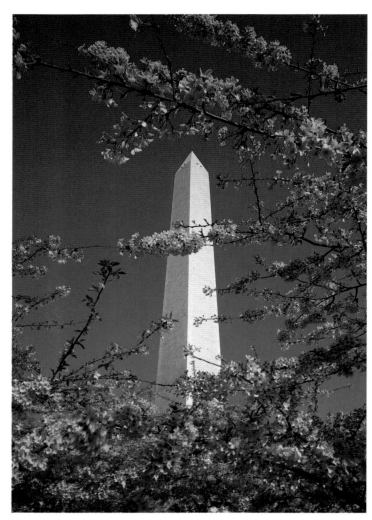

Washington Monument framed by cherry blossoms,
Washington, D.C. SCOTT T. SMITH

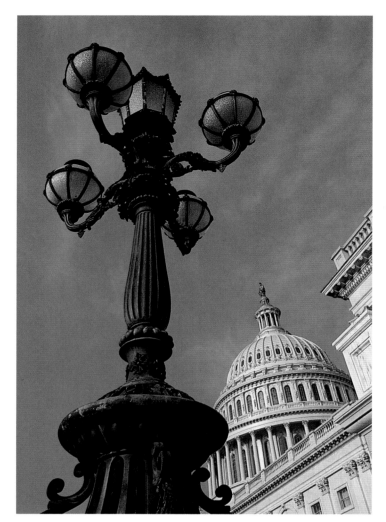

The Capitol dome and streetlamp, Washington, D.C.
CATHERINE KARNOW

" I believe that out of the whole body of our past, out of our differences, our quarrels, our many interests and directions, something has emerged that is itself unique in the world: America—complicated, paradoxical, bullheaded, shy, cruel, boisterous, unspeakably dear, and very beautiful. "

John Steinbeck,
America and Americans

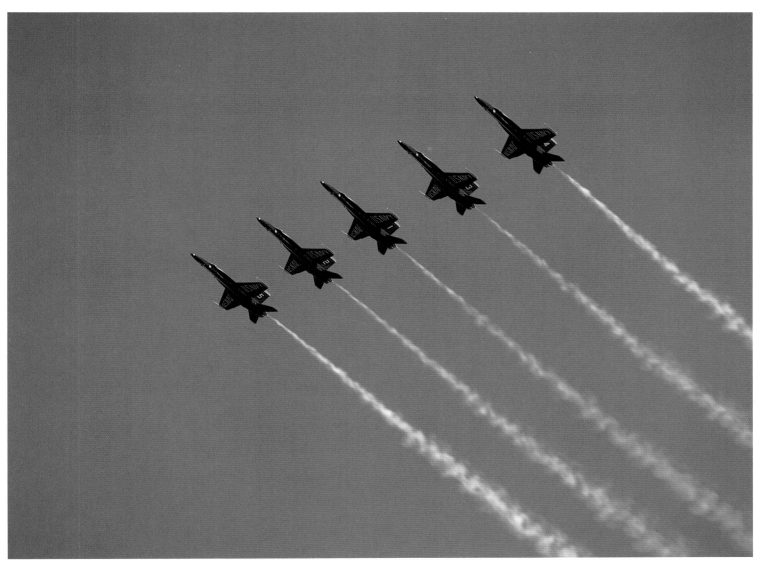

The U.S. Navy's Blue Angels in formation above the Patuxent River Naval Air Station, Maryland THOMAS R. FLETCHER

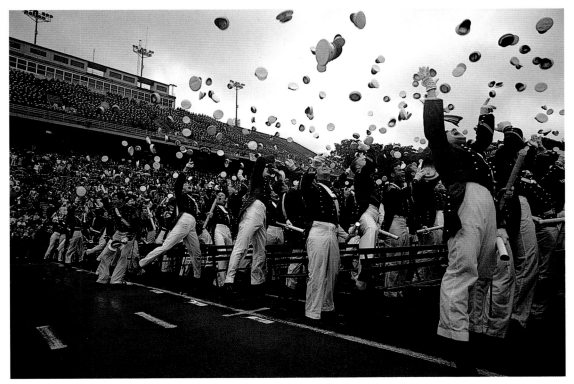

Celebrating graduation at the U.S. Military Academy, West Point, New York BILL FOLEY / STOCK SOUTH

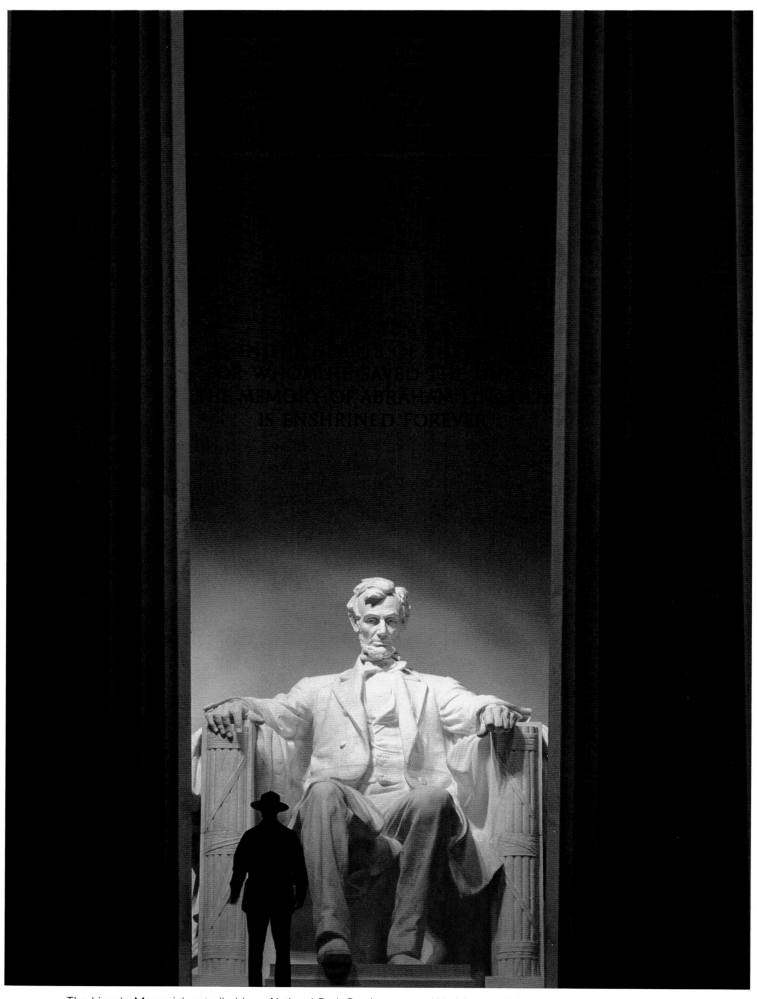

The Lincoln Memorial, patrolled by a National Park Service ranger, Washington, D.C. STEPHEN TRIMBLE / DRK PHOTO

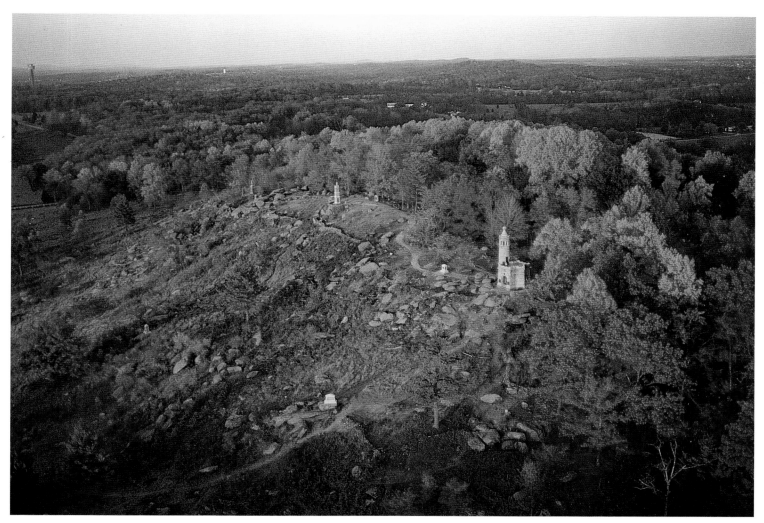

Little Round Top, where Union forces turned back Confederates in the Battle of Gettysburg, Pennsylvania SAM ABELL

Remembering the past in Tupelo, Mississippi JACK OLSON

“ *It is rather for us to be here dedicated to the great task remaining before us—that from these honored dead we take increased devotion to that cause for which they here gave the last full measure of devotion—that we here highly resolve that these dead shall not have died in vain—that this nation, under God, shall have a new birth of freedom—and that government of the people, by the people, for the people, shall not perish from the earth.* ”

Abraham Lincoln,
address at Gettysburg
November 19, 1863

The First Amendment at work in Washington, D.C. DAVID LORENZ WINSTON

> *Congress shall make no law respecting an establishment of religion, or prohibiting the free exercise thereof; or abridging the freedom of speech, or of the press; or the right of the people peaceably to assemble, and to petition the Government for a redress of grievances.*

First Amendment,
Constitution of the United States

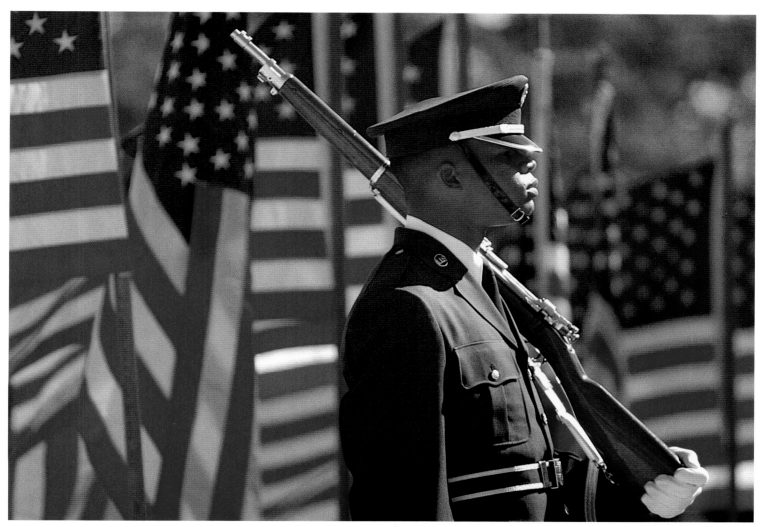

Flag ceremony at Carswell Air Force Base, Fort Worth, Texas DOUG MILNER / DRK PHOTO

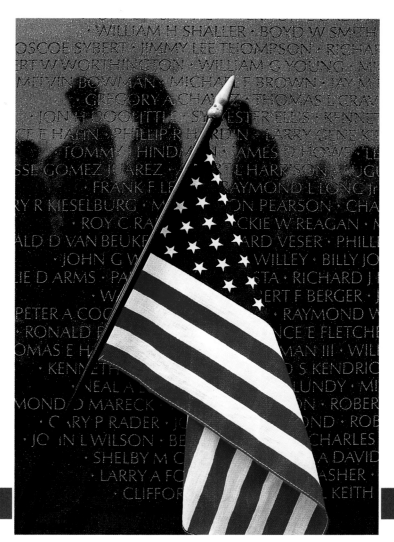

Vietnam Veterans Memorial, Washington, D.C. KIM HEACOX

" *The thing I like best about life today*
Is that I can say what I want to say.
Freedom is what I'm talking about.
I have freedom to yell and freedom to
 shout.
I have freedom of speech, I have
 freedom of choice.
I don't have to listen to a king raise his
 voice.
There's lots of freedom everywhere.
There's enough freedom for everyone to
 share. "

Justin Hatch, Grade 3,
Logandale, Nevada.
From ''Life in America''
in the Young Writer's Contest.

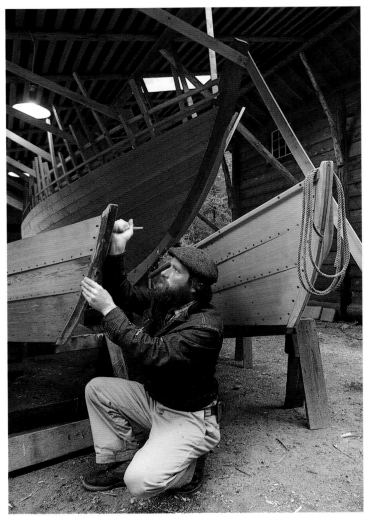

Traditional boat building, San Juan Islands, Washington
FRANS LANTING / MINDEN PICTURES

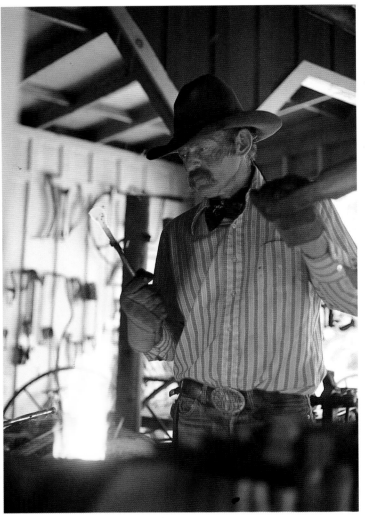

Between the forge and the anvil near Fiddletown, California
TOM MYERS

" To the laborer in the sweat of his labor, the raw stuff on his anvil is an adversary to be conquered. . . . But to the laborer in repose, able for the moment to cast a philosophical eye on his world, that same raw stuff is something to be loved and cherished, because it gives definition and meaning to his life. "

Aldo Leopold,
A Sand County Almanac

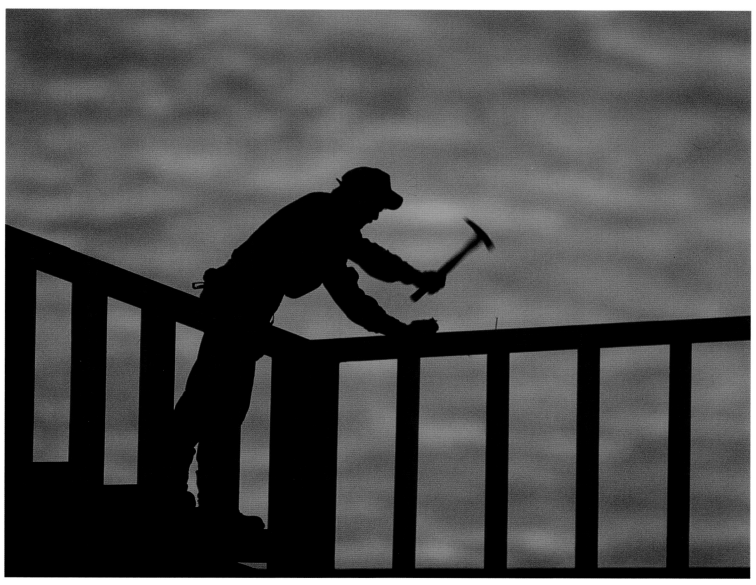

Last nail of the day at the University of Idaho, Moscow, Idaho SCOTT SPIKER

Weaving form and function in a Navajo rug, Santa Fe, New Mexico STEPHEN TRIMBLE

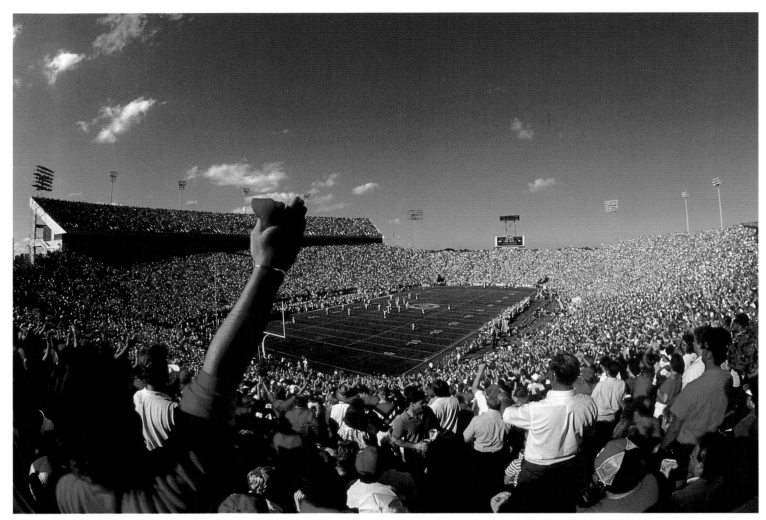

Cheering the Georgia-Florida game at the Gator Bowl, Jacksonville, Florida GORDON JOFFRION / STOCK SOUTH

" *They say football is America's greatest game, but it's not. The greatest game in America is called opportunity. Football is merely a great expression of it.* **"**

Joe Kapp,
quoted by James Lawton
in The All American War Game

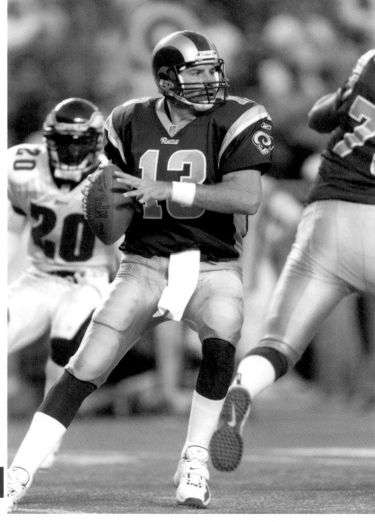

Always looking for opportunities, Kurt Warner of the St. Louis Rams
ELIOT SCHECHTER / ALLSPORT

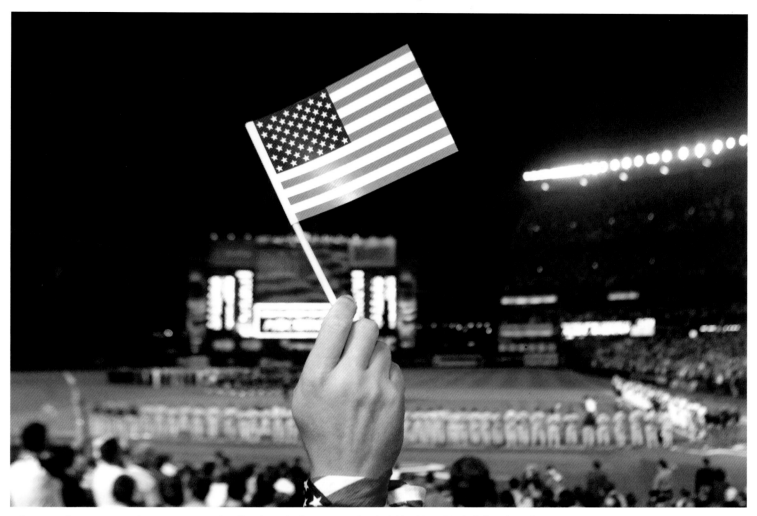

Shea Stadium, September 21, 2001, the first baseball game to be held in New York following the September 11 terrorist attacks on the World Trade Center MIKE SEGAR / REUTERS

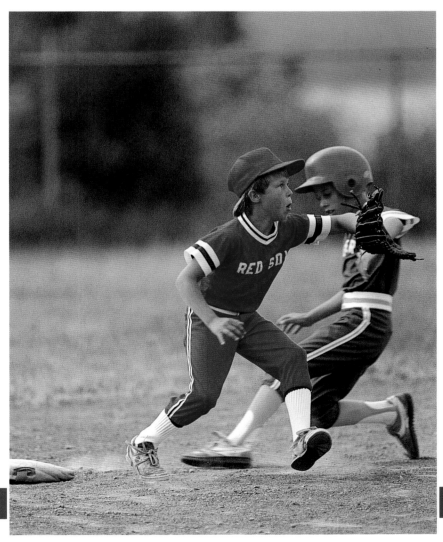

Learning baseball in L'Anse, Michigan DON & PAT VALENTI / DRK PHOTO

" *Whoever wants to know the heart and mind of America had better learn baseball.* *"*

Jacques Barzun,
God's Country and Mine

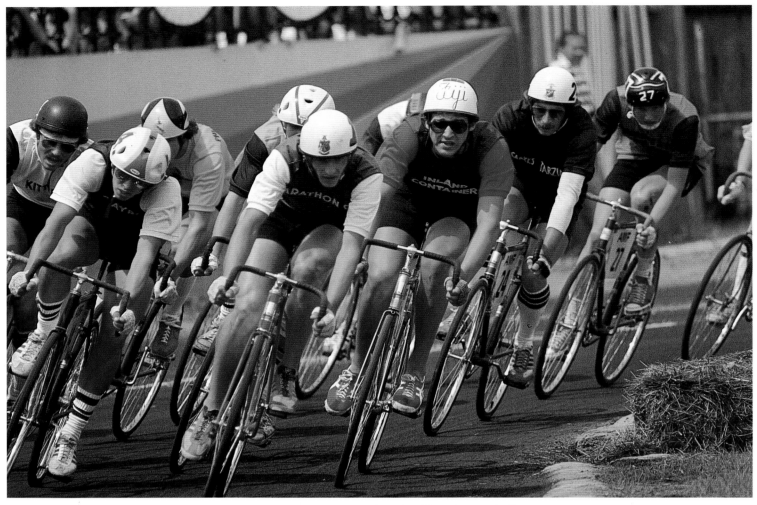

Breaking away at the Little 500 Bicycle Race, Indiana University, Bloomington, Indiana DAVID PERDEW / STOCK SOUTH

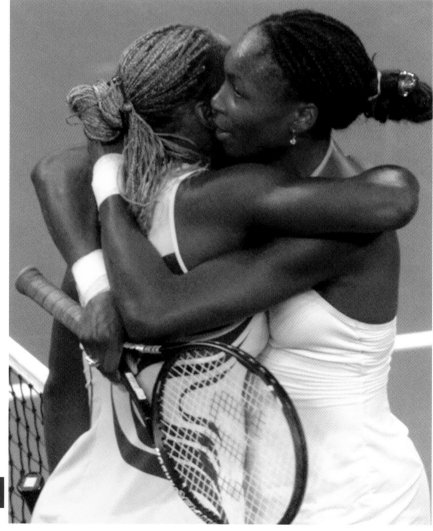

Venus Williams embracing her sister Serena Williams after she won
the women's final at the U.S. Open Tennis Championship, New York,
September 8, 2001 GARY HERSHORN / REUTERS

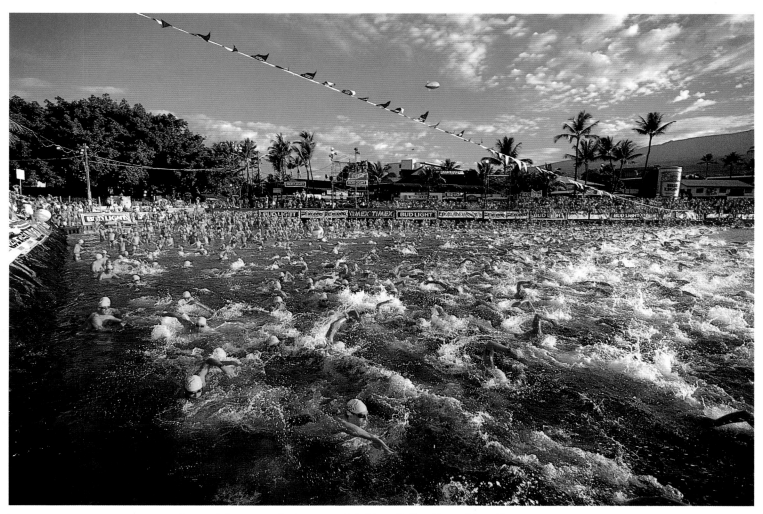

Start of the 140-mile Ironman Triathlon, Kailua-Kona, Hawaii GREG VAUGHN

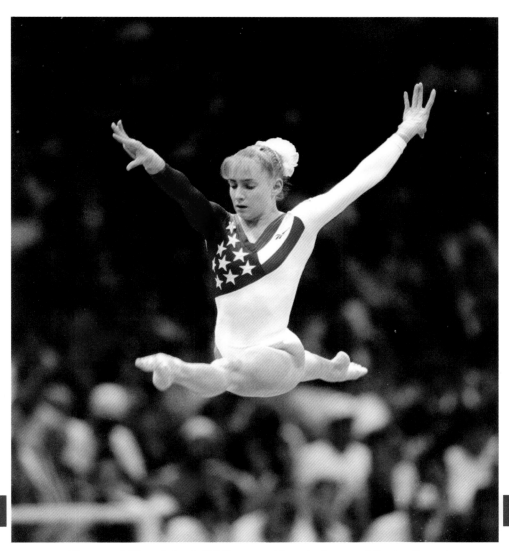

Shannon Miller at the 1996 Summer Olympic Games, Atlanta, Georgia
MIKE POWELL / ALLSPORT

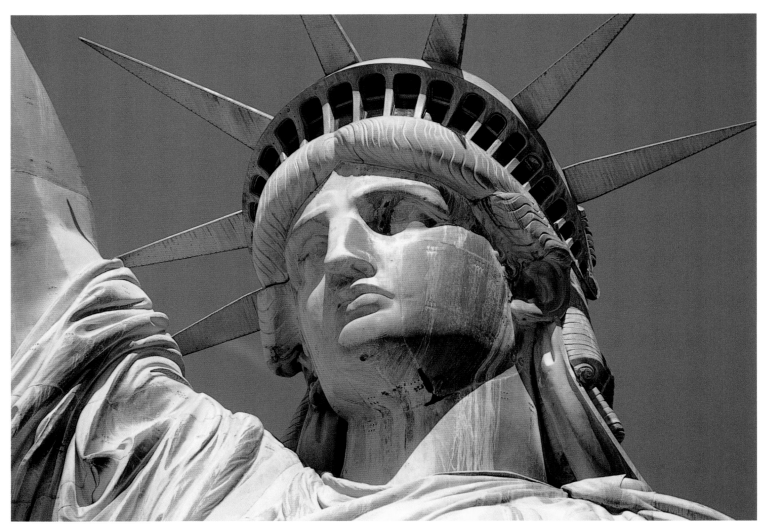

Portrait of the Mother of Exiles PETE SALOUTOS / PHOTOGRAPHIC RESOURCES

" Here at our sea-washed, sunset gates shall stand
A mighty woman with a torch, whose flame
Is the imprisoned lightning, and her name
Mother of exiles. "

Emma Lazarus,
The New Colossus

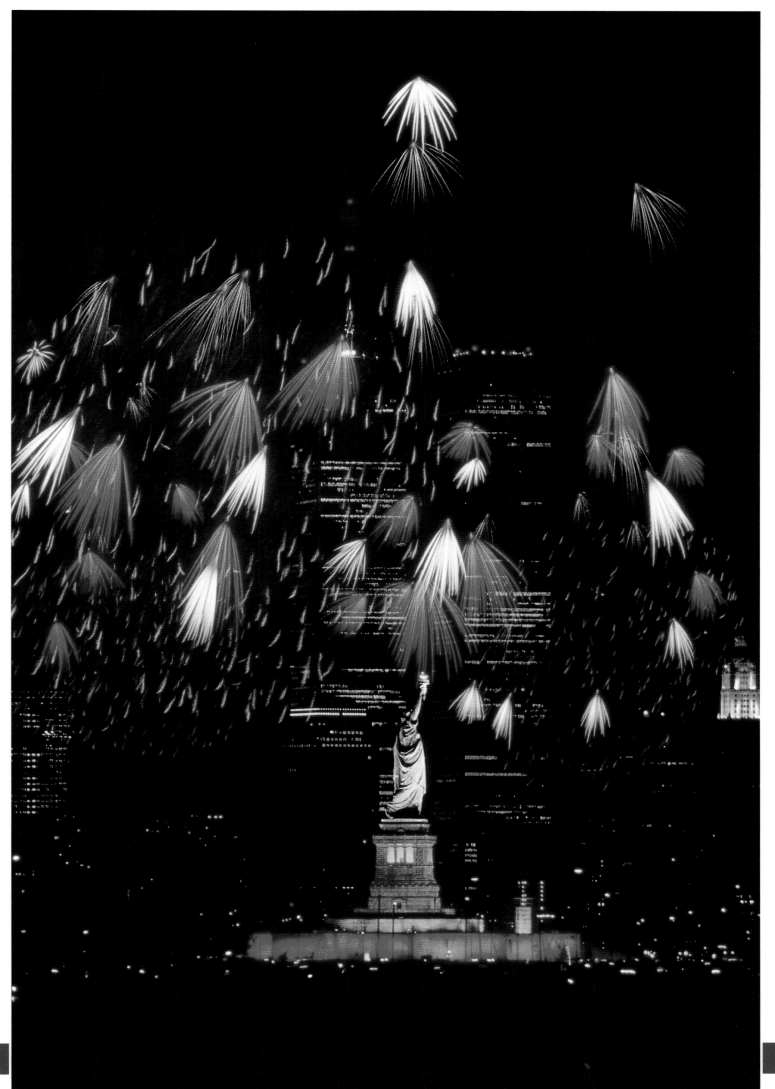

Celebrating the Fourth of July, 1986, after the restoration of the Statue of Liberty BILL FOLEY / STOCK SOUTH

A blizzard of snow geese above the Delaware River estuary between Delaware and New Jersey ROBERT PERRON

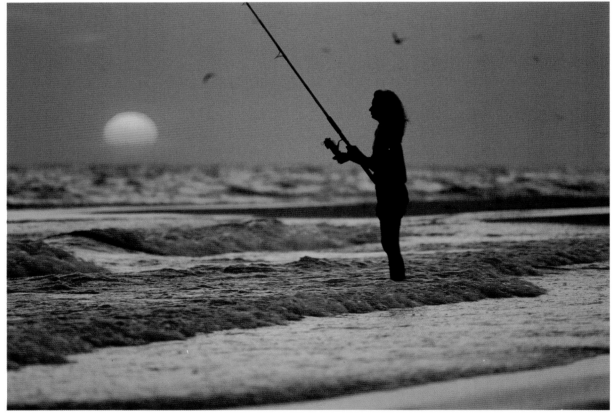

Surf fishing on Cape Cod, Massachusetts ANNIE GRIFFITHS BELT / DRK PHOTO

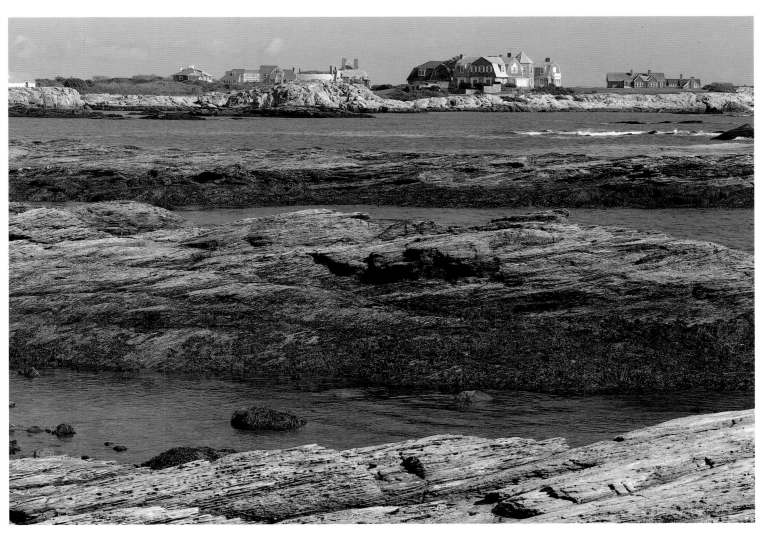

Edge of the Atlantic at Lands End near Newport, Rhode Island DAVID MUENCH

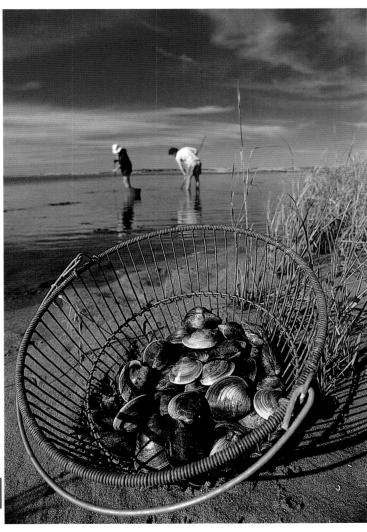

Collecting quahogs, the main ingredient for clam chowder,
on Nantucket Island, Massachusetts CATHERINE KARNOW

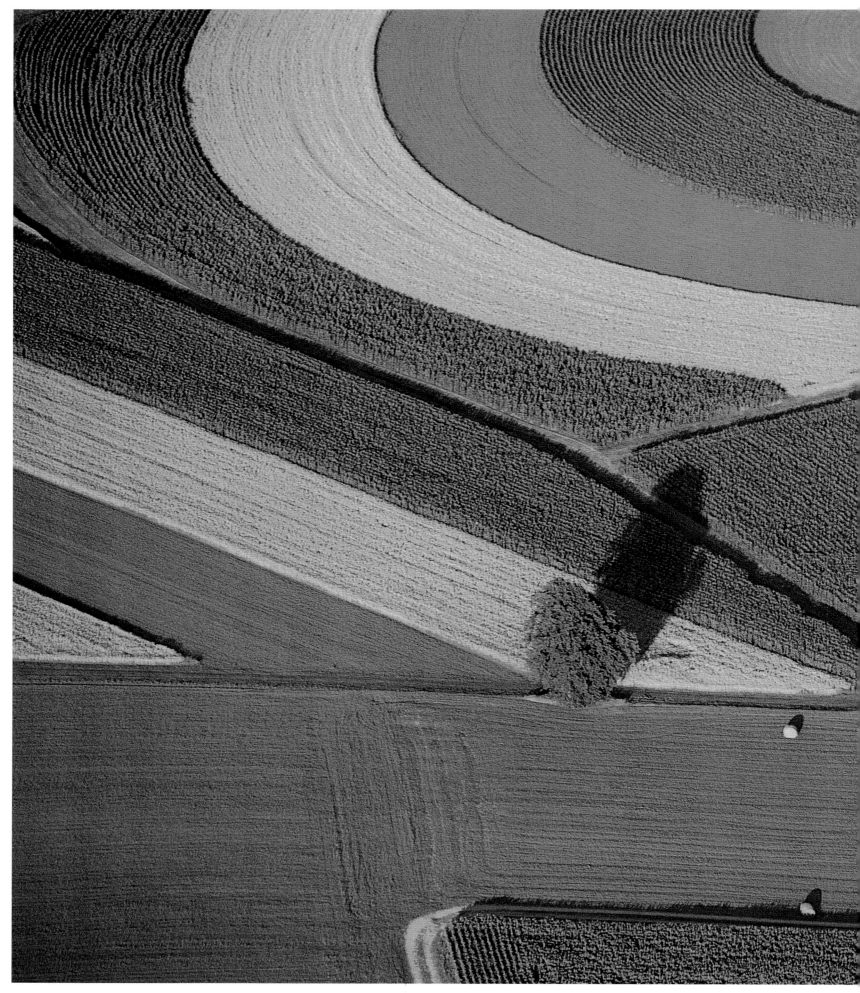

Fertile contours of corn, oats, and alfalfa in southeast Minnesota RICHARD HAMILTON SMITH

Man-sized soybeans, giant-sized corn near St. Charles,
Missouri FRANK OBERLE / PHOTOGRAPHIC RESOURCES

 “ *The windy springs and
the blazing summers, one after
another, had enriched and
mellowed that flat tableland; all
the human effort that had gone
into it was coming back in long,
sweeping lines of fertility. The
changes seemed beautiful and
harmonious to me; it was like
watching the growth . . . of a
great idea.* **”**

Willa Cather,
My Antonia

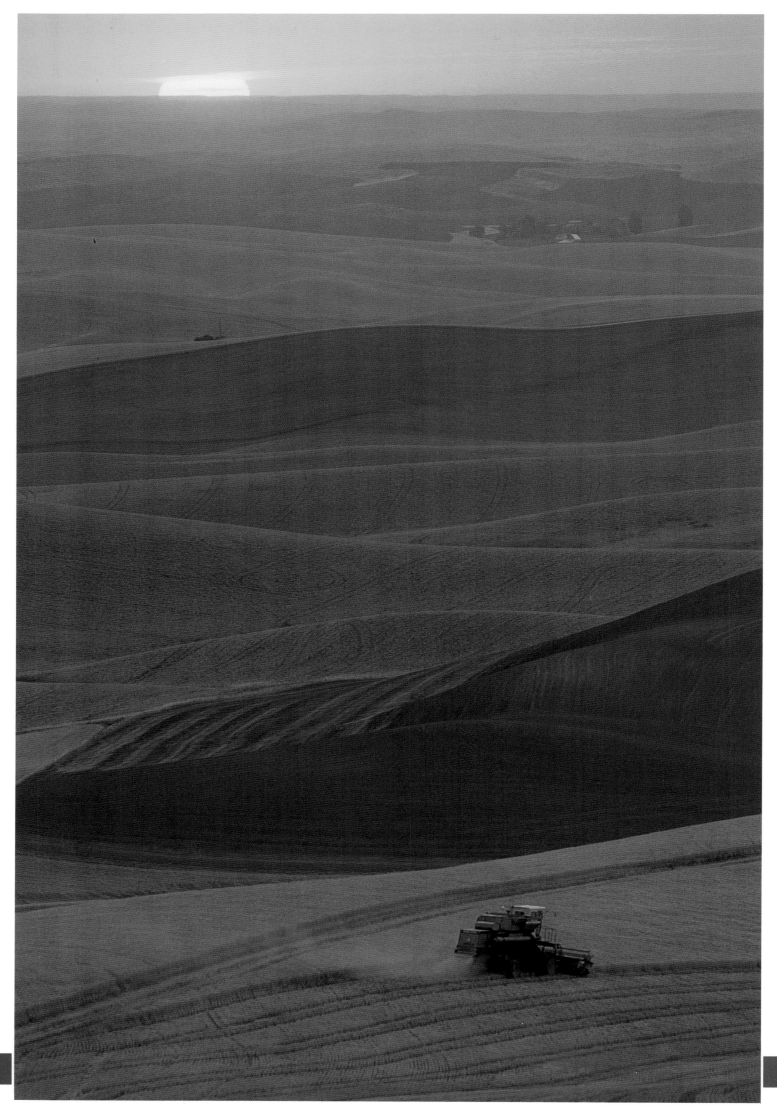

Harvesting wheat on the rolling hills of the Palouse area in eastern Washington SCOTT SPIKER

Alternating rows of sunflowers and wheat in west-central North Dakota ANNIE GRIFFITHS BELT

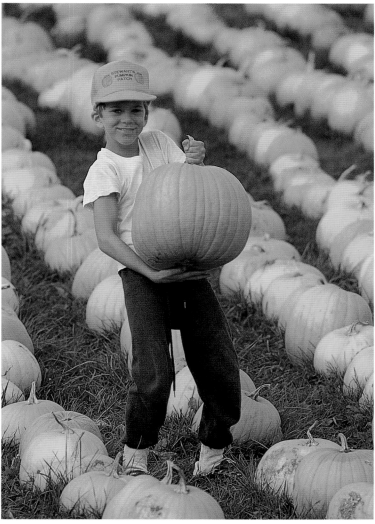

A meeting of minds in the South Dakota badlands
ANNIE GRIFFITHS BELT

Pick of the pumpkins, Presque Isle, Maine DOUGLAS MERRIAM

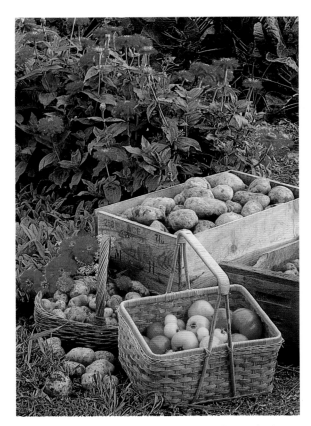

Food for the body, feast for the eye, Decorah, Iowa
DAVID CAVAGNARO / DRK PHOTO

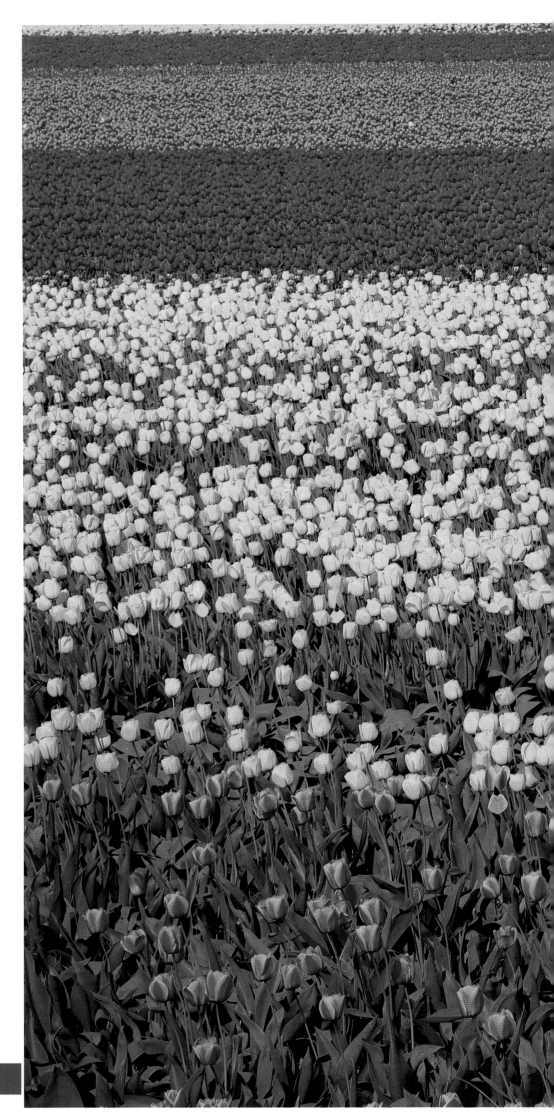

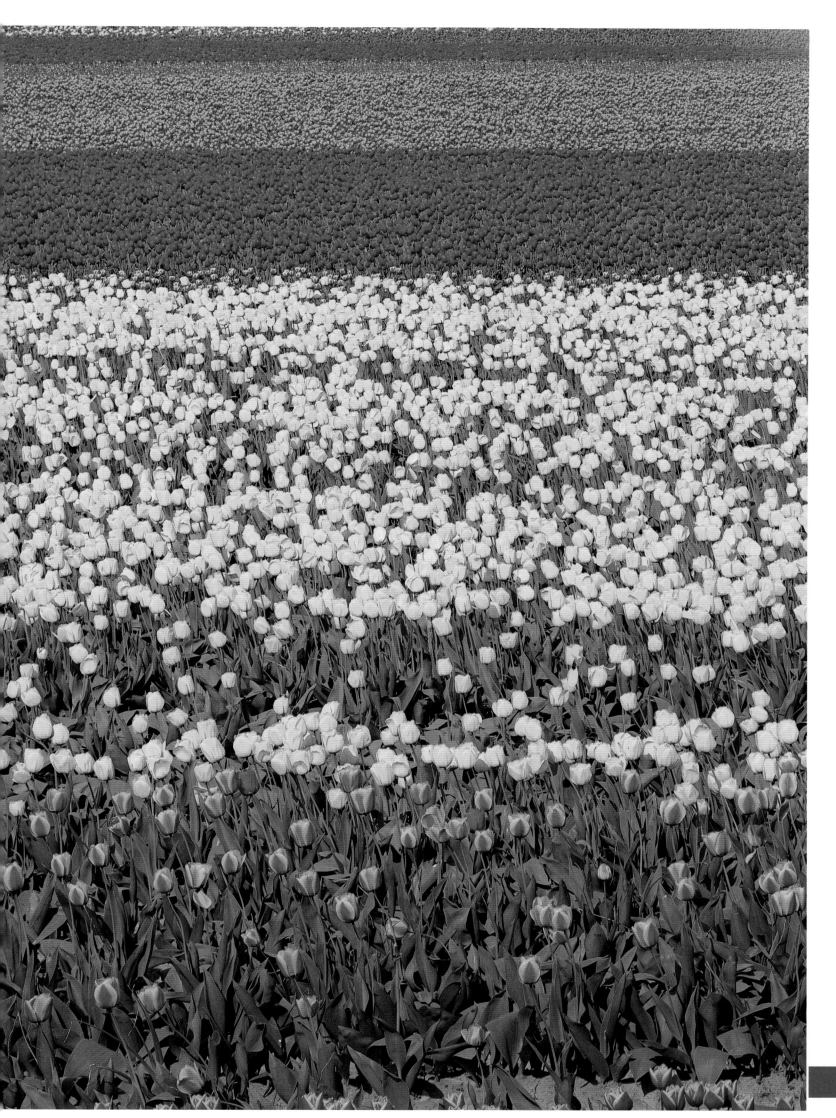

135

Floral farming: commercial tulip fields in Skagit County, Washington CHARLES GURCHE

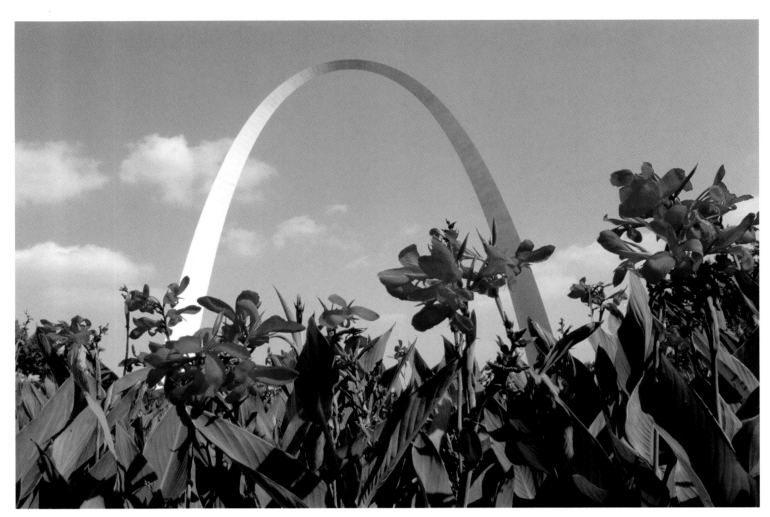

Gateway Arch, portal to the American West, in St. Louis, Missouri
JEREMY WOODHOUSE

" *The American, by nature, is optimistic. He is experimental, an inventor and a builder who builds best when called upon to build greatly.* "

John F. Kennedy,
address in Washington, D.C.,
January 1, 1960

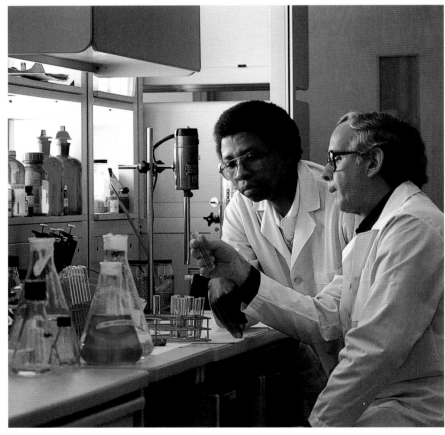

Looking for solutions in a San Francisco laboratory, California
TOM TRACY / PHOTOGRAPHIC RESOURCES

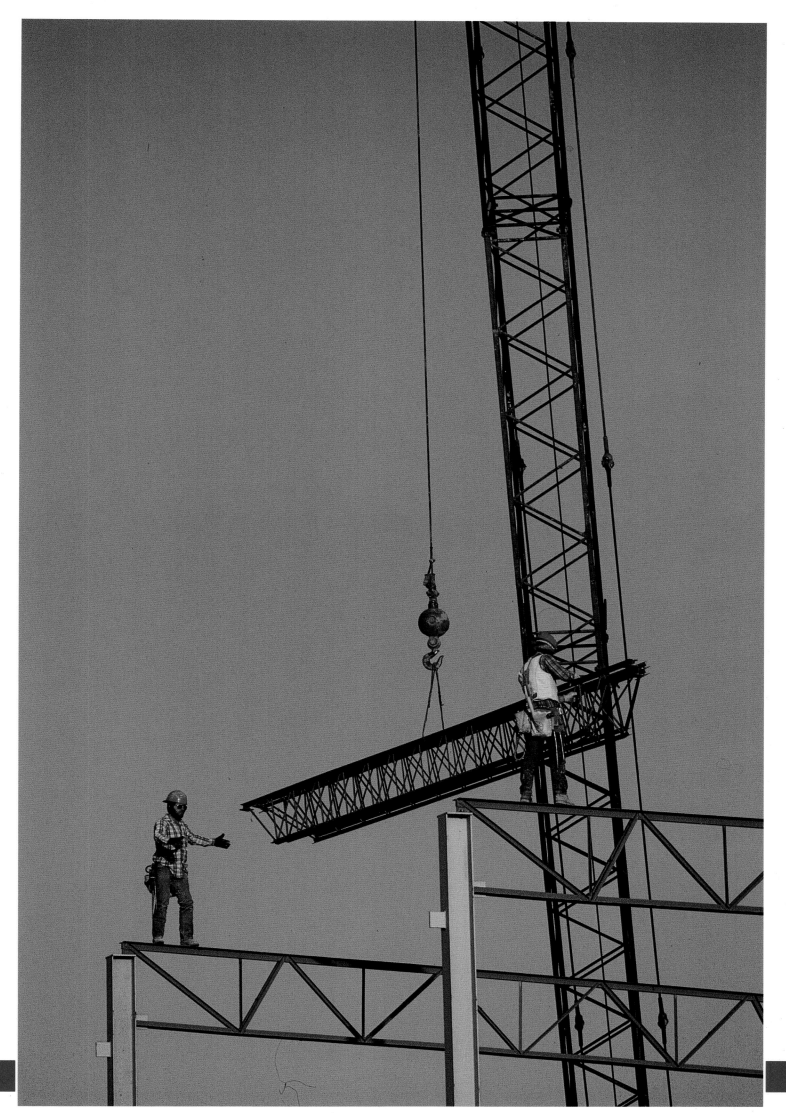

Industrial balancing act in Erlanger, Kentucky JAMES R. FISHER / DRK PHOTO

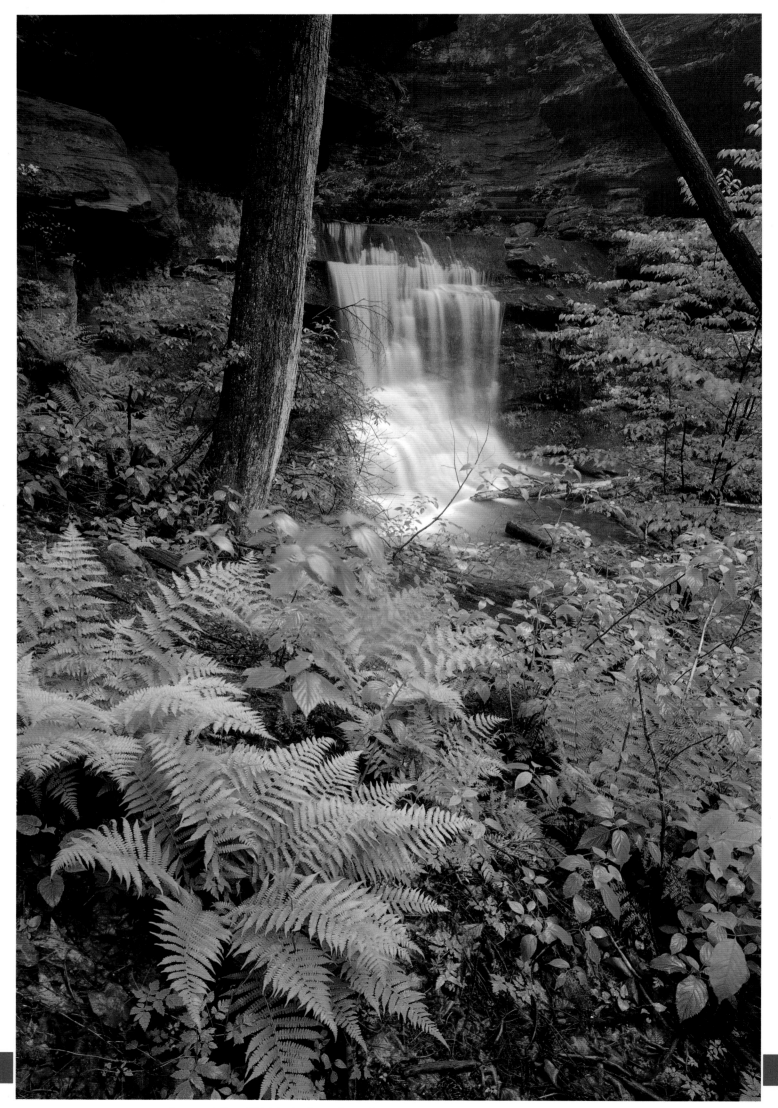

A waterfall at Old Man's Cave State Park southeast of Columbus, Ohio TOM TILL

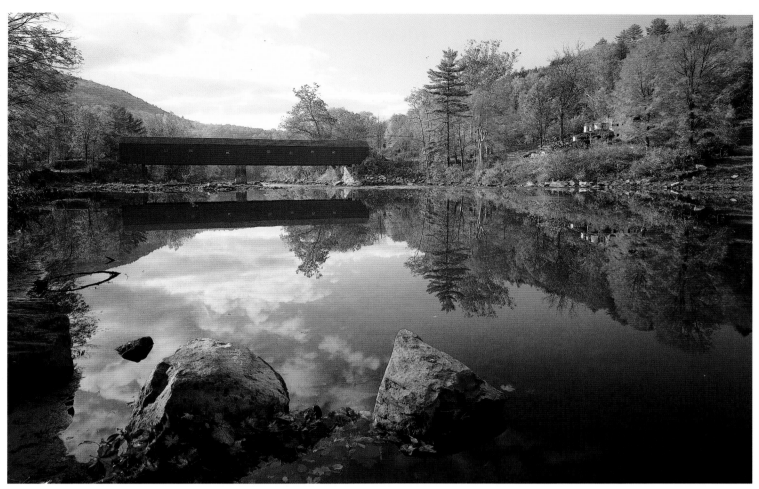

Reflections in the Housatonic River near Cornwall Bridge, Connecticut DAVID MUENCH

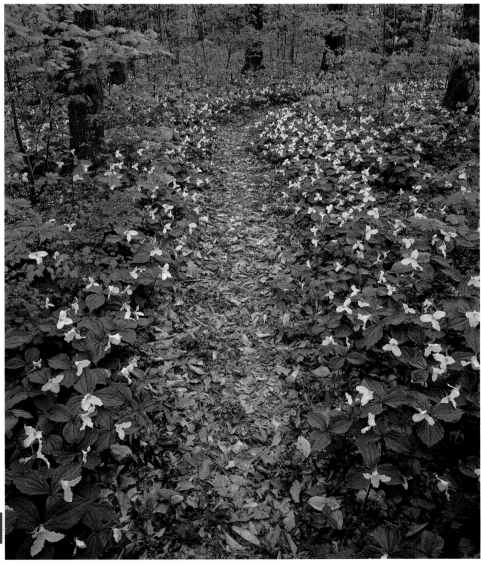

Trillium-lined trail in Selkirk Shores State Park north of Syracuse, New York CARR CLIFTON

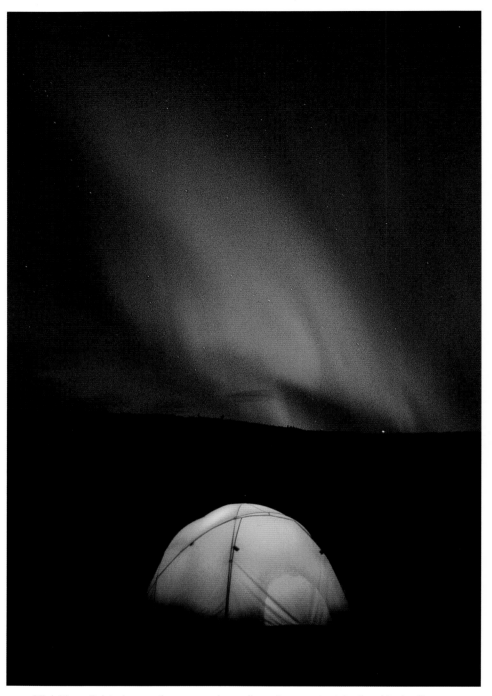

Nighttime light show—the aurora borealis—above a tent in the Alaska Range, Alaska SCOTT T. SMITH

> *The great grizzly bear*
> *Lifts his mighty head,*
> *The white-tailed deer pricks his*
> *Small ears to the sky*
> *And knows that he is safe in*
> *America....*
> *When the wild mustang of Wyoming*
> *Whinnies into the darkness of the night,*
> *That means I love America.*

Jedediah Brown, Grade 4,
Pinedale, Wyoming.
From ''Never Ending Sureness''
in the Young Writer's Contest.

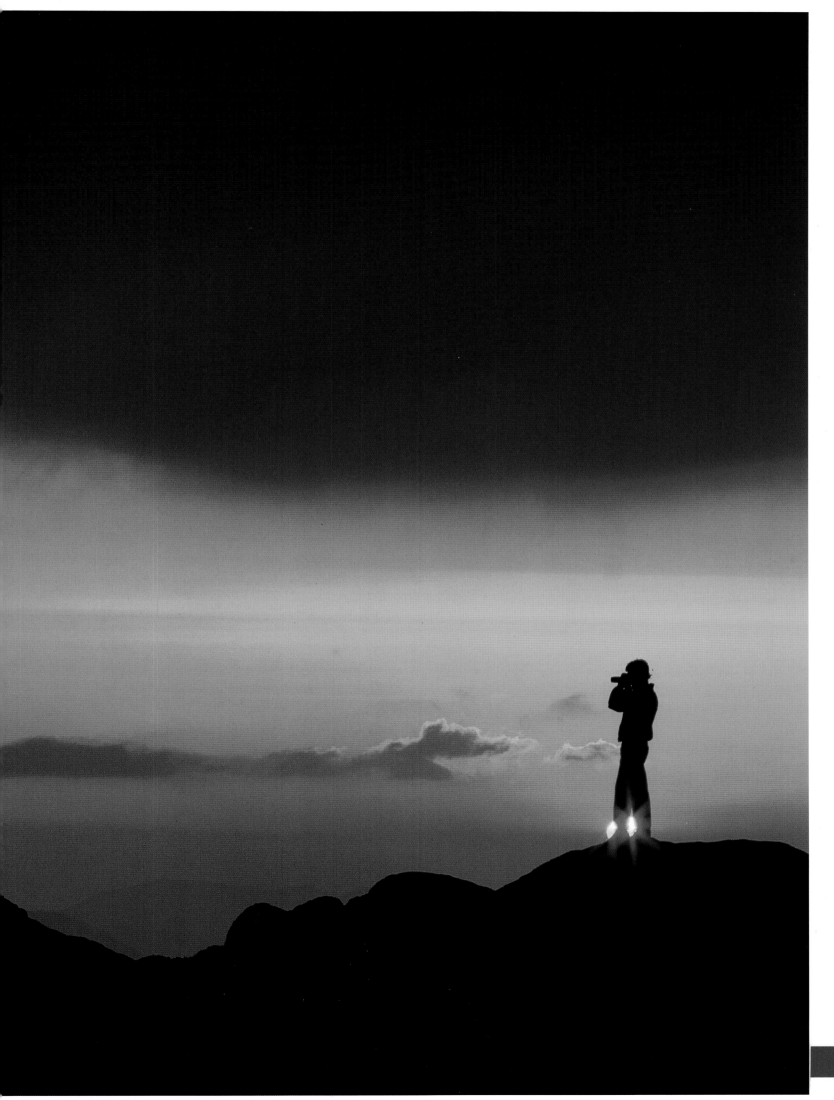

Sunset in the Norse Peak Wilderness, Mount Baker-Snoqualmie National Forest, Washington PAT O'HARA

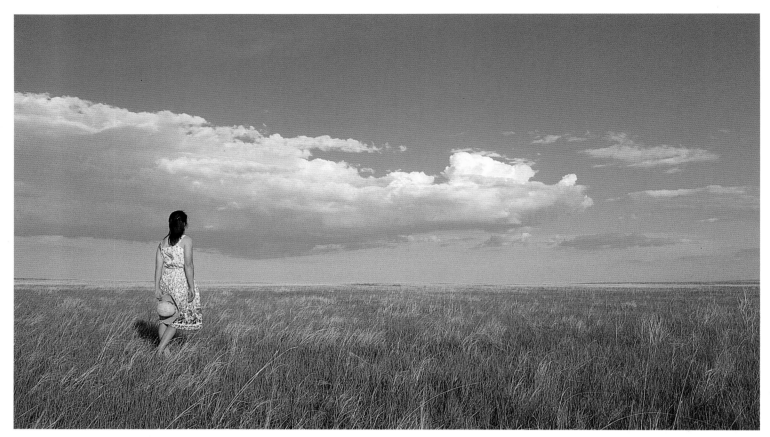

Prairie vision, Badlands National Park, South Dakota TOM BEAN / DRK PHOTO

❝ The prairie sings to me in the forenoon and I know in the night I rest easy in the prairie arms, on the prairie heart. ❞

Carl Sandburg,
"Prairie," in Complete Poems

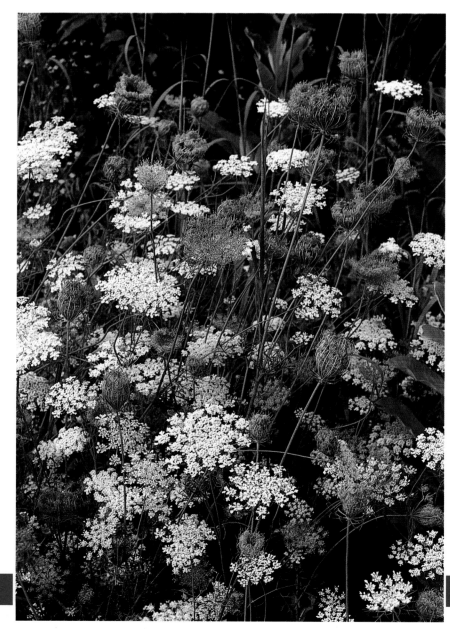

Queen Anne's lace decorating the Oklahoma prairie
STEPHEN J. KRASEMANN / DRK PHOTO

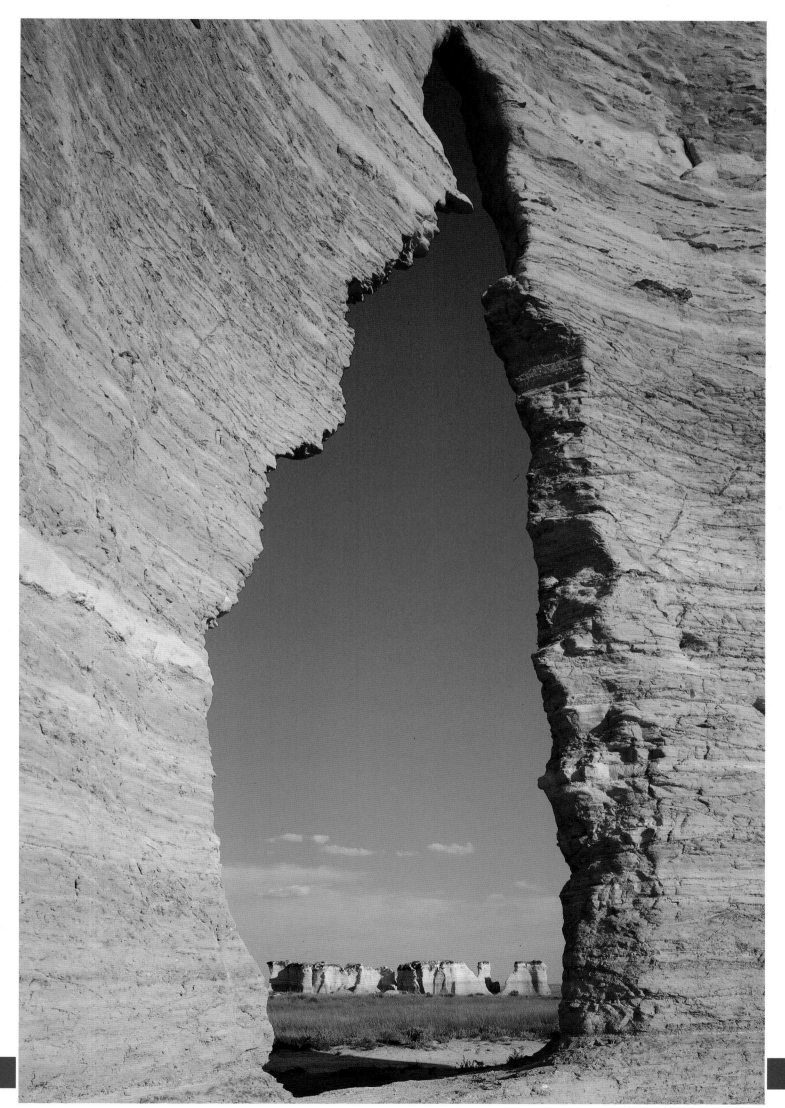

143

Monument Rocks in eastern Kansas, landmark to wagon trains on the Butterfield Trail DAVID MUENCH

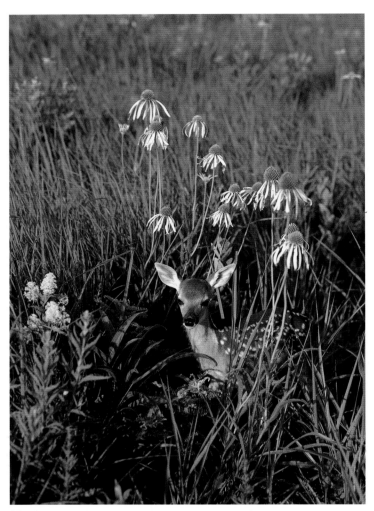

Native grasslands of The Nature Conservancy's Flint Hills Preserve
near Alma, Kansas DAVID MUENCH

Whitetail fawn and coneflowers at The Nature Conservancy's
Tallgrass Prairie Preserve, Oklahoma HARVEY PAYNE

❝ *As I walked along the ridge I looked out across the plains, the*
hills barely rippling in the sun, each hill so small in the distance. I began
to feel a beat, a rhythm, like the beat of my heart but much, much
bigger It was the beat of the plains, the hills and the draws and the
flats, and yesterday and today and tomorrow ❞

Hal Borland,
High, Wide and Lonesome

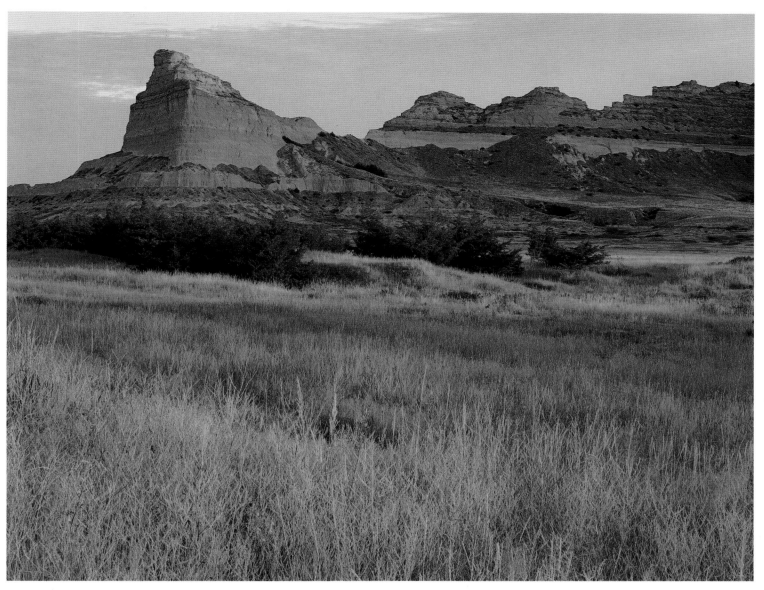

Scotts Bluff, landmark for emigrants along the Oregon Trail, Nebraska WILLARD CLAY

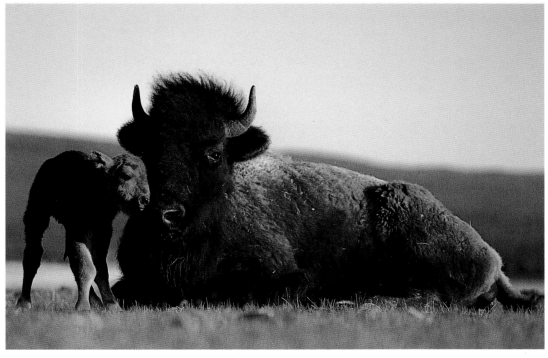

Living symbol of the plains, bison and calf at the Wichita Mountains National Wildlife Refuge, Oklahoma MICHAEL S. SAMPLE

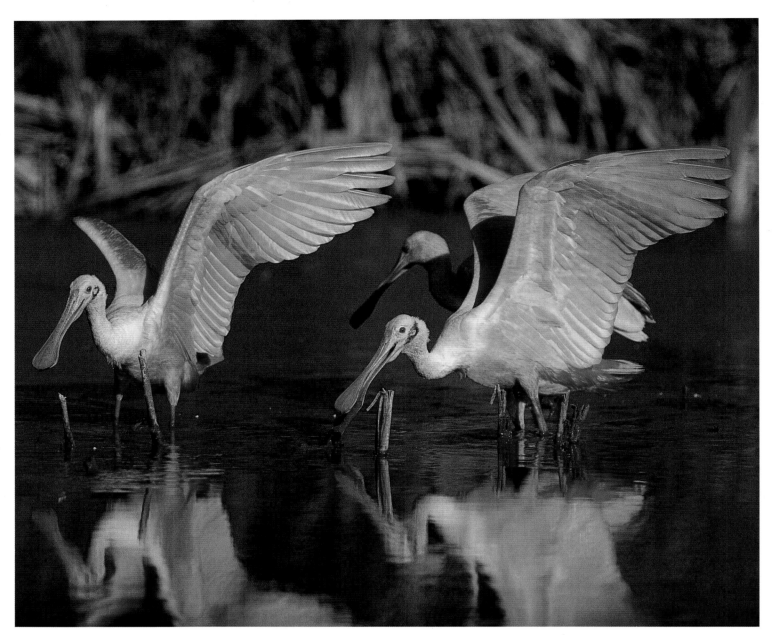

Roseate spoonbills in breeding plumage, Everglades National Park, Florida LARRY LIPSKY

“ *Lying in comfort by the sea, you receive gratefully the gift of the sun, the gift of the South. This is true seduction.* **”**

E. B. White,
The Points of My Compass

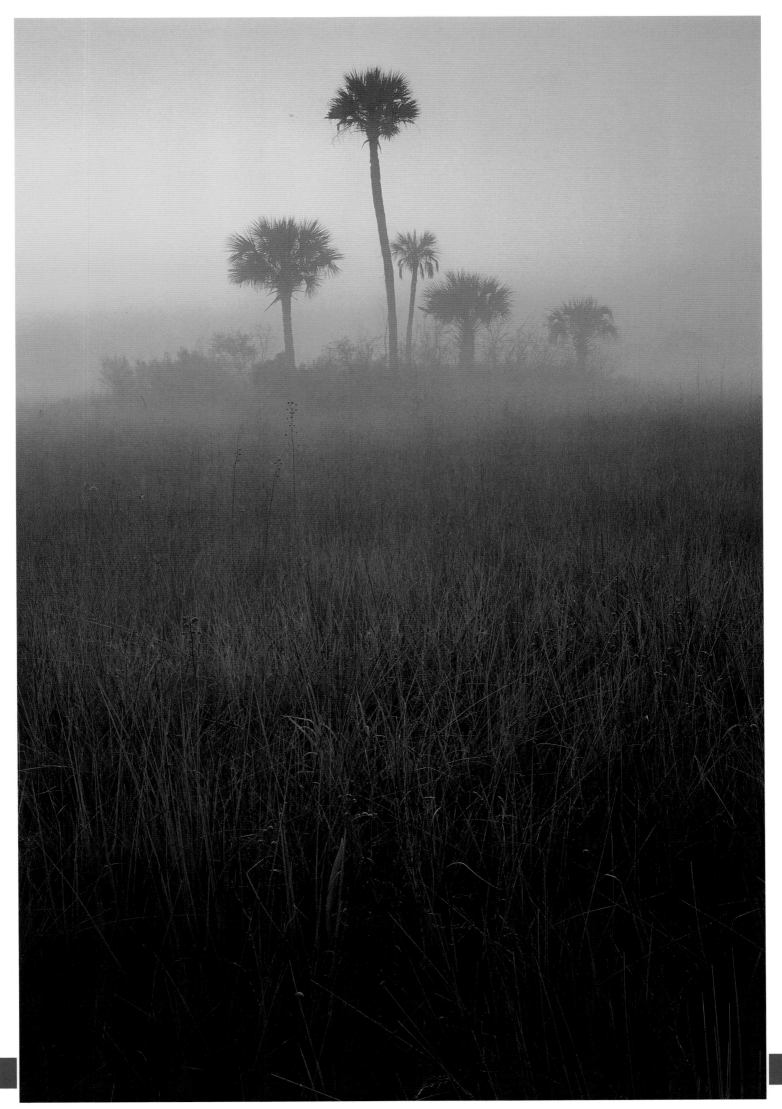

147

A patch of cabbage palms at dawn, Big Cypress National Preserve, Florida CARR CLIFTON

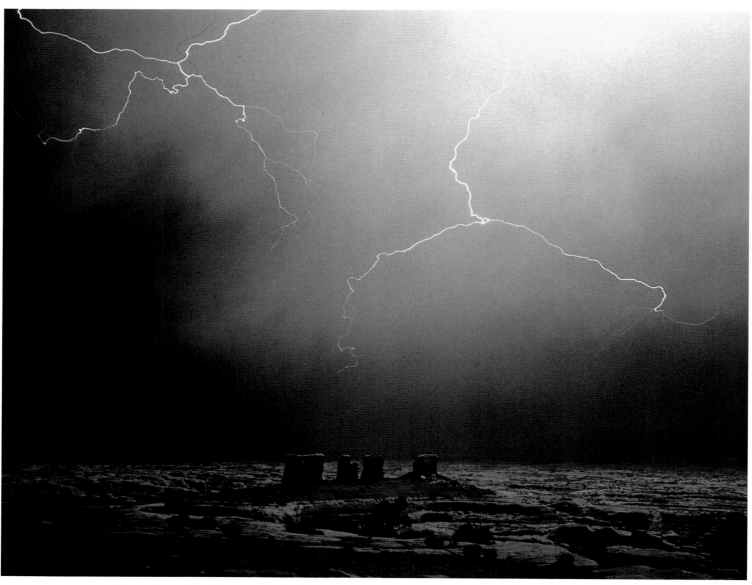

Natural neon in a big empty, the Maze district of Canyonlands National Park, Utah GARY LADD

❝ *I prefer the absences and the big empties, where the wind ricochets from sand grain to mountain. I prefer the crystalline dryness and an unadulterated sky strewn from horizon to horizon with stars. I prefer the raw edges and the unfinished hems of the desert landscape.* **❞**

Ann Zwinger,
The Mysterious Lands

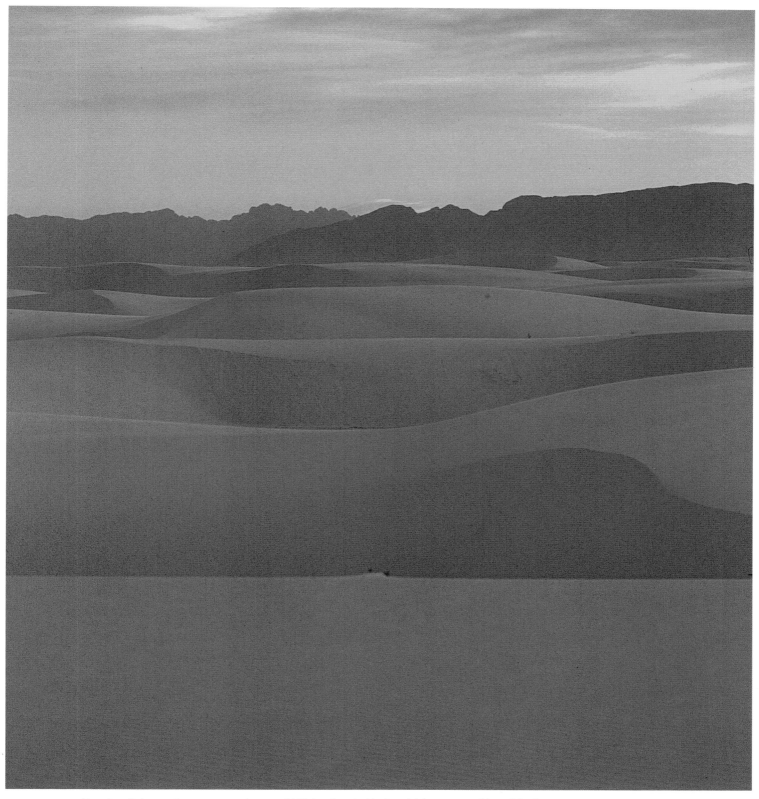

Evening light on the gypsum dunes of White Sands National Monument, New Mexico DENNIS & MARIA HENRY

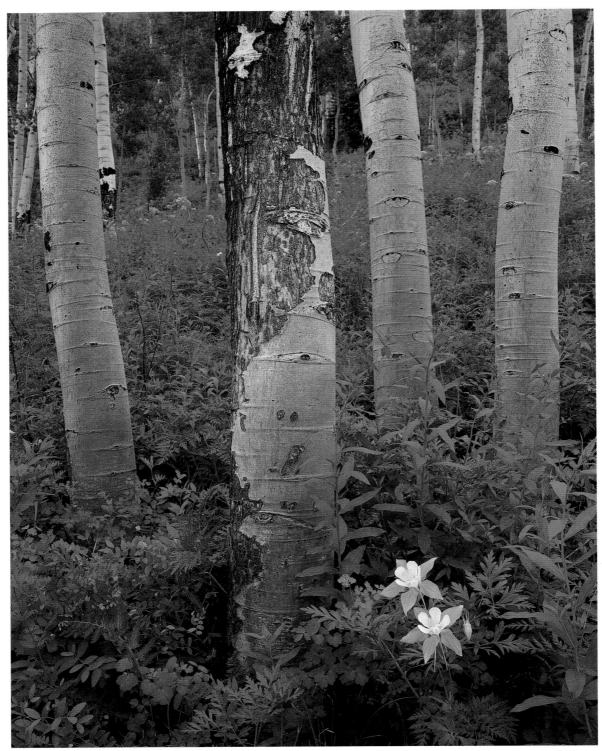

Aspen forest accented by blue columbines, Gunnison National Forest, Colorado WILLARD CLAY

66 *The forests of America, however slighted by man, must have been a great delight to God, because they were the best He ever planted.* 99

John Muir,
quoted by John Gunther in Inside U.S.A.

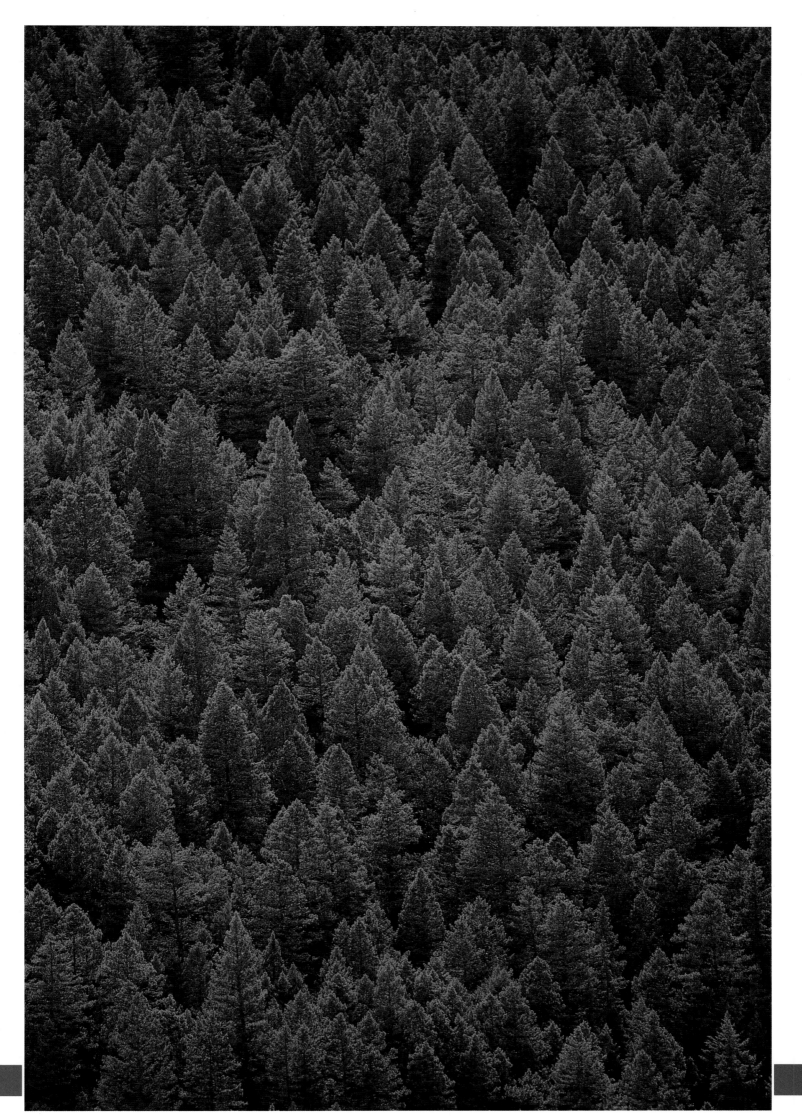

Emerald expanse of conifer trees in Bighorn National Forest, Wyoming TOM BEAN

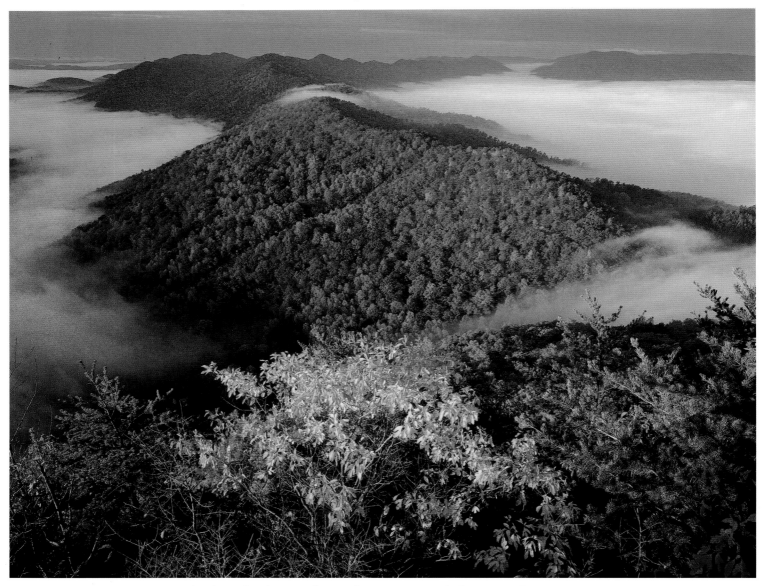

Appalachian Mountains from Cumberland Gap National Historic Park, Kentucky / Tennessee / Virginia TOM TILL

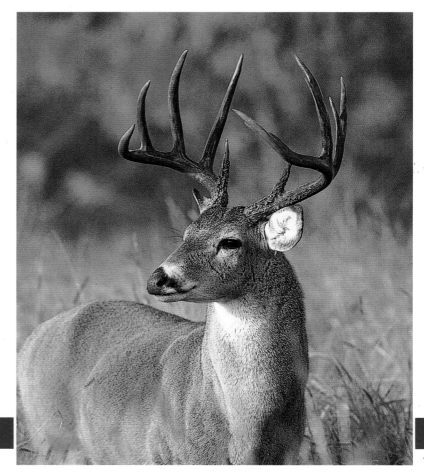

Whitetail buck near San Antonio, Texas
CLAUDE STEELMAN / TOM STACK & ASSOCIATES

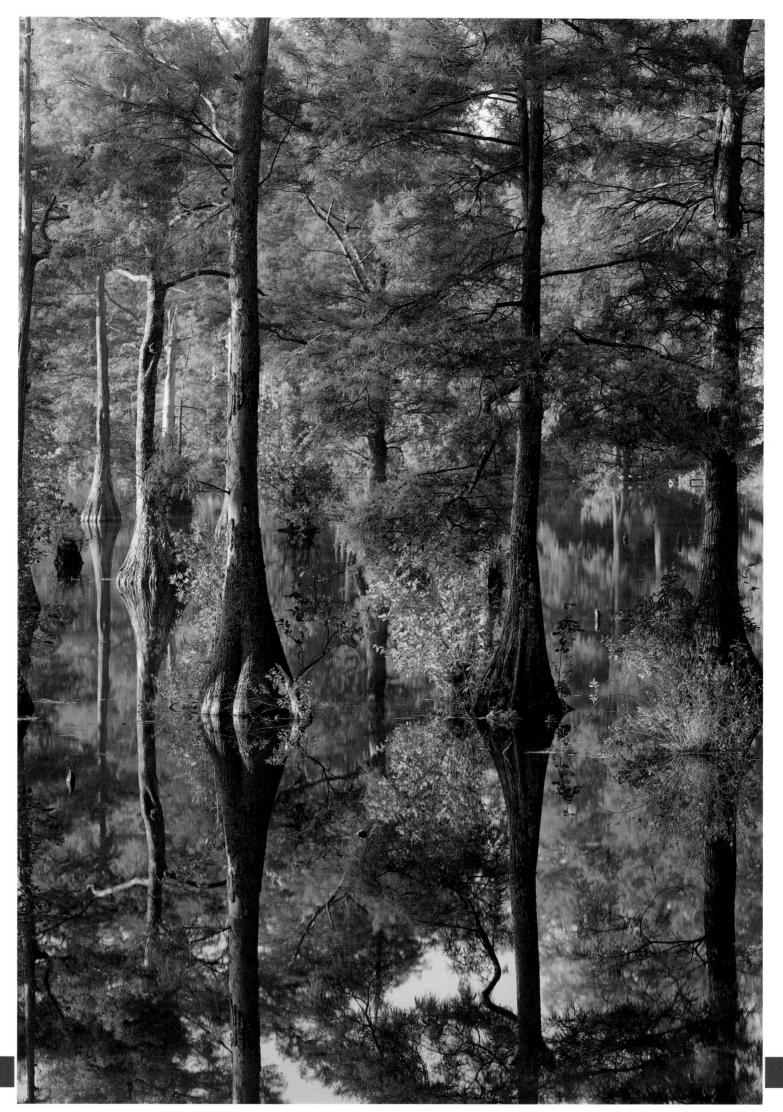

153

Bald cypress knee-deep in Trussum Pond State Preserve, Delaware DAVID MUENCH

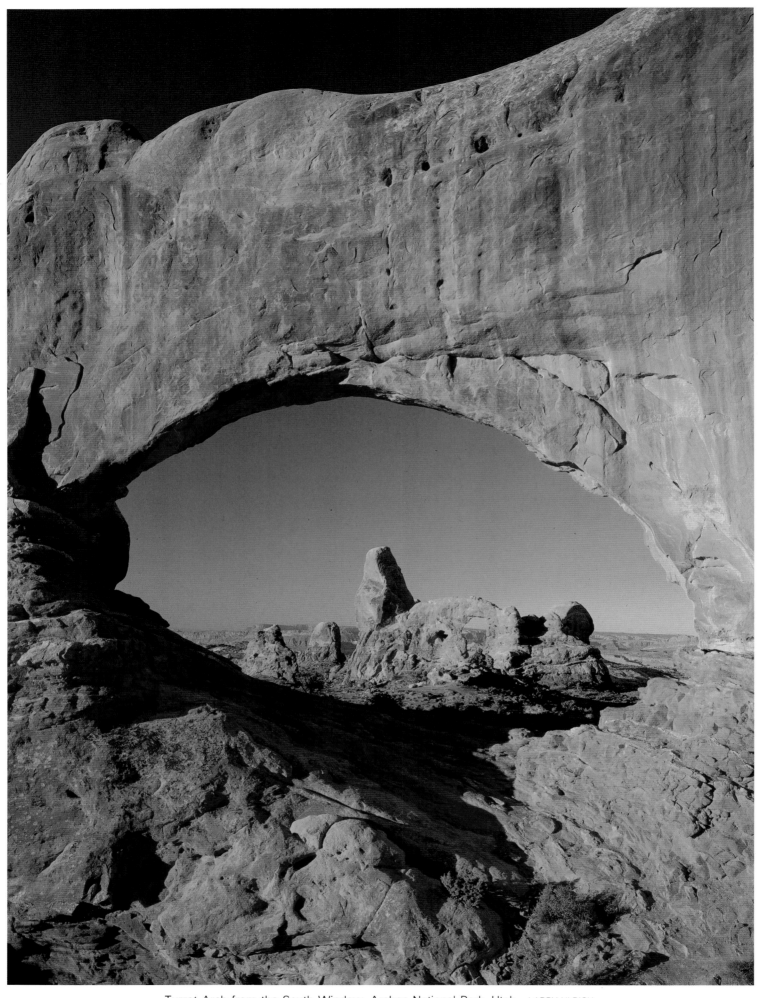

Turret Arch from the South Window, Arches National Park, Utah LARRY ULRICH

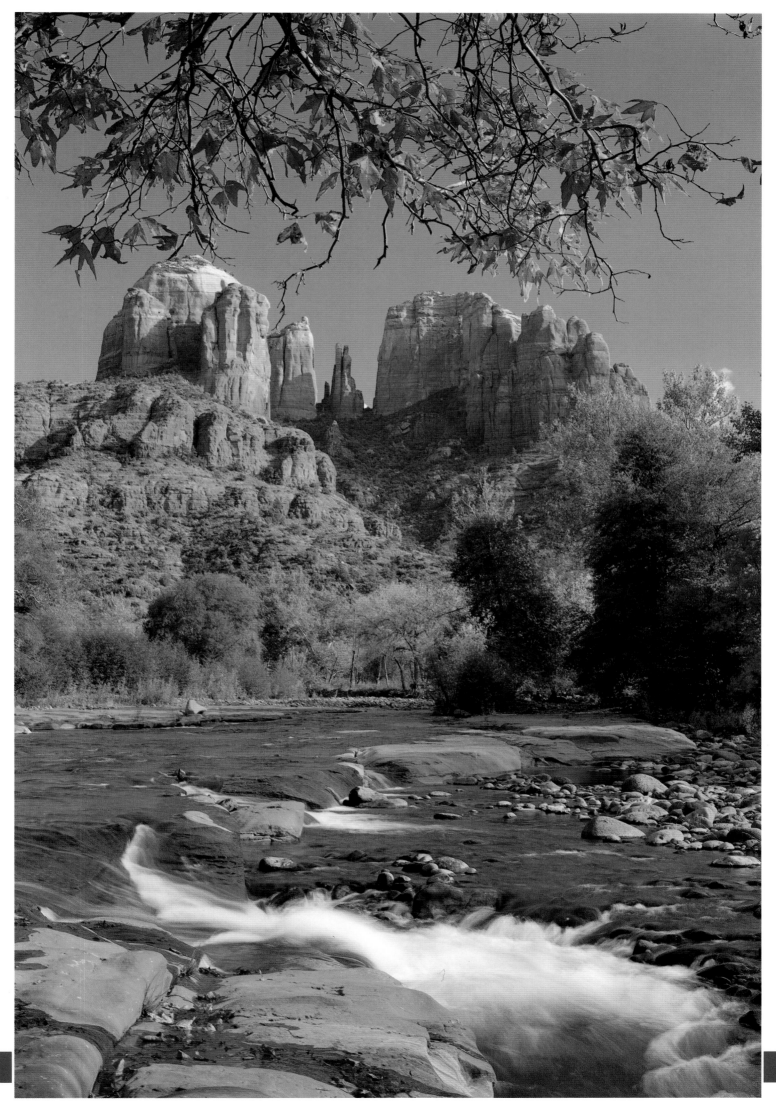

Oak Creek and Cathedral Rock, Coconino National Forest, Arizona LARRY ULRICH

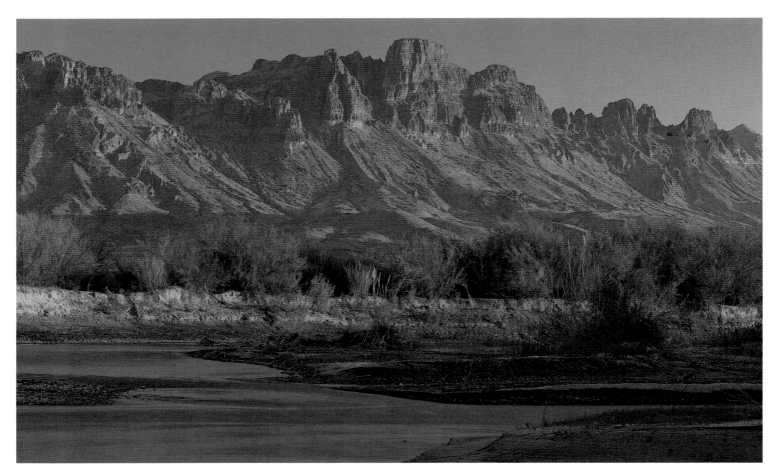

Morning light on the Chisos Mountains and Rio Grande in Big Bend National Park, Texas WILLARD CLAY

" It is good to realize that, if love and peace can prevail on earth, and if we can teach our children to honor nature's gifts, the joys and beauties of the outdoors will be here forever. "

Jimmy Carter,
An Outdoor Journal

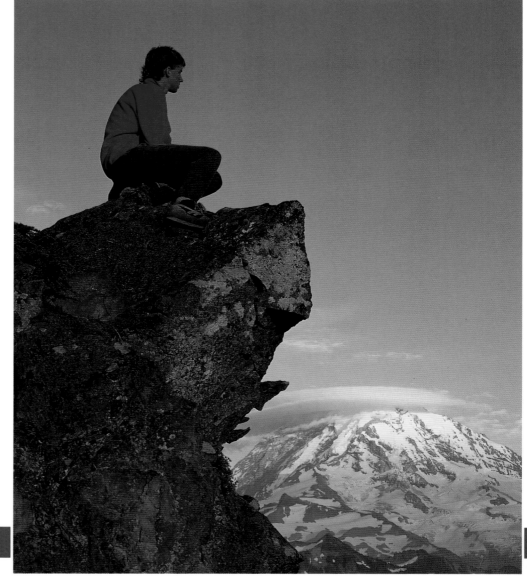

Viewing 14,410-foot Mount Rainier from Tolmie Peak in
Mount Rainier National Park, Washington PAT O'HARA

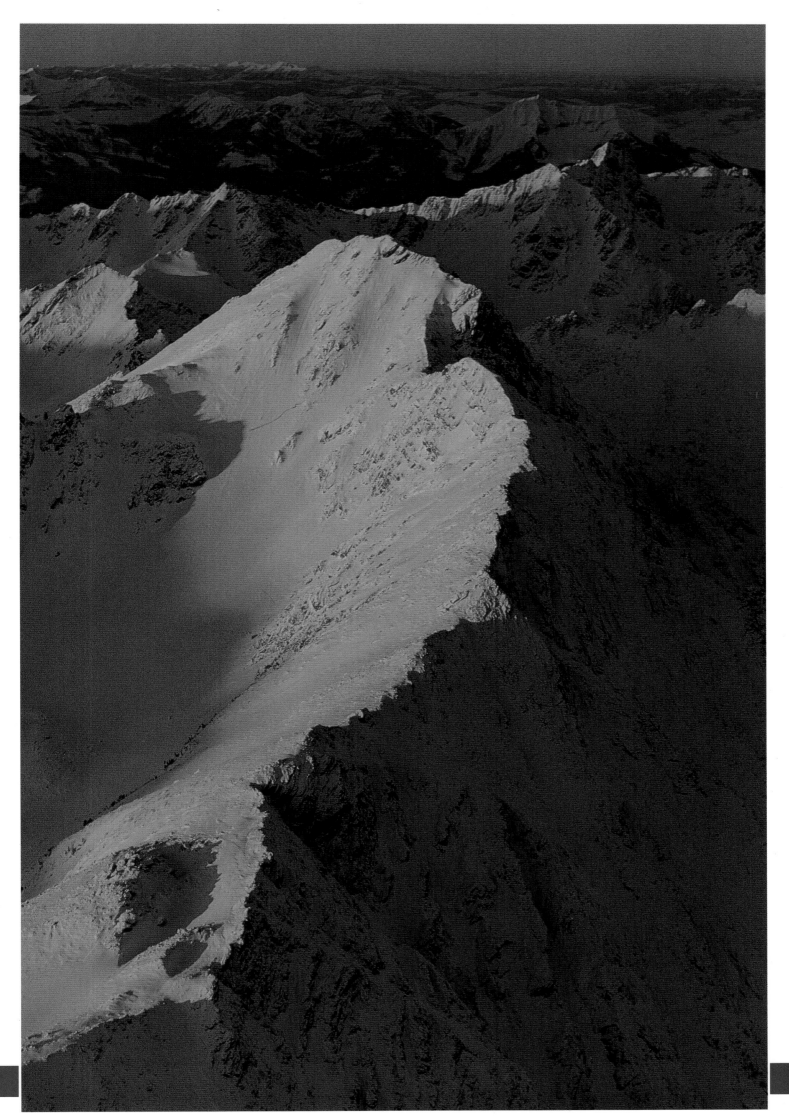

The edge of day on 11,012-foot Gallatin Peak, Gallatin National Forest, Montana MICHAEL S. SAMPLE

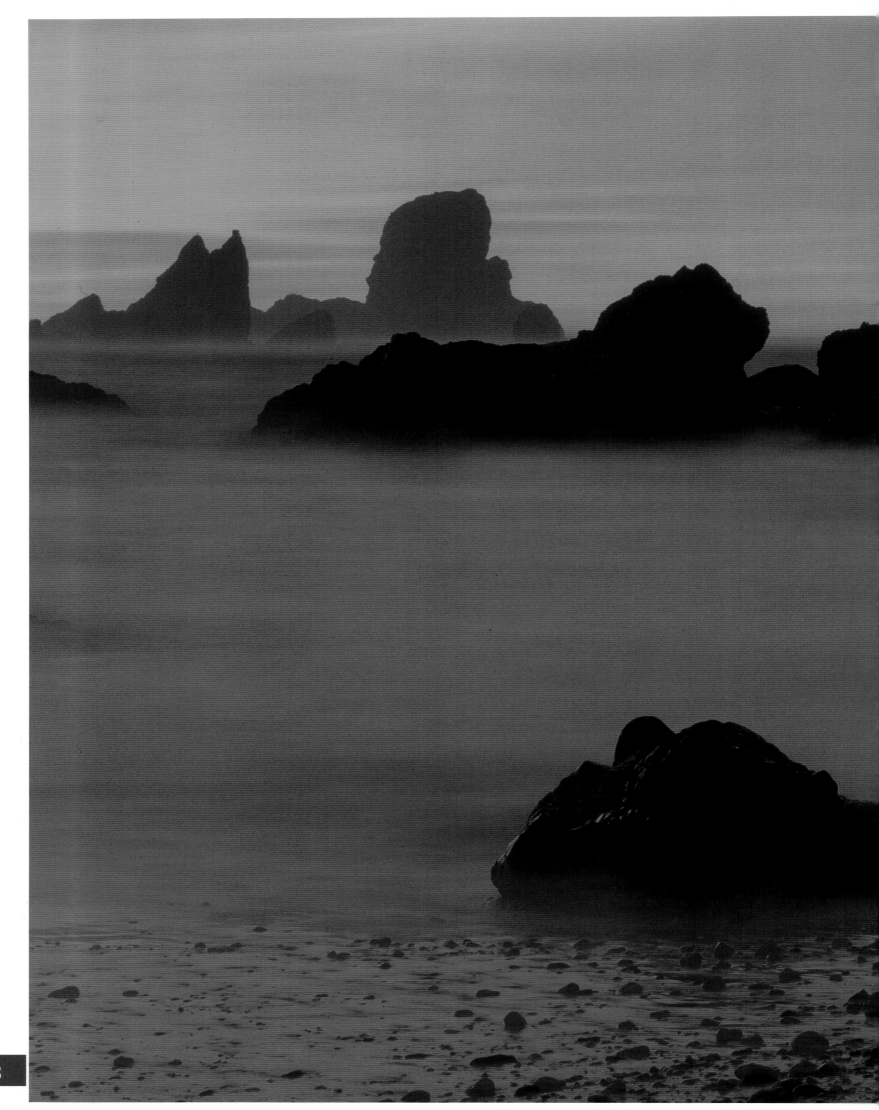

Sunset at Crescent Beach, Ecola State Park, Oregon WILLARD CLAY

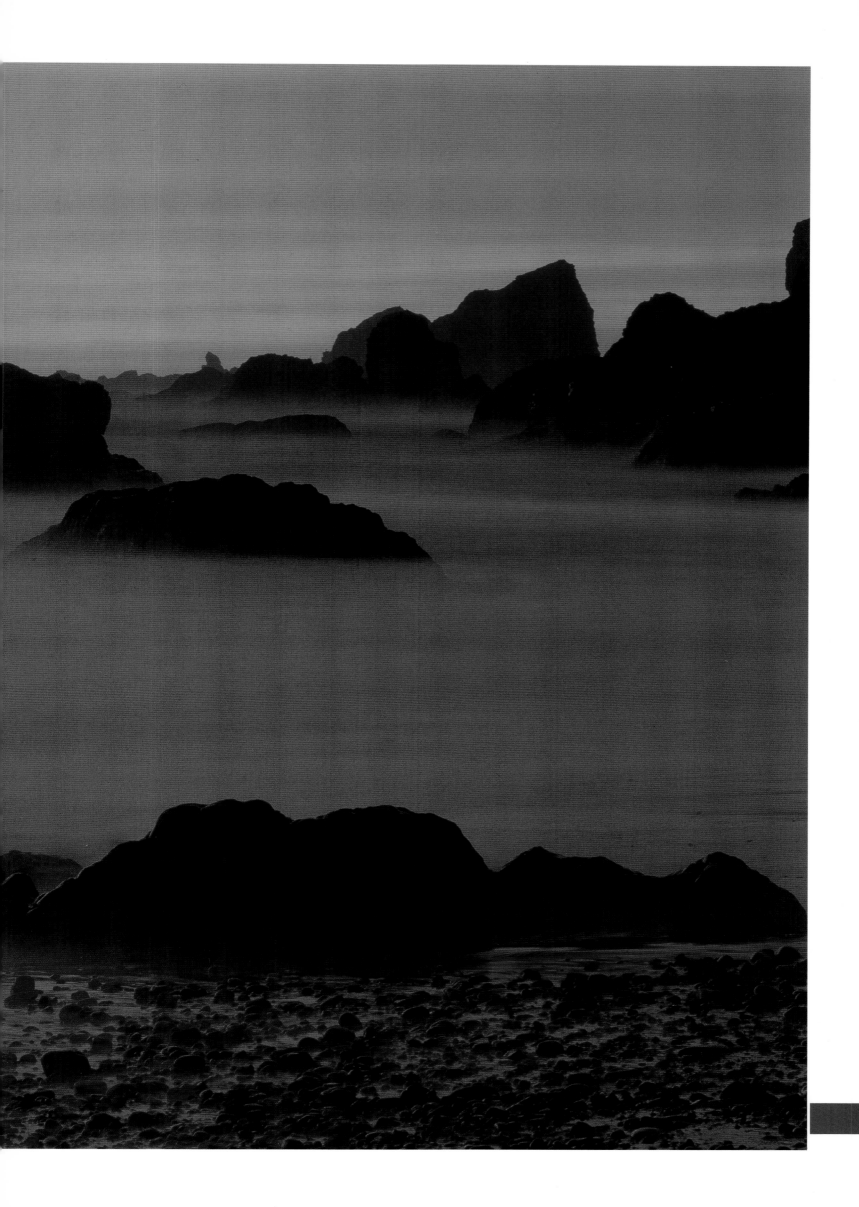

they made it possible

America has always been a land of opportunity, not least for its photographers. From windswept prairies to majestic mountains, from colorful deserts to busy cityscapes, America lends itself to the kind of magnificent images presented in *America on My Mind*.

But the photographers, too, deserve credit—for making sure they were in the right place at the right time, for seeing with a discriminating eye, for mastering complex technical skills, and for recording the moments and places of artistic merit for the rest of us to enjoy. They hiked and climbed, watched and waited, shot and edited, and as a result they have preserved the best of America.

America on My Mind would not exist without the creative and technical skills of these 100 men and women. They succeeded in capturing this nation's spirit, heritage, pride, and beauty. For this, we are grateful.

The Globe Pequot Press

Photographers in *America on my Mind*

Sam Abell
Aiuppy Photographs
Bill Bachmann
Noella Ballenger
 & Jalien Tulley
Tom Bean
Annie Griffiths Belt
Matt Bradley
S. Carmona
Linda Cauble
David Cavagnaro
Paul E. Clark
Willard Clay
Carr Clifton
Peter Cole
W. Perry Conway
Daniel J. Cox
Larry R. Ditto
John Eastcott
 & Yva Momatuik
John Elk III
Terry Farmer
Bob Firth
Gene Fischer
James R. Fisher
Thomas R. Fletcher
Bill Foley
Jeff Foott
Allen Fredrickson
Ken Gallard
James Kirk Gardner

John Gerlach
Jeff Gnass
Charles Gurche
Kim Heacox
Anne Heimann
Dennis & Maria Henry
Gary Hershorn
Fred Hirschmann
Laura House
Gordon Joffrion
Lee Kaiser
Catherine Karnow
Stephen J. Krasemann
Gary Ladd
Russell Lamb
Wayne Lankinen
Frans Lanting
Robert F. Leahy
Tom & Pat Leeson
Cliff Leight
Ted Levin
Larry Lipske
Thomas D. Mangelsen
Curtis Martin
Steve Mason
Buddy Mays
Rick McIntyre
Douglas Merriam
Mark & Jennifer Miller
Doug Milner
Doug Miner

David Muench
Tom Myers
Scott Nielsen
Frank Oberle
Pat O'Hara
Jack Olson
Rob Outlaw
Harvey Payne
David Perdew
Robert Perron
Larry Pierce
Mike Powell
James Randklev
Chris Roberts
Randall K. Roberts
Galen Rowell
Greg L. Ryan
 & Sally A. Beyer
William R. Sallaz
Pete Saloutos
Michael S. Sample
Ron Sanford
Eliot Schechter
J.D. Schwalm
Mike Segar
Frank Siteman
Richard Hamilton Smith
Scott T. Smith
Scott Spiker
Allen Dean Steele
Claude Steelman

David Stoecklein
Chase Swift
Steve Terrill
Tom Till
Tom Tracy
Stephen Trimble
Larry Ulrich
Tom J. Ulrich
Don & Pat Valenti
Greg Vaughn
David Lorenz Winston
Art Wolfe

And these photo agencies:
 Allsport
 Corbis
 DRK Photo
 DRS Productions
 Firth Photobank
 Minden Pictures
 National Aeronautics &
 Space Administration
 New England Stock
 Photo
 Photographic Resources
 Reuters
 Stock South
 Tom Stack & Associates
 Visions from Nature